MARKING THE LAND

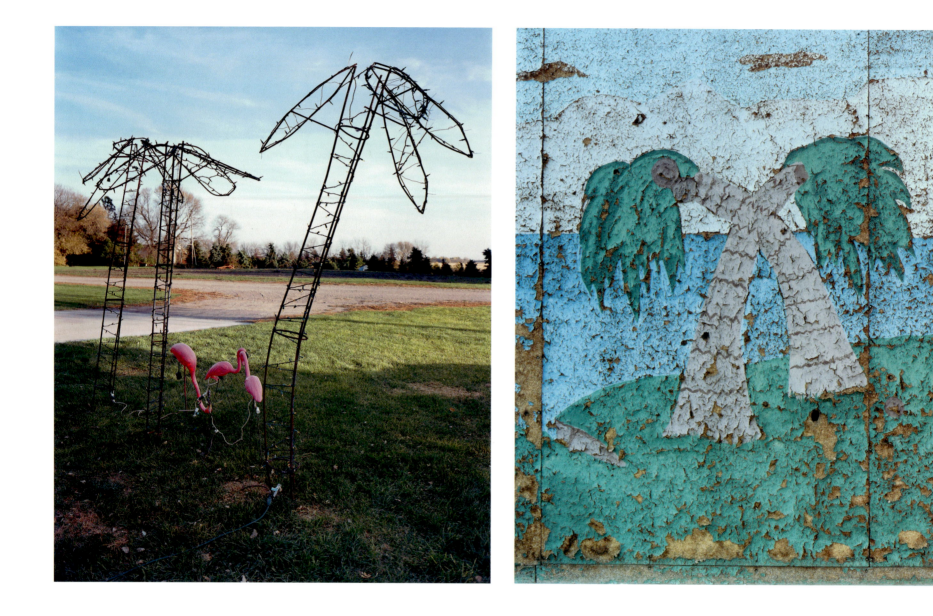

Marking the Land
Jim Dow in North Dakota

Photographs and Narrative by Jim Dow
Edited with an Essay by Laurel Reuter

North Dakota Museum of Art
Grand Forks, North Dakota

The Center for American Places
Santa Fe, New Mexico, and Staunton, Virginia

Center Books on American Places
George F. Thompson, Series Founder and Director

The Center for American Places, Inc.
P. O. Box 23225
Santa Fe, New Mexico 87502, U.S.A.
www.americanplaces.org

North Dakota Museum of Art
261 Centennial Drive, Stop 7305
Grand Forks, North Dakota 58202-7305, U.S.A.
www.ndmoa.com

Distributed by the University of Chicago Press
www.press.uchicago.edu

15 14 13 12 11 10 09 08 07 1 2 3 4 5

Library of Congress Cataloging-in-Publication Data
is available from the publisher upon request.

Limited Clothbound Edition:
ISBN-13: 978-1-930066-63-2
ISBN-10: 1-930066-63-5

Paperback:
ISBN-13: 978-1-930066-64-9
ISBN-10: 1-930066-64-3

For the Center for American Places:
George F. Thompson, President and Publisher
Amber K. Lautigar, Publishing Liaison and Associate Editor
A. Lenore Lautigar, Publishing Liaison and Assistant Editor
Purna Makaram, Manuscript Editor

For the North Dakota Museum of Art:
Laurel Reuter, Director and Editor
Robert W. Lewis, Manuscript Editor
Lois Wilde, Copy Editor
Steven Kirschner, Designer
Randy Nelson, Production Manager
Greg Vettel, Exhibition Coordinator
Brian Lofthus, Editorial Assistant
Matt Wallace, Editorial Assistant

CONTENTS

PREFACE

Throughout the vast Northern Plains and over the course of the last decades of the twentieth century, seismic change has swept away family farms and ranches, small towns and rural schools. The land is now occupied by agribusiness with its massive machinery, global positioning systems for precision crop management, worldwide marketing networks, and government safety nets. The lone farmer, the cowboy, crews of custom combiners, migrant workers and field hands gradually moved on. The remains of that earlier life dot the landscape like the skeletons of fish washed up on far distant shores—but they live on in *Marking the Land: Jim Dow in North Dakota.*

In the early 1980s, the North Dakota Museum of Art commissioned Jim Dow to photograph folk art within the landscape. The Museum had mounted a large survey of regional folk art and concluded that much lay elsewhere, unmovable, unrecognized, at risk to the elements. Target Stores agreed to fund Dow's first forays into this silent land in order to capture those elusive creations. Twenty years later, Dow returned, once again "in love with North Dakota." This time his instructions were to photograph whatever he pleased. Ultimately the 300-plus images became part of the Museum's larger *Emptying Out of the Plains* initiative through which artists have been commissioned to respond to the population shifts that are forcing the people of the Northern Plains to re-imagine their lives. Jim Dow's work in North Dakota and surrounding areas and this resulting book have been underwritten by:

ARCHER DANIELS MIDLAND FOUNDATION

JANET BORDEN

NATHAN CUMMINGS FOUNDATION

ELIZABETH FIRESTONE GRAHAM FOUNDATION

EMMET AND EDITH GOWIN

THE HART FAMILY

NATIONAL ENDOWMENT FOR THE ARTS

NORTH DAKOTA MUSEUM OF ART FOUNDATION

TARGET STORES

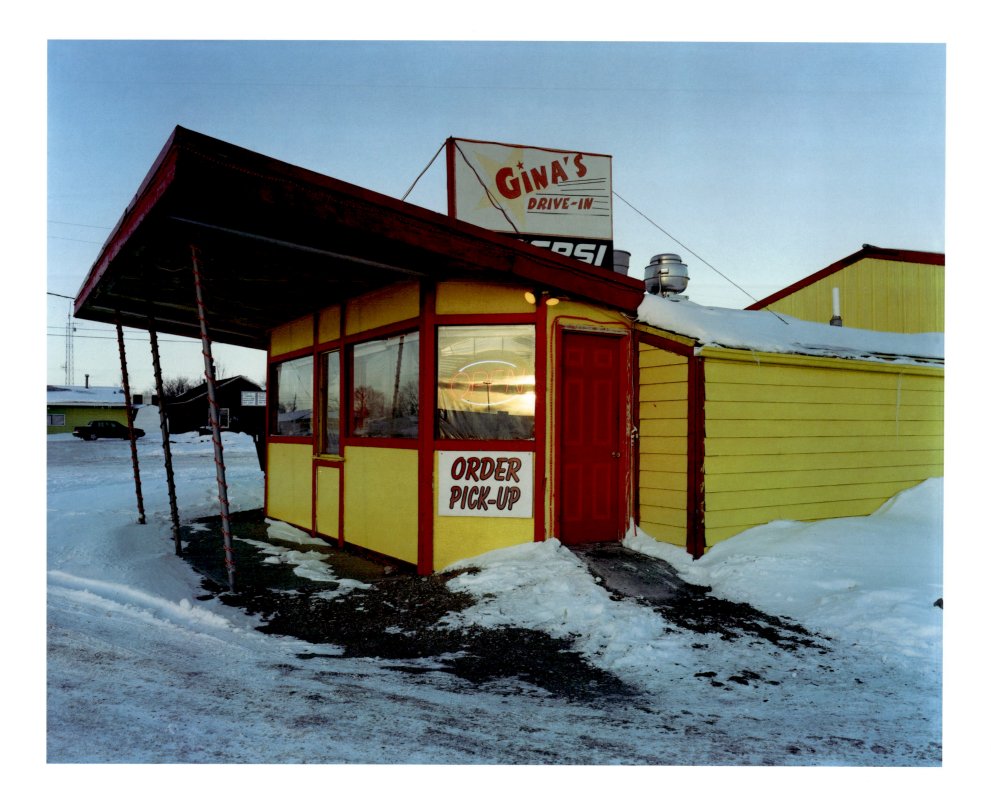

IN NORTH DAKOTA JIM DOW

It used to be said that only mad dogs and Englishmen ventured out in the noonday sun in places such as Khartoum, Cairo, and Calcutta. And certainly it would take a fool of similar magnitude to agree to travel around North Dakota in January and February to take photographs of folk-art objects that couldn't be moved. Yet that is exactly what I agreed to do during a telephone conversation with Laurel Reuter, the eminently persuasive Director of the North Dakota Museum of Art.

Just a few days later, I found myself in Grand Forks, on the twentieth of January 1981 with the thermometer standing at seventy degrees. Two days later, it had dropped to zero, but such fluctuations of temperature have been only one aspect of what has turned out to be twenty-five years full of contradictions and surprises.

In North Dakota, what is on, in, or below the surface of the land governs everyone's fortune, good and bad. Coming from the East, my first impression was to gasp at the enormous scale of what I then saw as unfettered, incomprehensibly empty space that stretched mile upon mile in every direction. It was only after some time and an enormous amount of help from a great many different people that I came to understand that almost every available inch of land is usefully engaged, often in multiple ways. Eventually I was able to see that the insistent, precisely parallel sugar beet rows are sown within a hairbreadth of the highway right-of-way; that the number of cattle permitted to graze per acre is painstakingly parsed out with strict adherence to what the local water table will bear; or that the scale of shale-oil operations is consistently governed by microscopic attention to calculations that balance the world price per barrel with exploratory costs of digging it all up and refining it. If intensity of land usage might be taken as analogous to density of population, then North Dakota offers the complexity of Manhattan or Mexico City.

There are relatively few people per square mile throughout the Dakotas, and that rarity gives a special value to each and every human activity and interchange. It may seem strange to think that this book is really about people, since, on first inspection, none appear in the pictures; but every single image reproduced here is both a document and a testimony to human enterprise and ingenuity. The subjects are as varied and complex as the population: consistently pragmatic, but also blending the symbolic, humorous, and ironic into a rich visual and cultural fabric that binds the enormous expanse of the High Plains into a coherent whole. At times, they are as straightforward as an outsized wooden watermelon slice, sculpted by a twelve-year-old girl wielding a chain saw. In other cases, they are as self-consciously subtle as the gentle arc of the art deco metal bar at Whitey's, lovingly restored after the 1997 flood that devastated much of Grand Forks and the surrounding area. In each and every instance, they are worthy of attention in their powerful testimony to the self-reliance, imagination, and character of the individual sensibilities that created them.

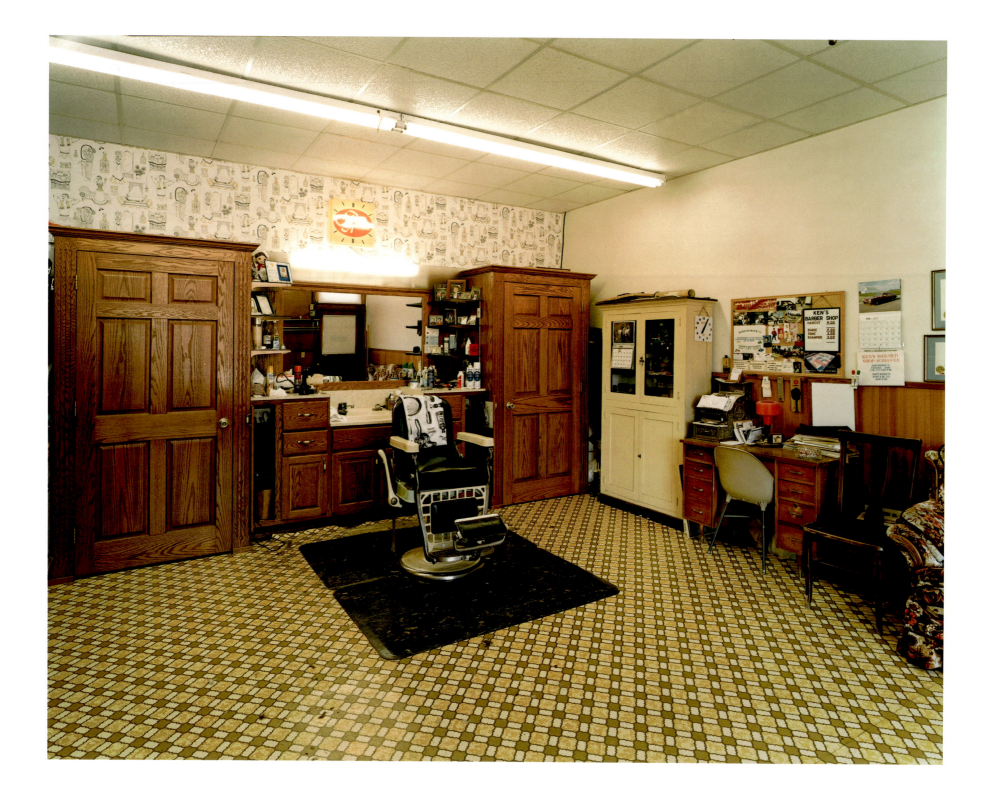

HE CAME TO CHERISH THEM LAUREL REUTER

The water retreated and alkali lay upon the land. Jim Dow first came to the semiarid Northern Plains in the winter of 1981 when the alkali lay heavily upon the land. Coinciding with his arrival, Bismarck experienced the highest January temperature on record: sixty-two degrees above zero, 100 degrees above Dow's expectations. And the word "snirt" entered his vocabulary.

Snirt, a miserable melding of snow and dirt, blows across the landscape during open winters. Bypassed by fall rains, the topsoil is bone dry at freeze-up, and the deepening cold squeezes the remaining wetness from the scant snow. Combining, these fine particles of shifting snirt blanket the earth and blacken the sky, making everyone wretched. When the prevailing westerlies die down, the snirt settles and Jim Dow's camera records a different truth. Under the shining sun, the graveyard near Hague (page 172) becomes glorious with its sheen of blue-black velvet, a foil for a field of elegant iron crosses forged by Germans from Russia, immigrants to the Dakotas at the end of the nineteenth century.

North Dakota: the landscape absorbs the people, marking them, possessing them. The seasons consume their minutes, their days, their years, and finally their lifetimes. In North Dakota, all conversations begin with the weather. While still back in Boston, Jim Dow's first exchanges were about his 8 x 10 camera: would it function in the brittle cold of January? He soon learned to worry about his fingers: the camera would manage just fine.

During the two decades between Jim Dow's first visits in the early 1980s and his return in 2000, the climate on the Northern Plains moved through a vast cycle of change. In 1988, dry weather once again gripped the land, only to be broken in 1993 by an exceptionally wet spring and summer, followed close on by heavy spring snowfall in 1994. The accumulation continued into the historic winter of 1996-1997, when raging blizzards and record snows culminated in an April flood of Biblical proportions. Battered by ice jams and overrun with melted snow, the north-flowing Red River grew into a vast inland sea, stretching from the South Dakota border, across eastern North Dakota, western Minnesota, and into Manitoba, where it drained into the Hudson Bay, hundreds of miles to the north. Dow sat glued to his television in Boston, little imagining how these changes would mark his adopted North Dakota—a place to which he was destined to return.

Farther west, the drama played out more slowly. Devils Lake is the largest freshwater lake in the state. It is also in a closed basin, second in size only to Utah's Great Salt Lake, neither of which has an outlet. When Dow began his photographic venture, some experts feared that Devils Lake was drying up again. Short years later, the lake began a relentless march, overflowing its banks, taking out hundreds of homes and businesses, reclaiming thousands of acres of farmland. Ten years later, the water tenaciously clings to its extended shoreline.

Shifting, changing weather, endless winds, extremes of heat and cold: these are the forces that dominate all forces across the Northern Plains; these are the powers that tailor the landscape and inform the spirit of the people. Uncannily absent, weather is the unseen frame that encircles every Jim Dow photograph.

Dow first came to the Northern Plains at the invitation of the North Dakota Museum of Art. The Museum had recently been involved in a statewide folk art survey that resulted in an exhibition. Oddly incomplete, the exhibition begged for all the stuff that wasn't there: stuff too large, too permanent, too embedded into the landscape, unrecognizable as folk art even. Yes, Dow agreed, he would spend a couple of months photographing folk art within the landscape.

In the beginning, North Dakota folklorist Nicholas Vrooman drew roadmaps and made introductions to bona fide "folk artists." It wasn't long, however, before Dow took over his own itinerary and began to expand the definition of "folk art" and "in the landscape." Crisscrossing the state, armed with his young bride and this photo student or that—all happy to sign on as assistants—Dow would pull into any and every town. The cafe or bar would be his first stop. Out would come a binder of pictures. "Anyone around here make something interesting?" Ever polite, looking not unlike the working man sitting on the bar stool next to him, Jim Dow got people remembering. "There is this old guy. . . ." and Dow would be off.

Again, the weather dictated the making. Most farmers and ranchers in places like North Dakota are skilled mechanics, gifted welders, brilliant make-doers. Their lives split into two seasons: farming and fixing. Their shops are their winter places of business—and their refuge. Christmas rolls around, and hidden under the tree among the warm socks and sweatshirts and books is a coveted tool, for, as soon as fall work is finished, the season of "winter repairs" begins.

Repair work gets tedious, so one welds together a dog cart, fabricates a mechanical toy, carves a wooden rocking horse. Maybe a planter for beside the house or a whimsical mail box. Soon, unplanned and unpremeditated, a sculpture emerges, then a yard full of objects that no local would think to call art, then a museum of one's own to contain it all. And the neighbors come by for a look, and the winter passes, and it's time to begin spring work. The shop reverts to its original place for repairing machinery. And lurking in the borders of every Jim Dow photograph is the human impulse to mark one's passing through ordinary days, to let the imagination wander, to allow some pleasure to creep into one's work, to wonder.

Dominating Dow's peopleless photographs are the people. North Dakota, a vast grassland mostly devoid of trees—excepting for a few trillion planted by white settlers—was always home to migrating peoples. Early farmers, the Mandan, Arikara, and Hidatsa settled along the Missouri River. The nomadic people, the Dakota and the Lakota, moved with the seasons from summer camps to winter grounds and back. Centuries later, white settlers came across the Canadian border from Scotland and Ireland, overland from the East, having arrived earlier from Norway and Sweden, from England. The Armenians and Syrians turned up, also from the East. Jews came south from Winnipeg. Chinese passed through on railroad crews, and a few stayed on to open restaurants. By and large, the English and the Jews retreated to more settled places. Life was hard. At the end of the nineteenth century, Iceland spewed out twenty-five percent of its population, some 10,000 to 15,000 immigrants, all starving. They stayed, bridging the territory between southern Manitoba and northeastern North Dakota, intent upon creating a New Iceland. Today, it remains the largest Icelandic

settlement outside of the home country. Germans from Russia formed self-contained communities in what would become south-central North Dakota. Scholars continue to seek them out, intent upon studying German as it was spoken all those years ago.

In the United States, the settling of the Dakota Territory occurred in the aftermath of the Industrial Revolution. The years between 1877 and 1913 saw populations explode, railroads snake their way across the continent, and factories, which primarily produced textiles before the Civil War, soon rolled out every kind of product. In 1889, midst all this change, North Dakota became a state with few traditional craft traditions. Why weave when yard goods could be bought in town for pennies? Why spend days and nights in the ceramic shed when kitchenware could be traded for a dozen eggs? But some skills couldn't be bought. Just as the Germans immigrants made their grave markers (pages 172-75), Norwegian woodworkers spent long winter months inside their churches carving traditional altars (page 168). Amateur architects imagined small buildings, the likes of which they had never seen. These wonders became magnets for early morning coffee or Saturday nights out. Surely the Kite Cafe in Michigan (page 132), the Starlite Garden in Fingel (page 134), or the Big Fish Supper Club in Bena, Minnesota (page 135), assisted in the transformation of lonely and demanding lives into knitted communities essential for survival.

And these people painted. How they painted! Signs, of course, were necessary, so signs became the canvas of choice for many a skilled amateur. Once signs could be made commercially, the painters became designers and the signs remained local inventions. Even industrial products begged for embellishment (page 158).

Jim Dow, ever the sports fan and widely recognized for his panoramas of major league baseball stadiums and the 1984 Los Angeles Olympic sports palaces, returned to North Dakota in 2000. He had been commissioned to photograph Northern League baseball fields. Passing through Grand Forks, Dow called and invited me to join him at a local, semipro baseball game. And it began all over again. Somehow the money came together, modest amounts, of course. Accompanied by a new batch of assistants, who were also his students at the Boston Museum School and Tufts University, Dow resumed his pilgrimages. This time there were no restrictions: "Shoot whatever you please. Sure, cross the borders into Minnesota and South Dakota, for they also are 'our' people, their 'stuff' is our stuff."

By the end of 2005, Jim Dow had shot more than 300 photos. Except for Walter Piehl, the lone artist sleeping in his studio (page 78), a crowd at a baseball game (pages 150-51), and photographs of outstanding citizens lining the halls of the capitol (page 144), Dow's photographs are devoid of people. Instead, they inhabit the margins, felt but unseen. Only their makings and their markings upon the land remain visible. This body of photographs is a gift to the people of this small corner of the world—little known people whose lives are ruled by climate and distance and longing—from an artist who has come to cherish them.

MARKING THE LAND

VIEWS OF NORTH DAKOTA

The twenty-five-foot-high brick walls, originally built in 1910 to encircle the North Dakota State Penitentiary, were, by 1981, a sagging, crumbling relic of more than a half century of enclosure and isolation for as many as 530 men whose transgressions against society ranged from keeping marijuana in the pickup to first-degree murder. With the death sentence outlawed since 1915 and a traditionally cautious approach by parole boards statewide, most inmates had to deal with the prospect of long sentences without being able to catch more than a glimpse of the rolling hills and wheat fields that surround the aging facility located on the outskirts of Bismarck, the state capital.

Charles Olive was sent to prison for the murder of a sixteen-year-old boy, David Ruff, a crime that included kidnapping and sexual abuse. Sentenced to life imprisonment, the front gates clanged shut behind him as he shuffled, handcuffed, into the slammer on January 30, 1956, facing the near certainty that he would spend the rest of his days within those four immense walls. Trained as a sign painter, he asked the warden if he could decorate the margins of the enclosure that demarcated his existence with a series of murals depicting all those places and spaces denied to him by his transgressions. The paintings, often as large as ten feet by twenty-five feet, were completed within a few years and covered three of the four walls. After serving sixteen years, a combination of good behavior and a thaw in Pardon Board policy resulted in his sentence being commuted in 1972 to fifty years. He was paroled in 1975 and stayed in the Bismarck area until his death in 1992.

Beginning in 1982, the original quadrangle of brickwork was replaced by chain-link fencing and razor wire that permitted broad, albeit slightly obscured, vistas for those inside and rendered Olive's skillful panoramic replicas superfluous. Time and weather had degraded the quality of many of the murals, and there was no attempt to preserve them. Some of the bricks, however, were rescued from the rubble, cut up into small rectangles, and attached to blocks of wood by enterprising inmates, who crafted them into commemorative plaques with the recipient's name and date of the wall's demolition incised on the front. They were then given away as gifts or sold as souvenirs.

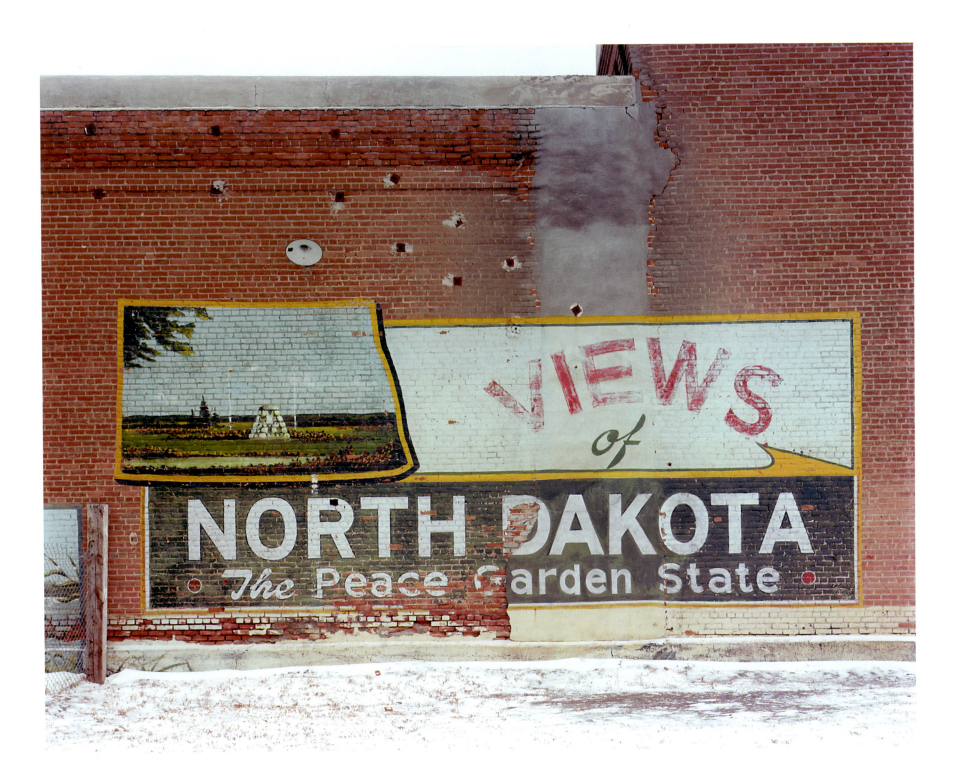

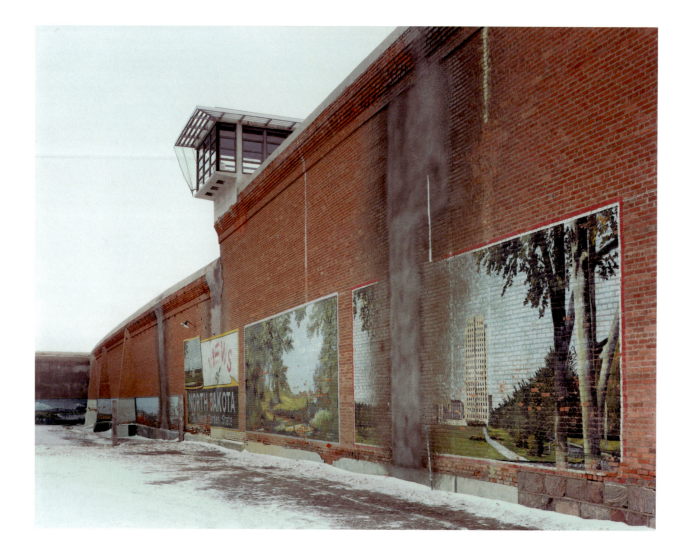

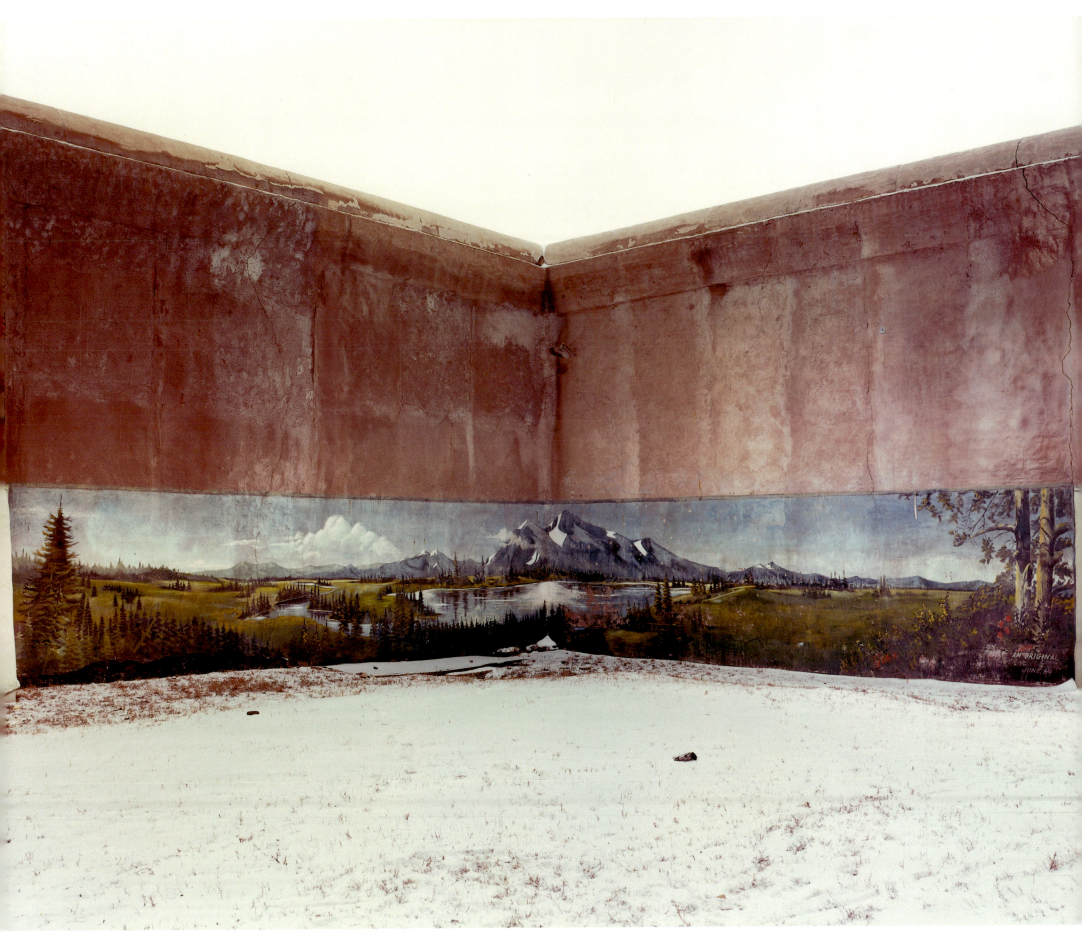

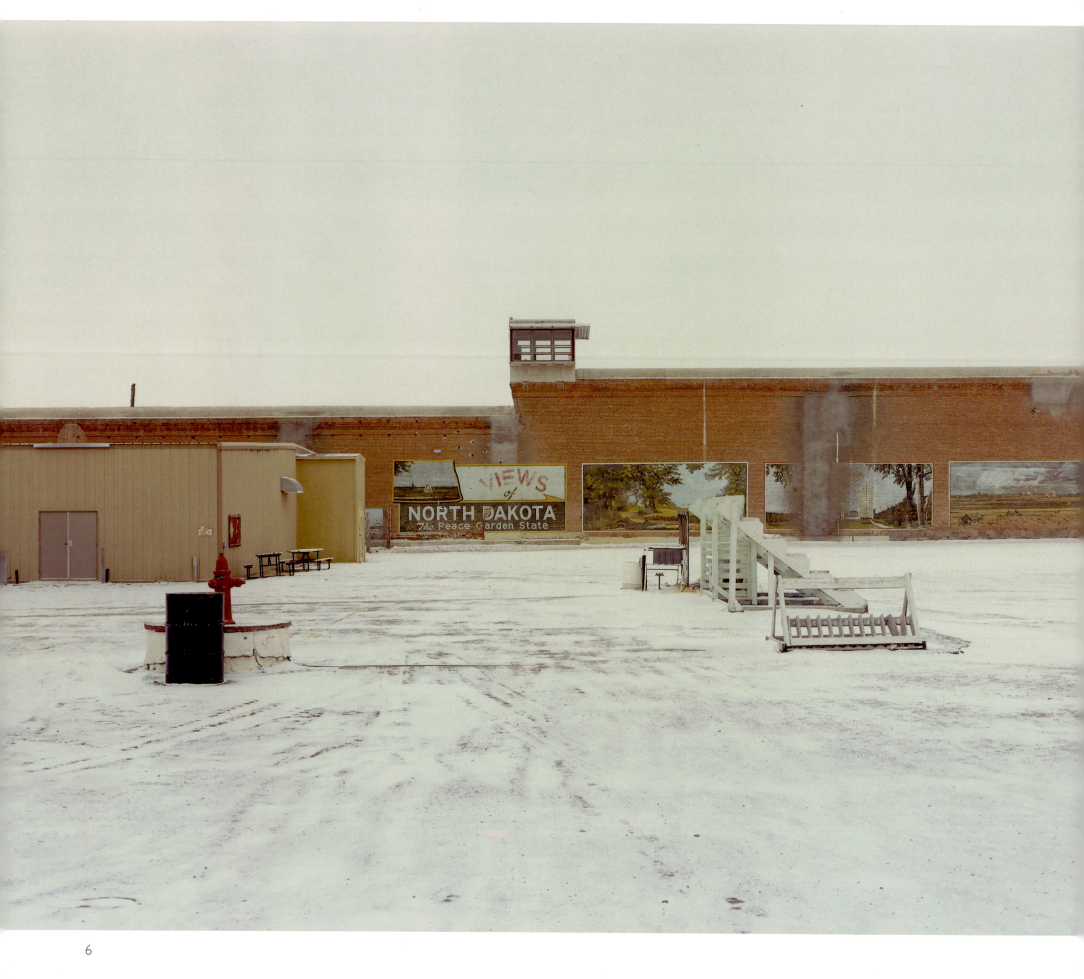

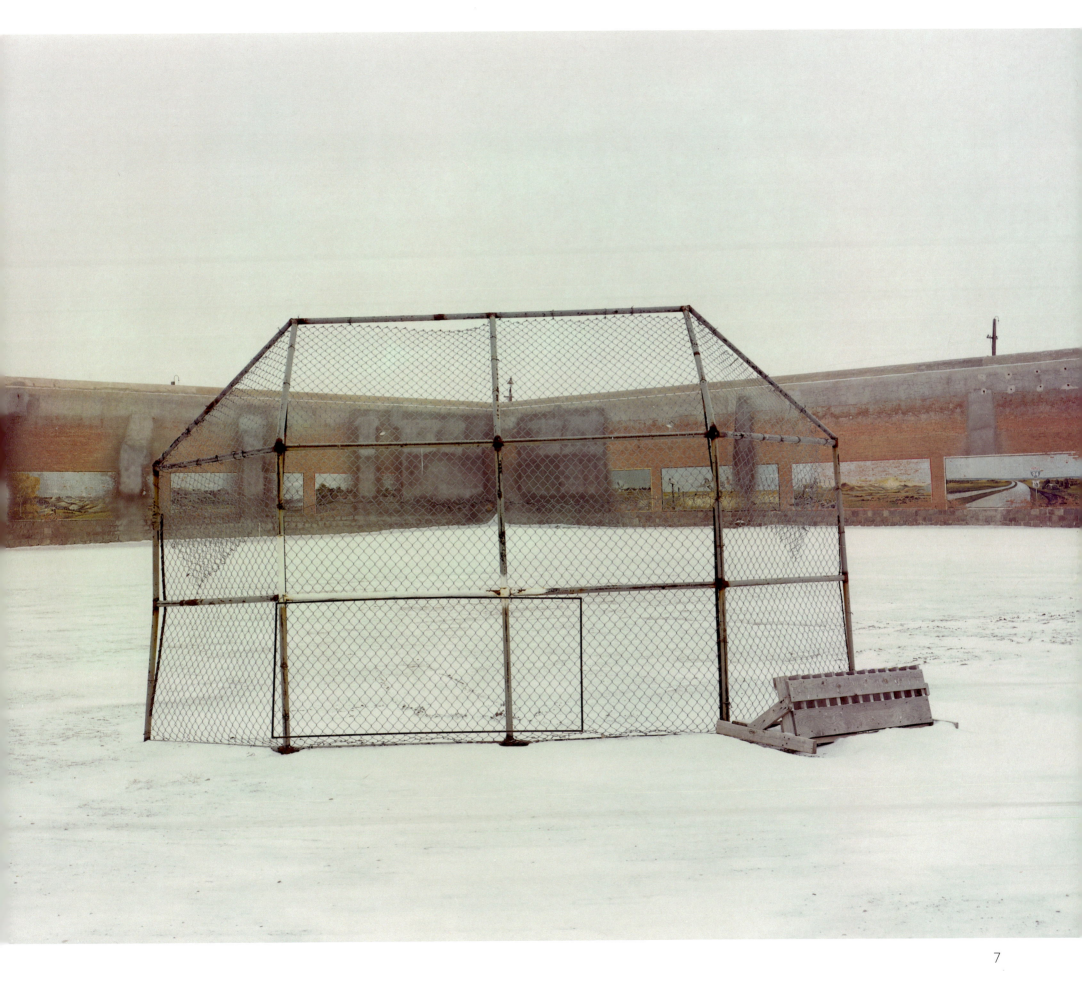

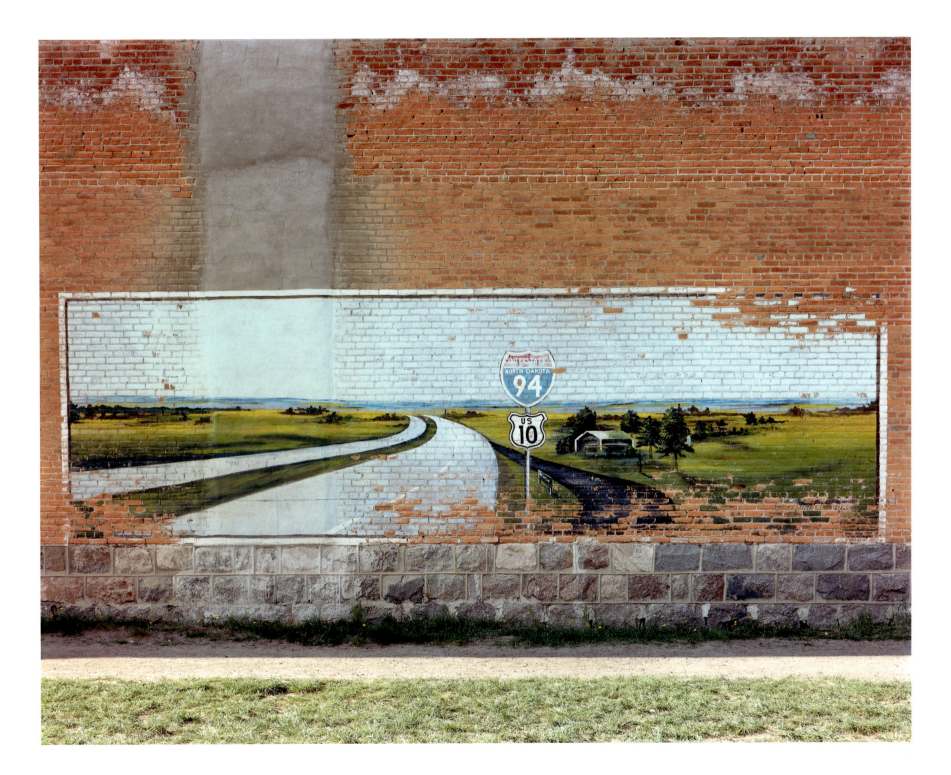

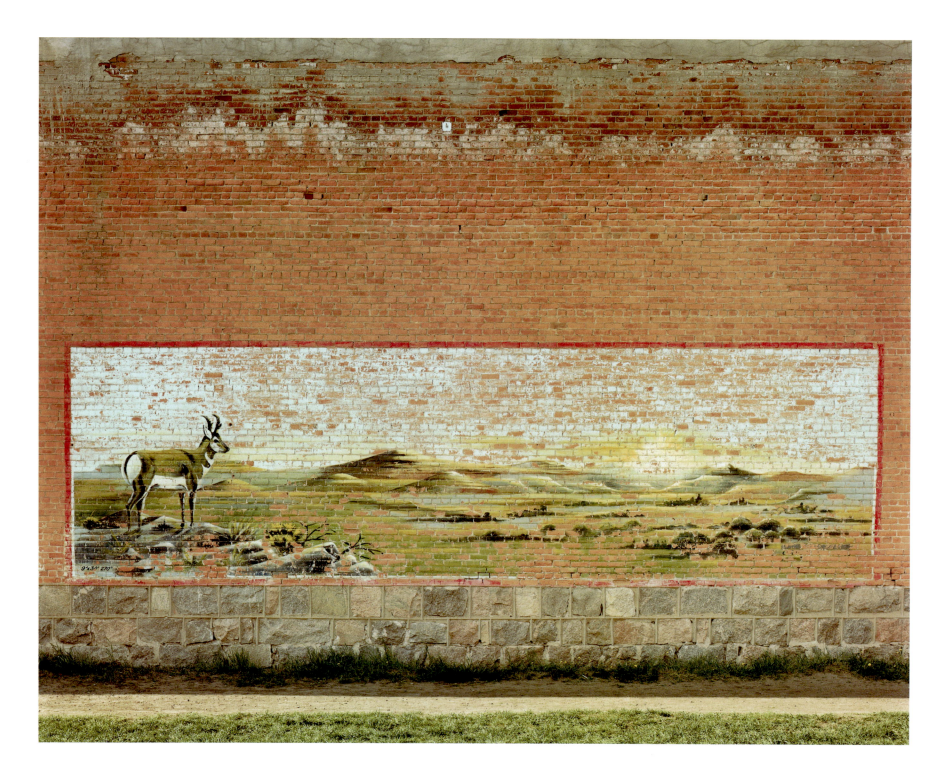

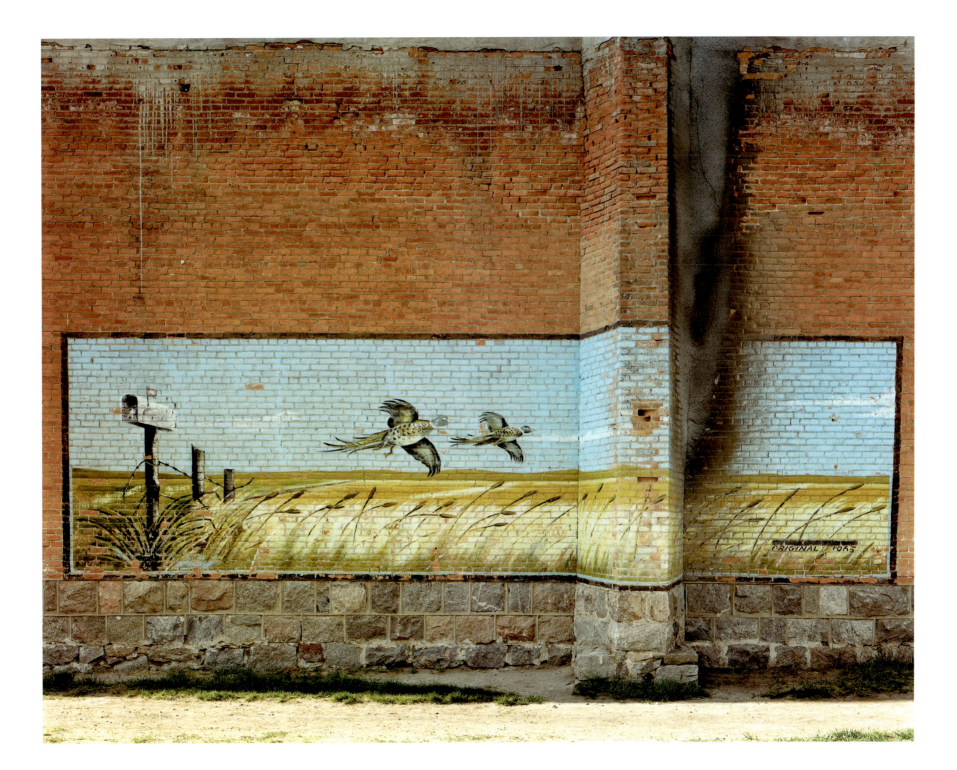

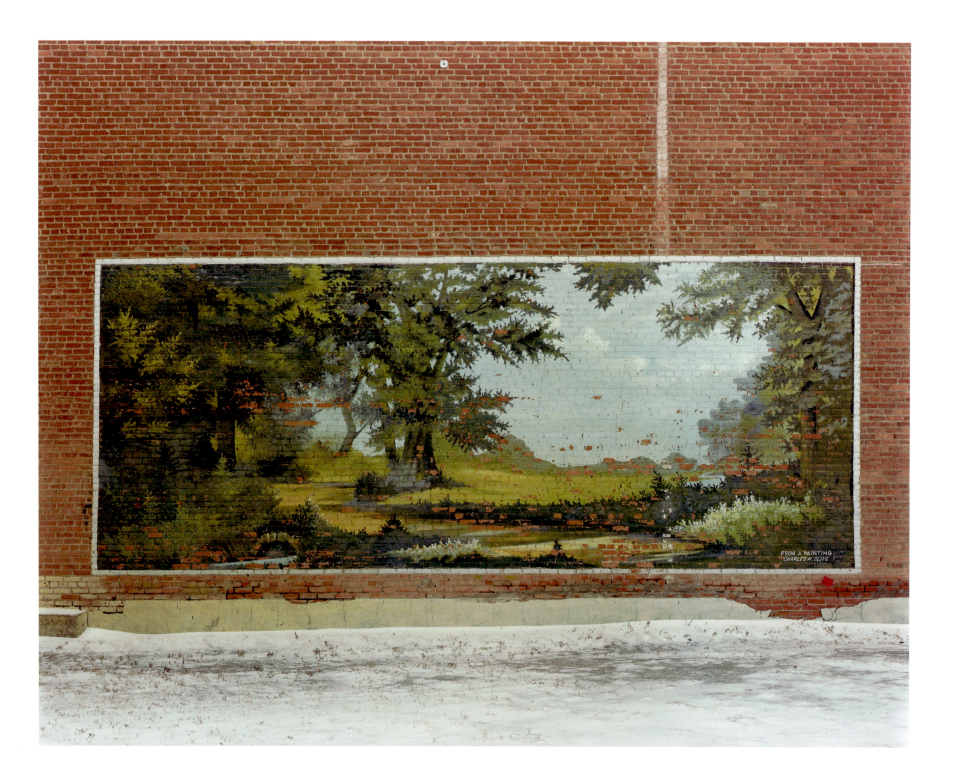

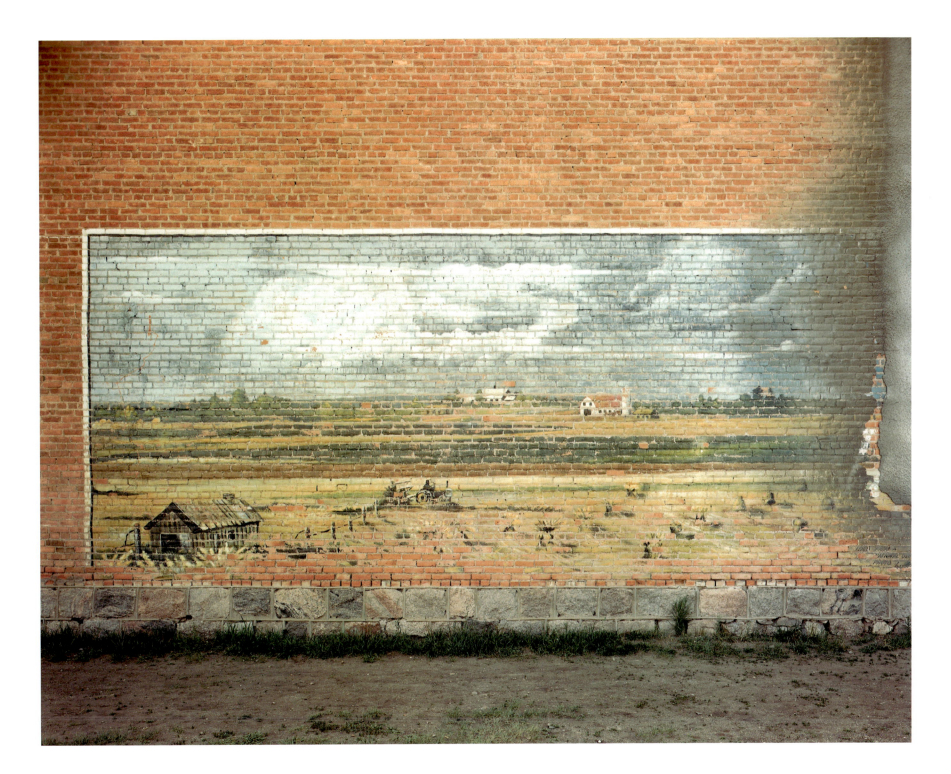

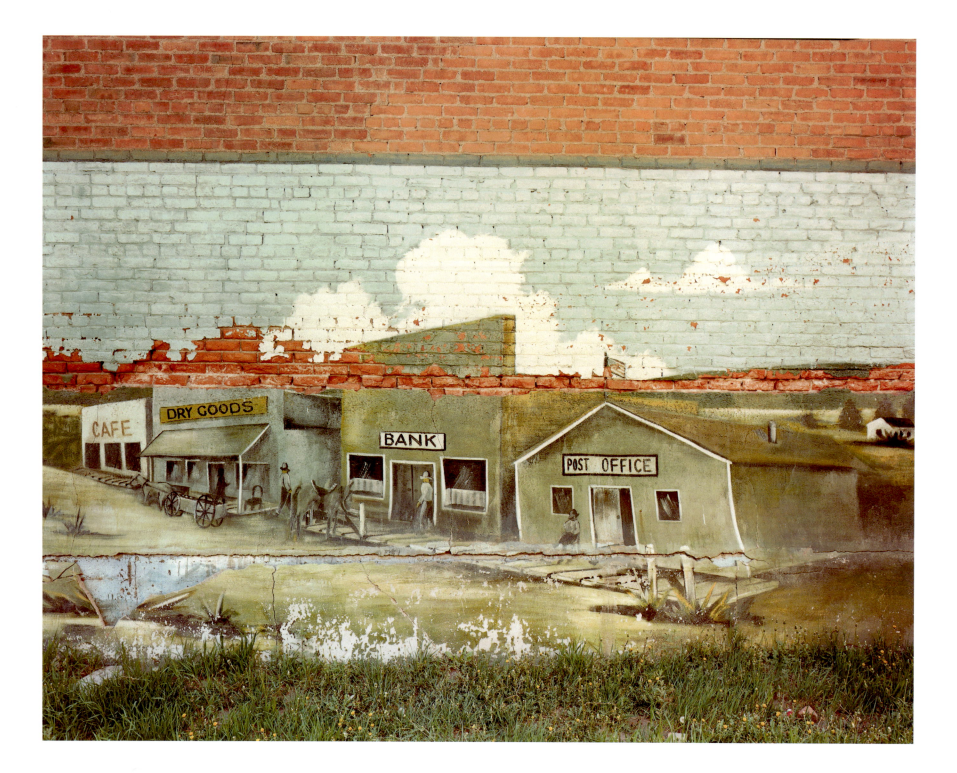

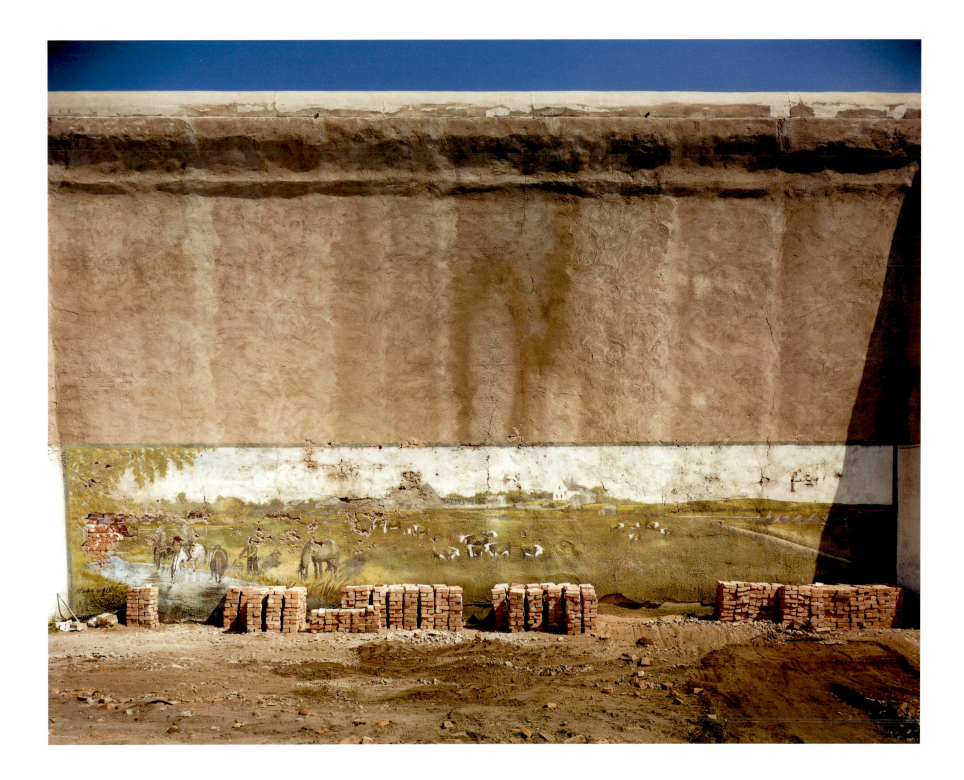

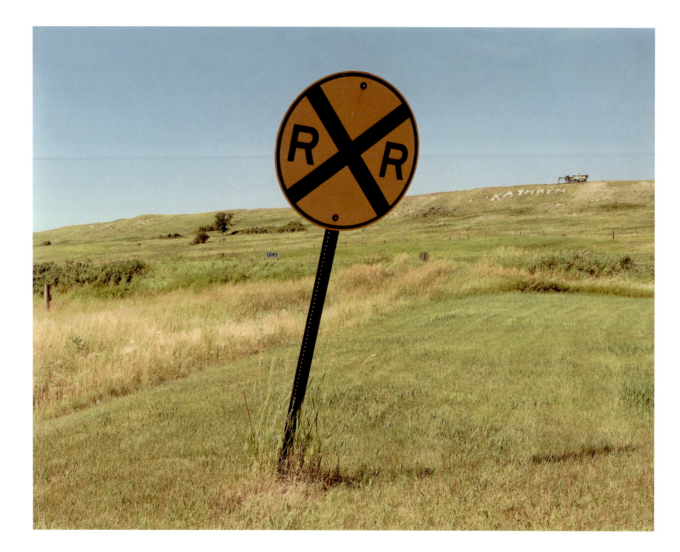

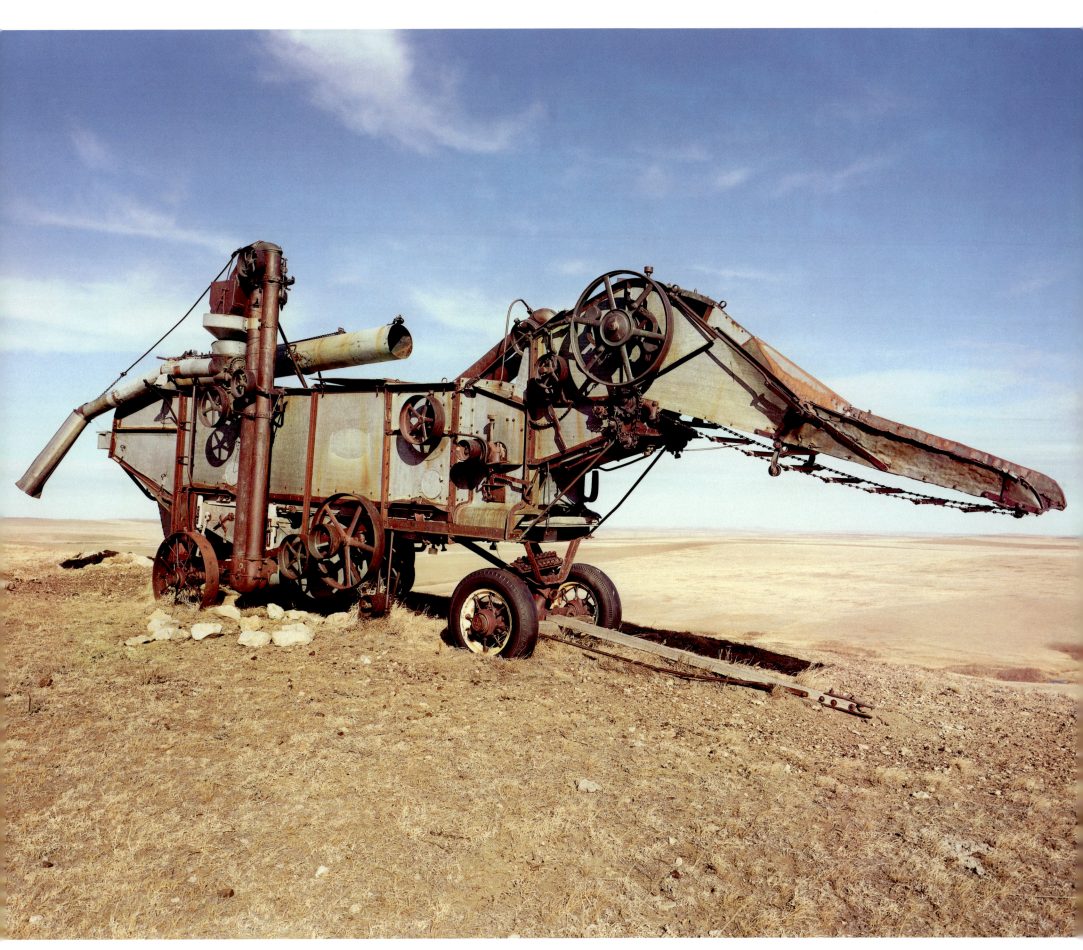

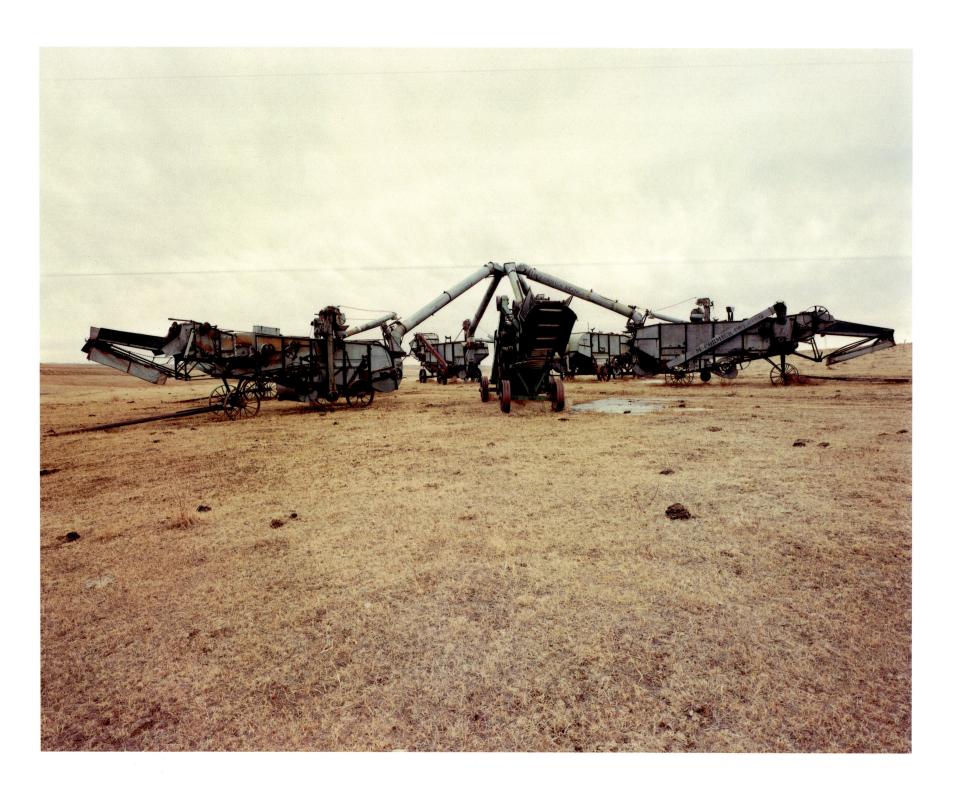

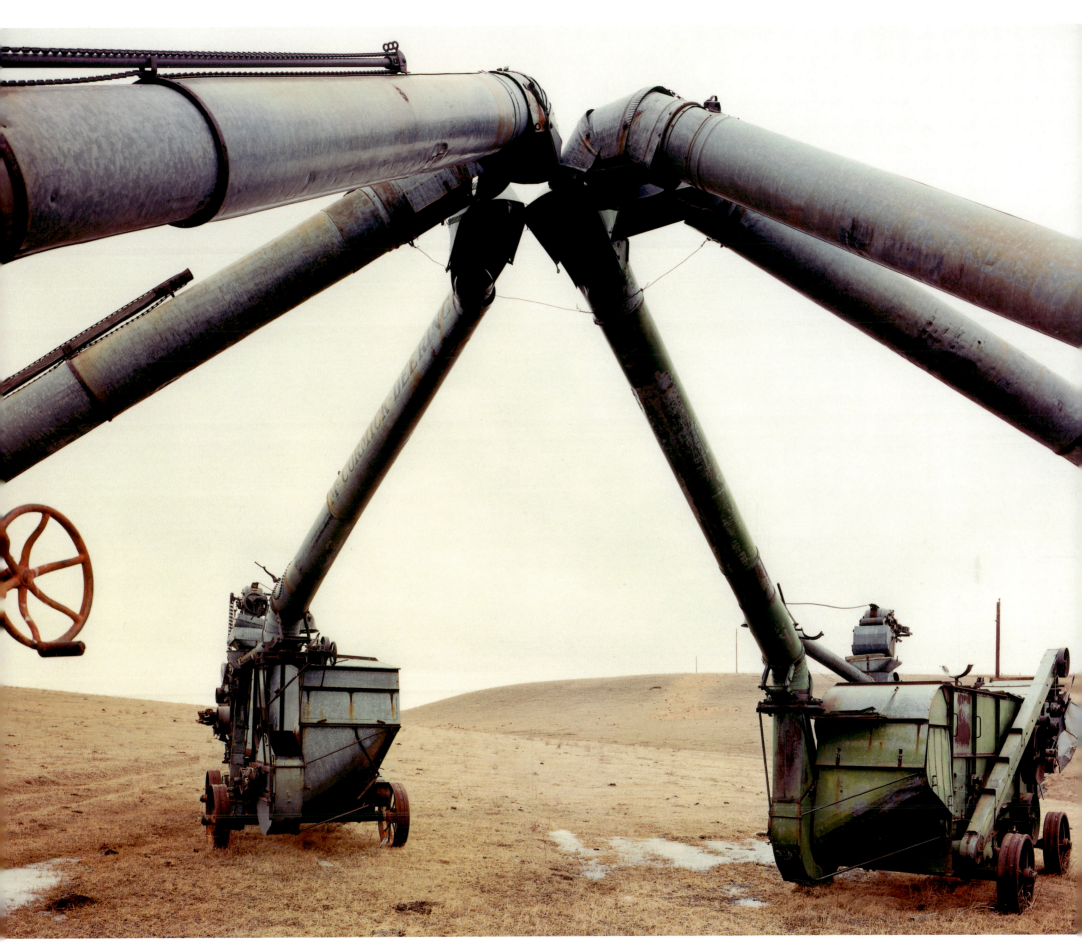

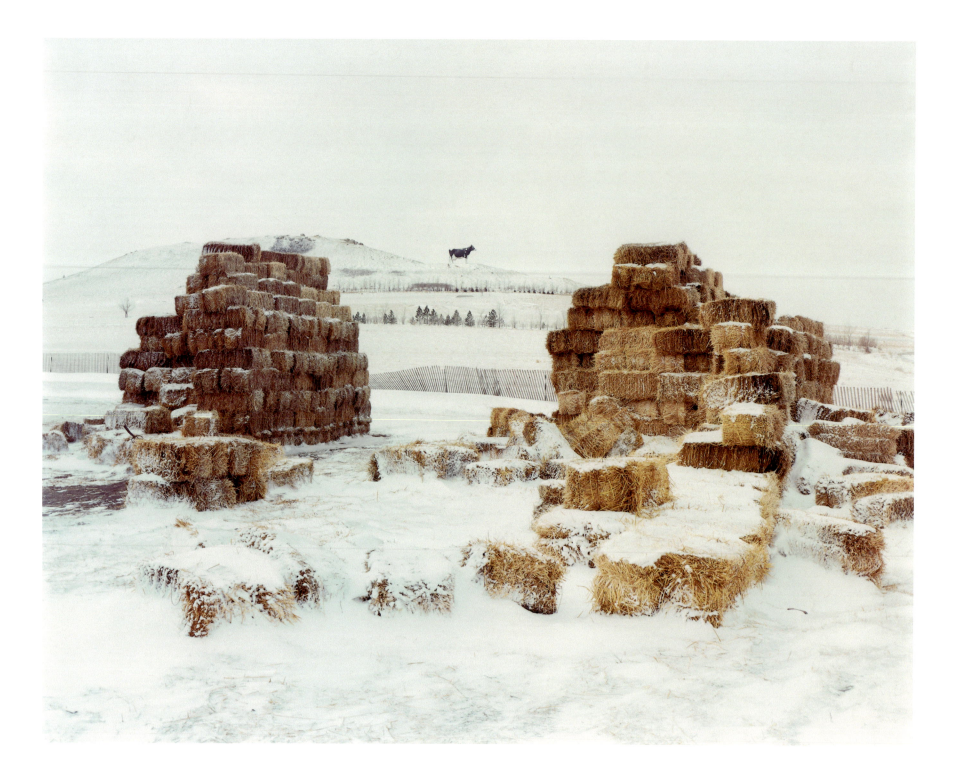

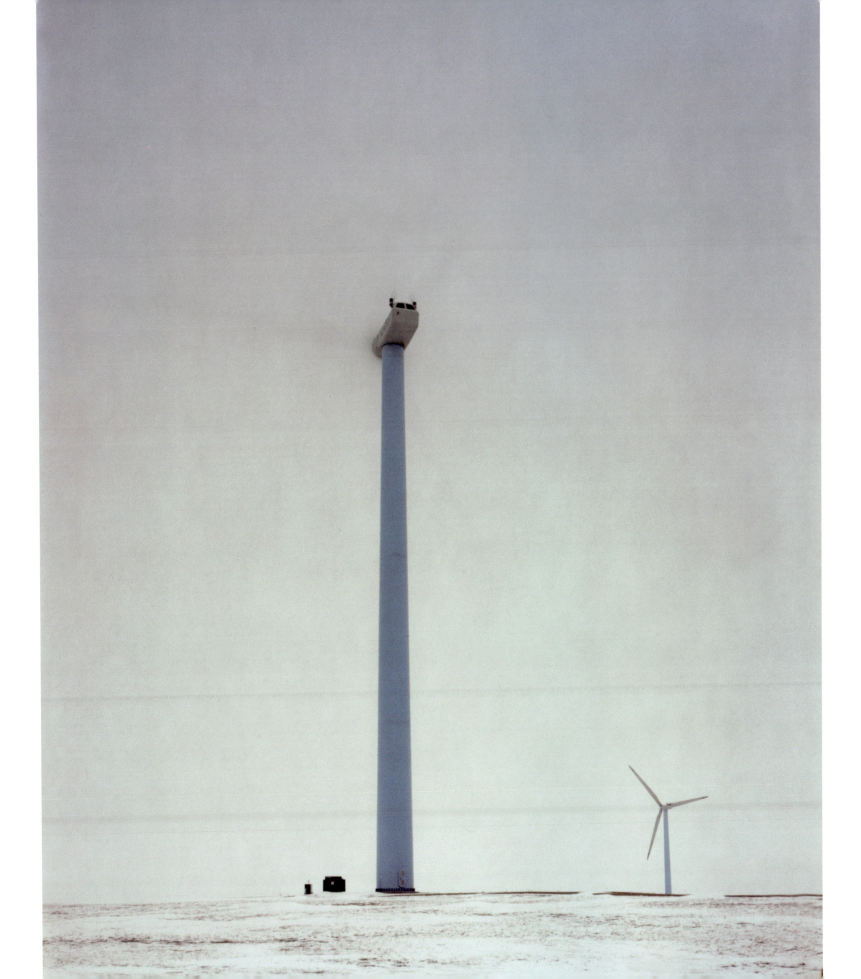

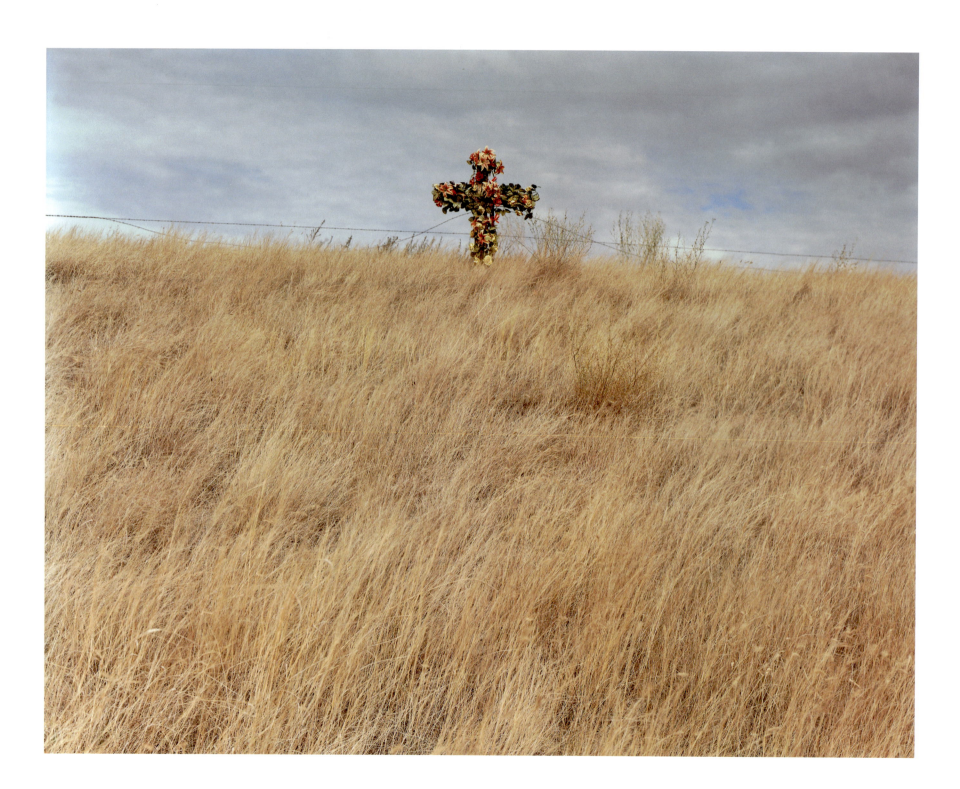

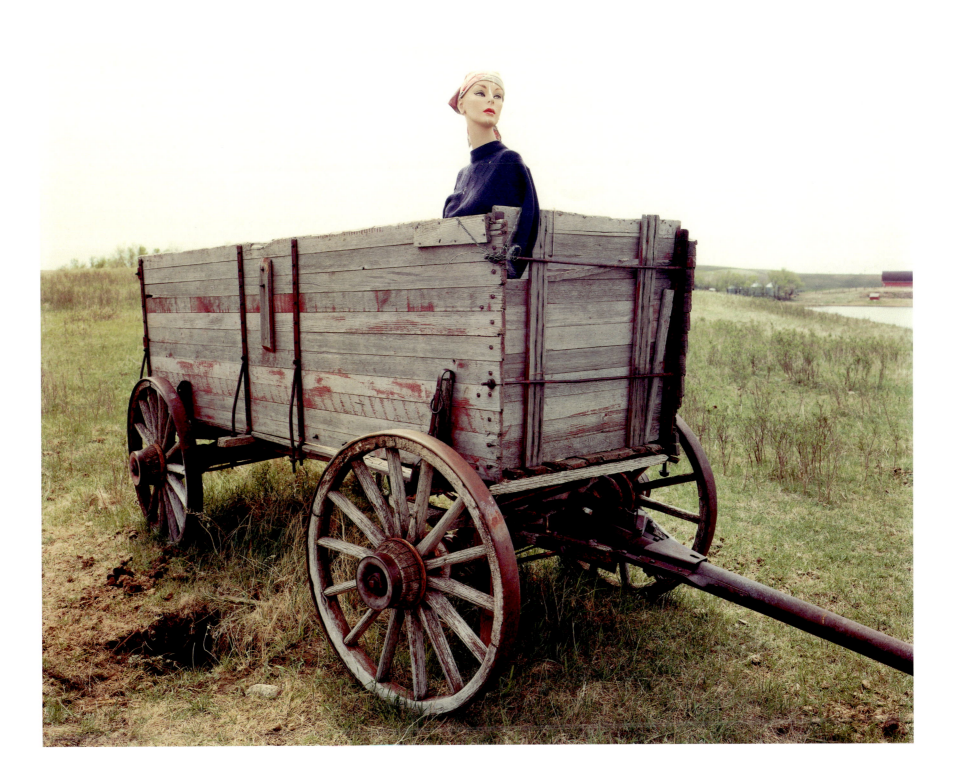

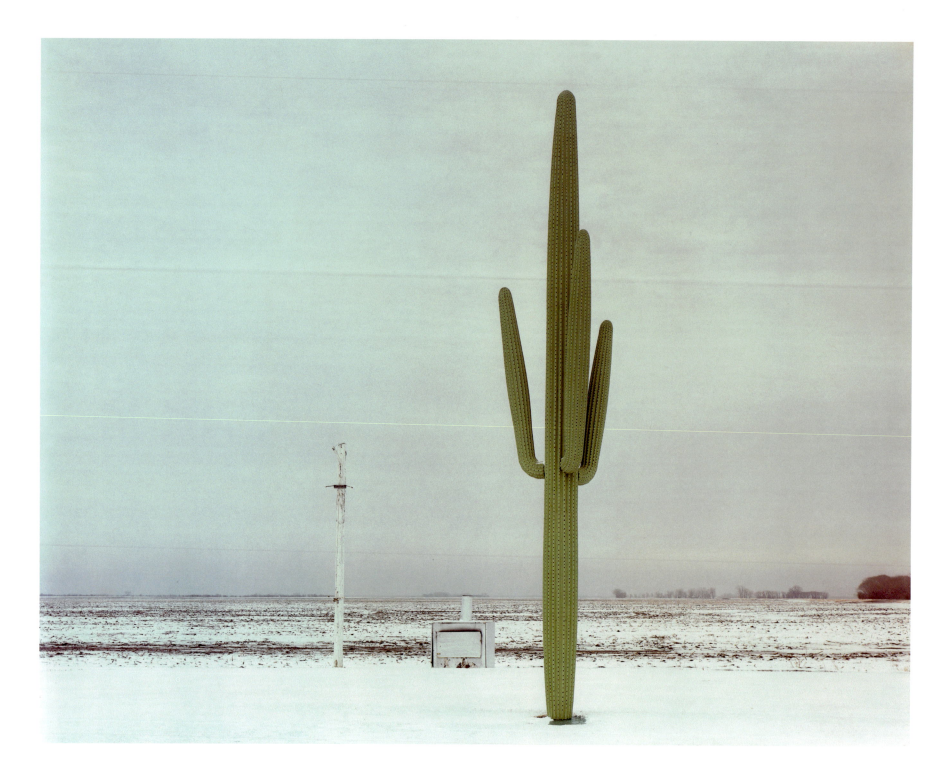

26

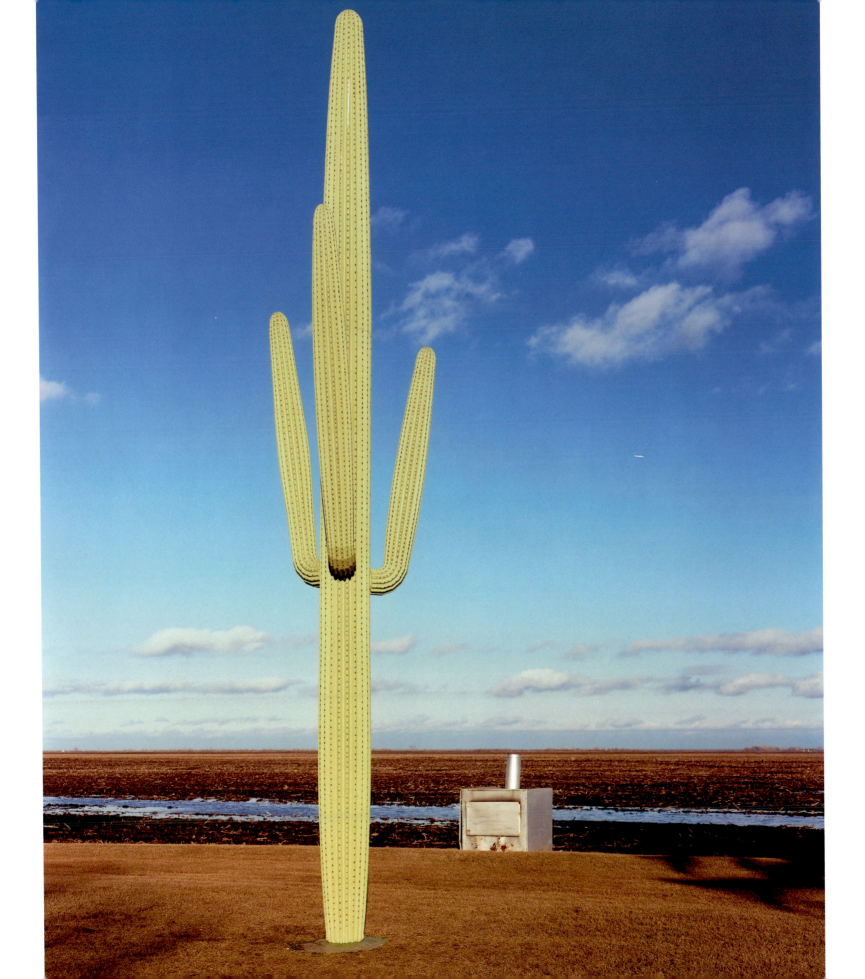

27

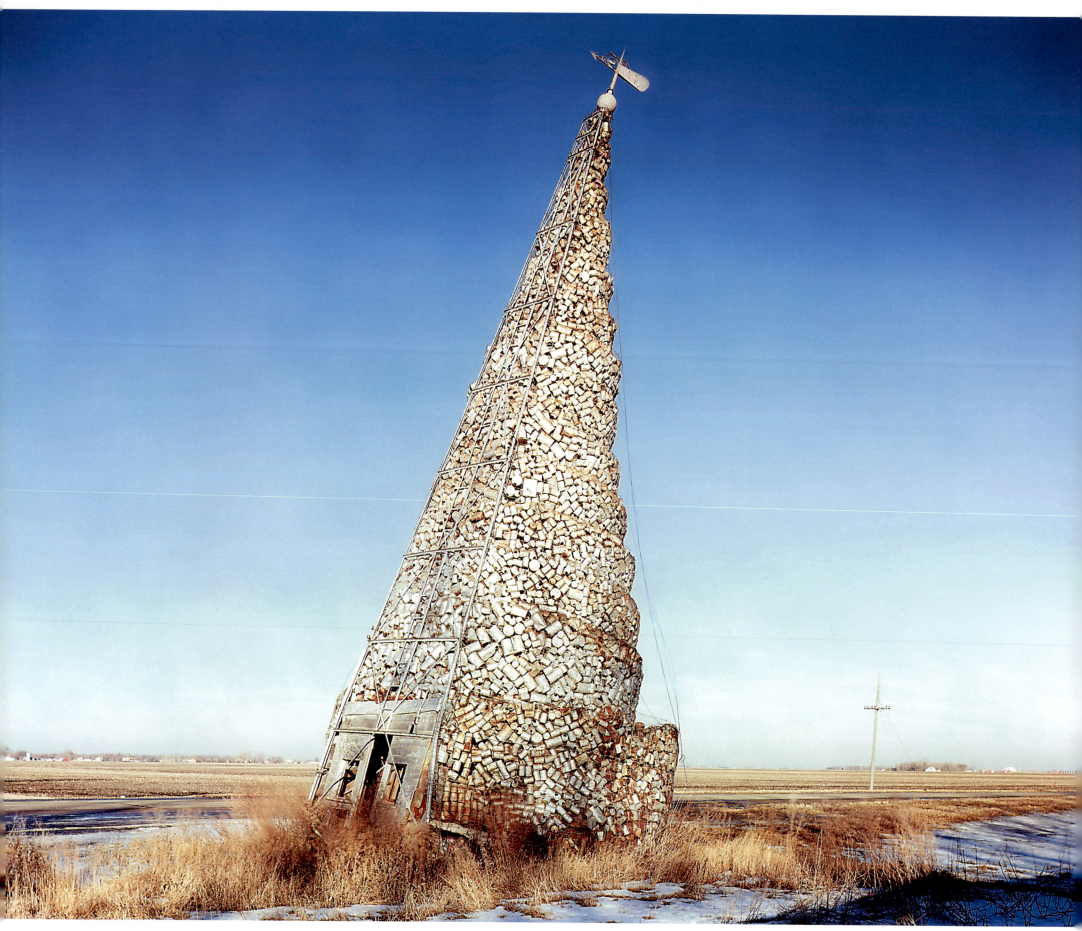

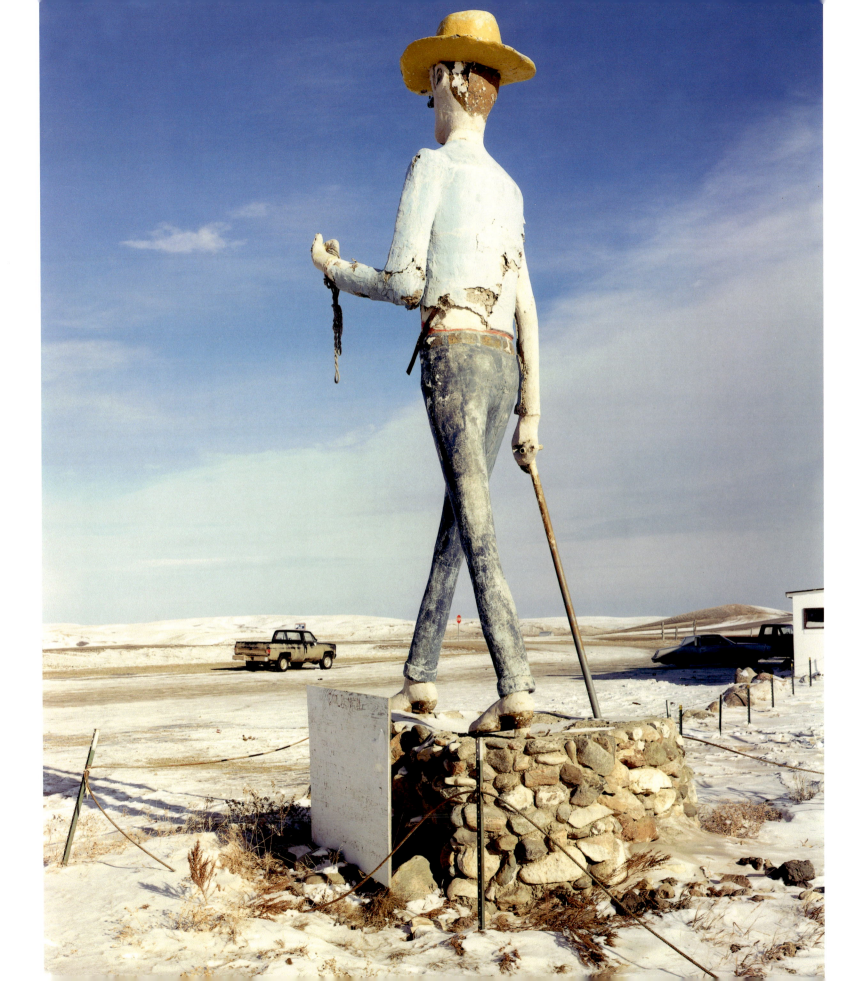

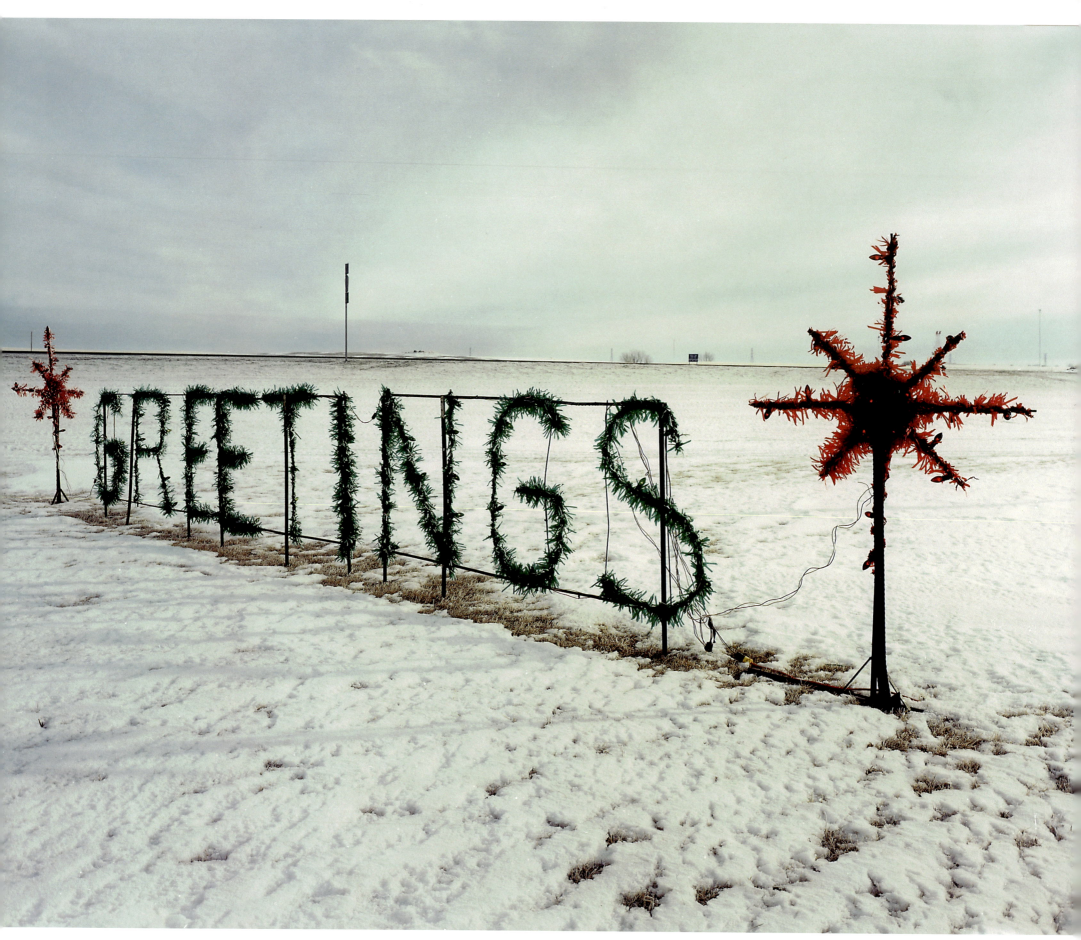

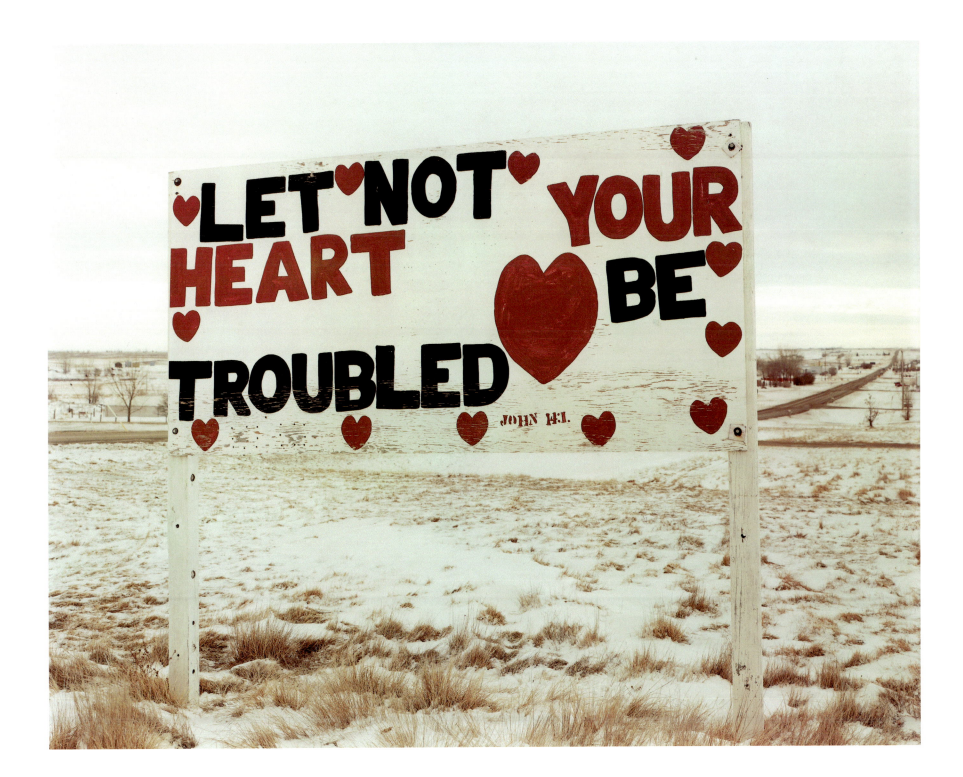

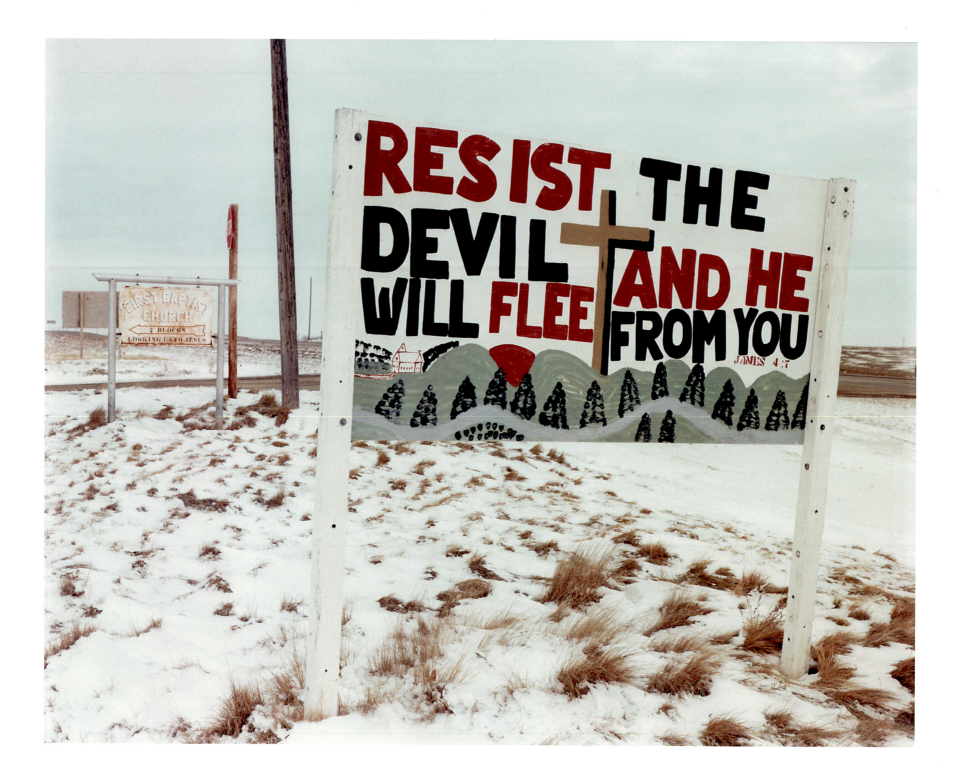

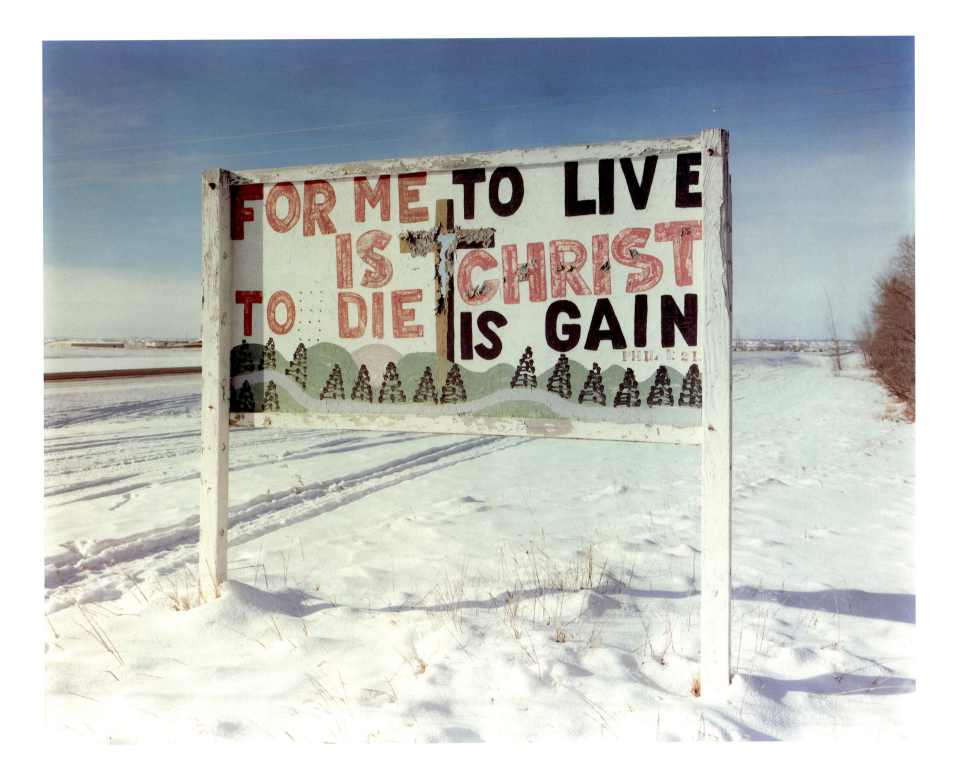

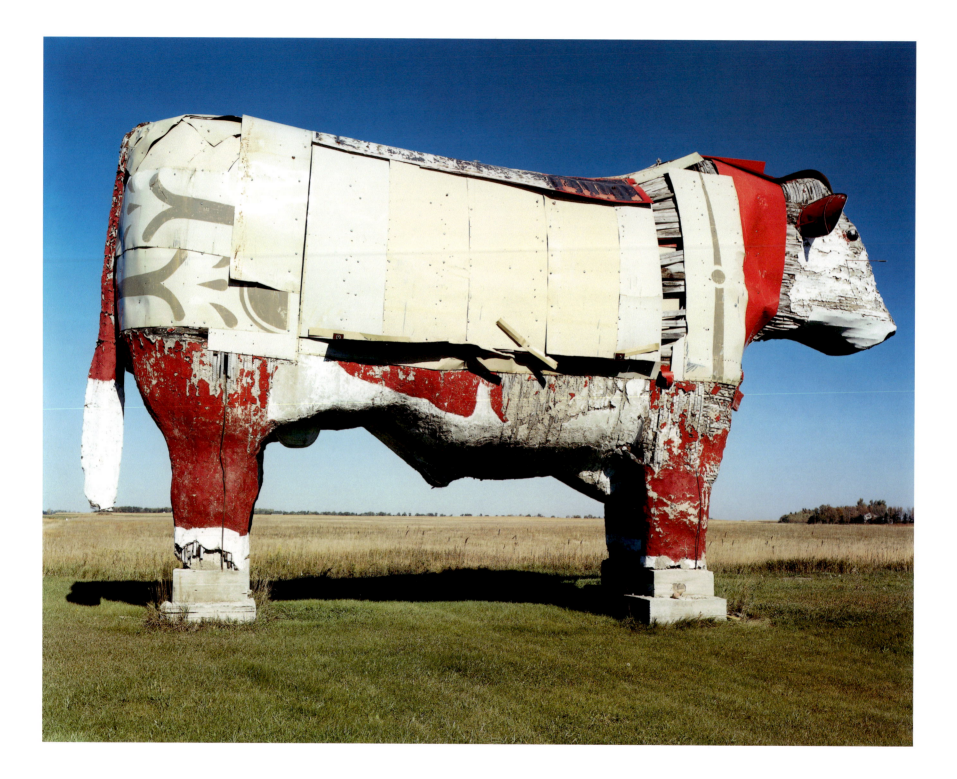

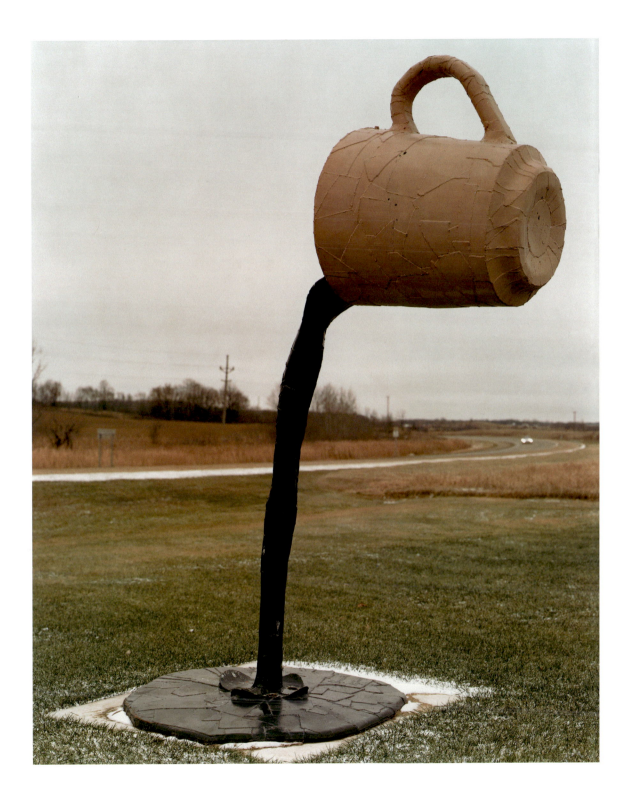

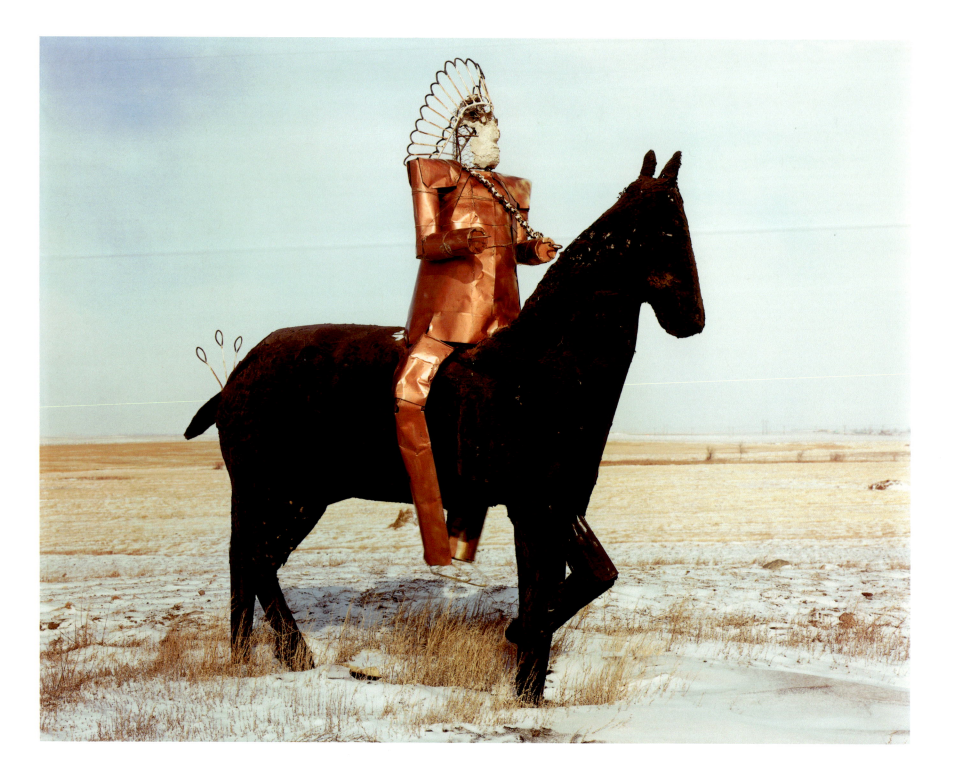

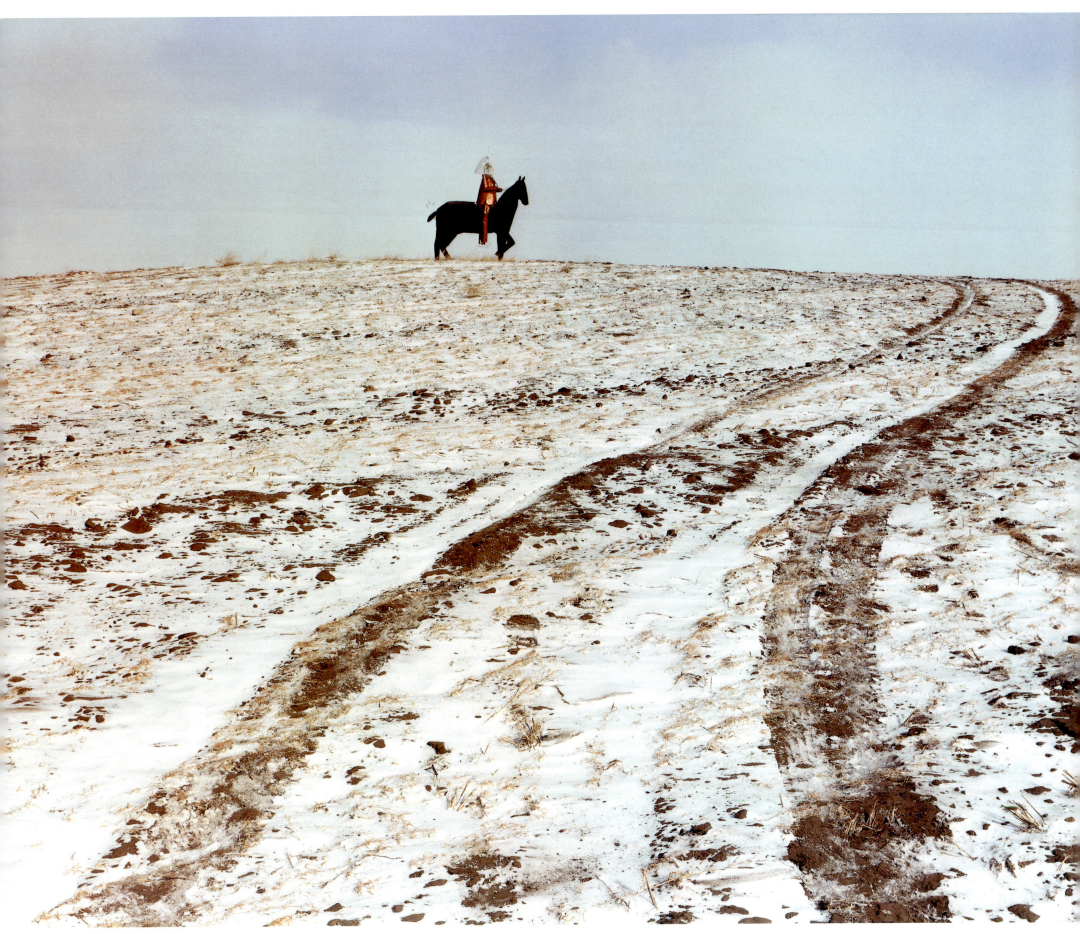

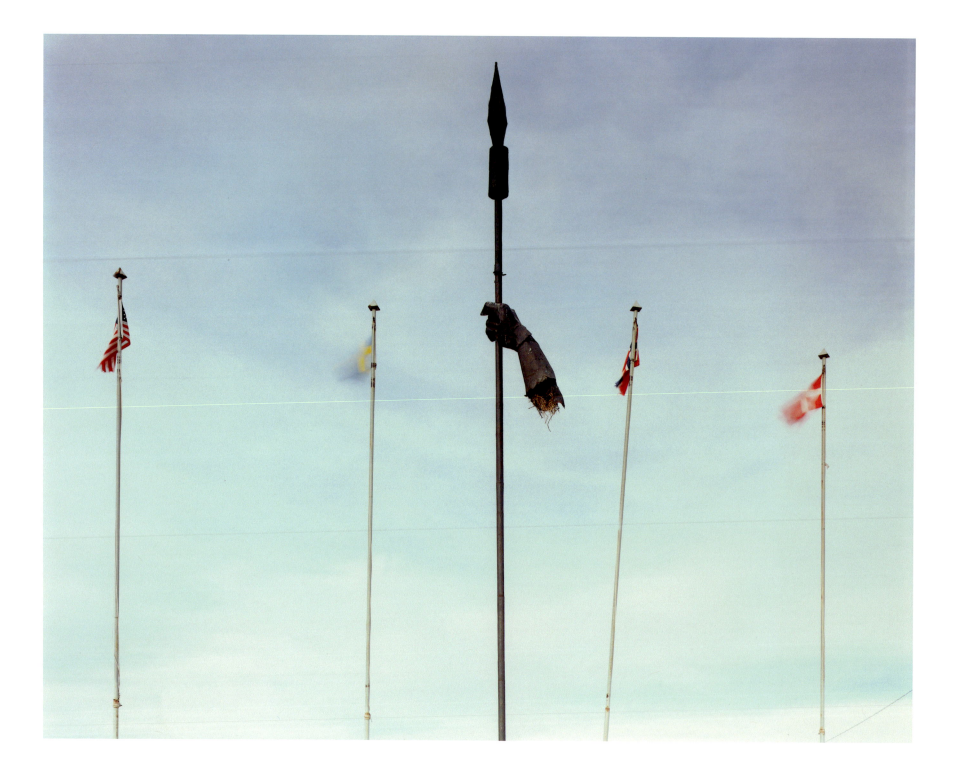

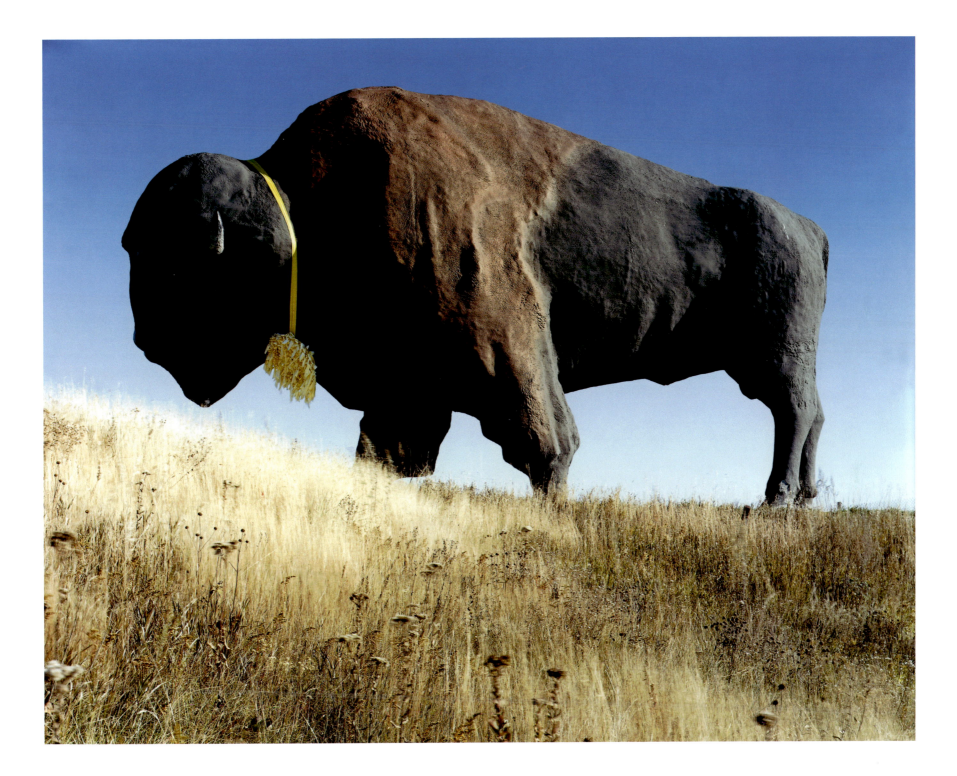

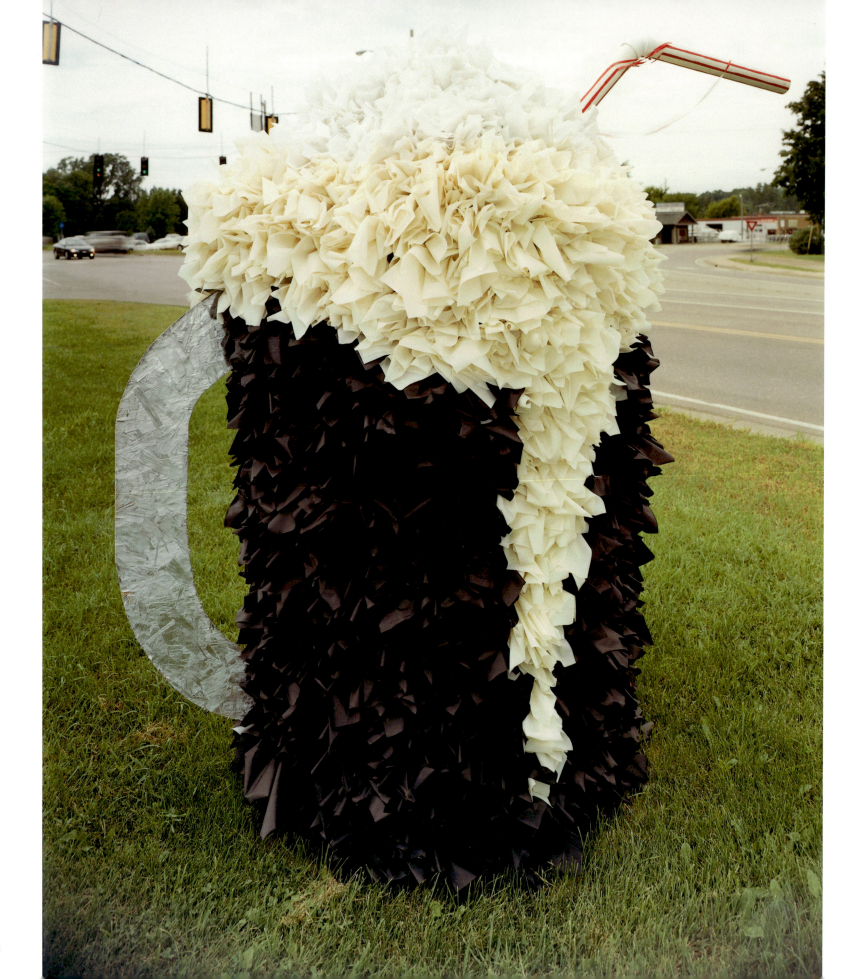

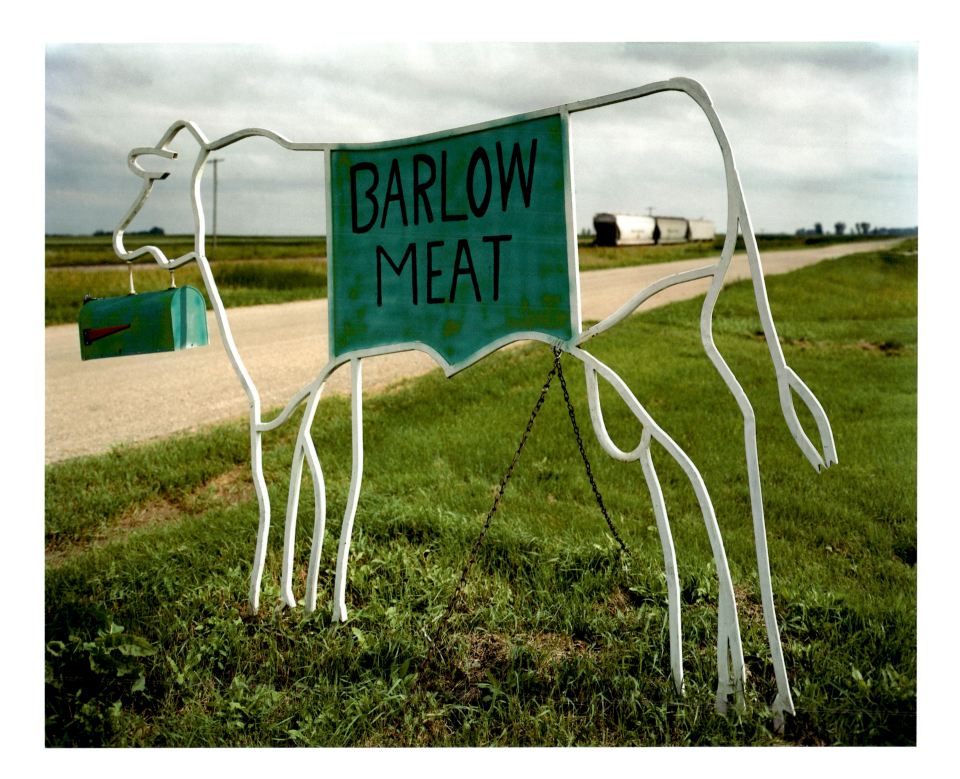

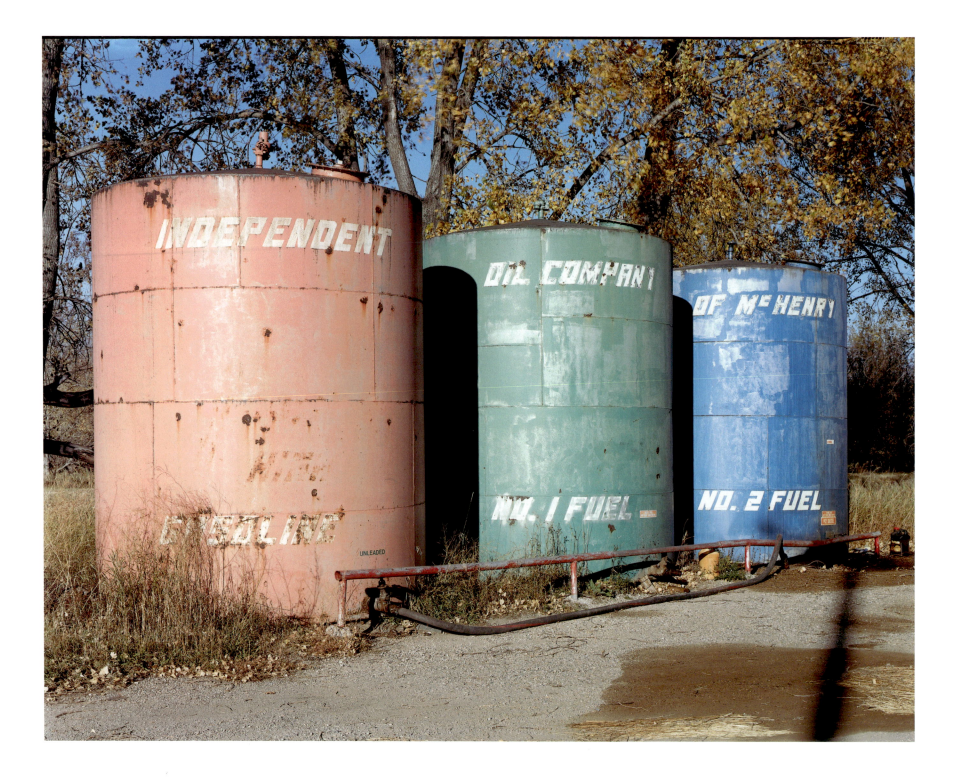

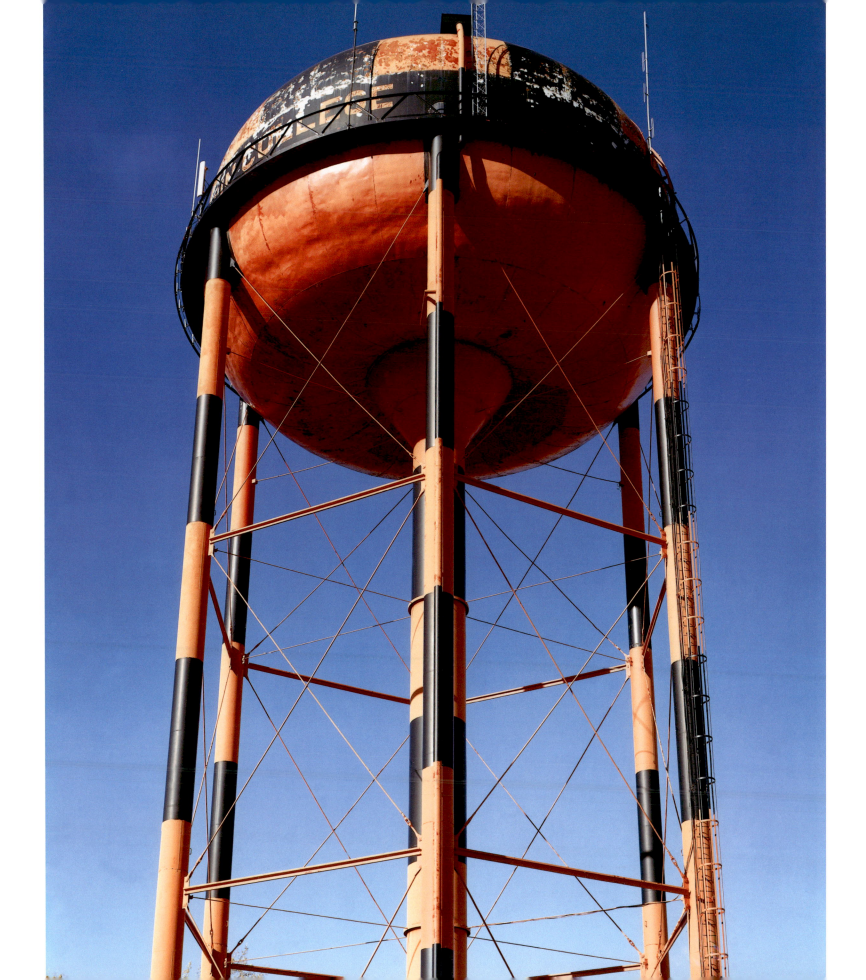

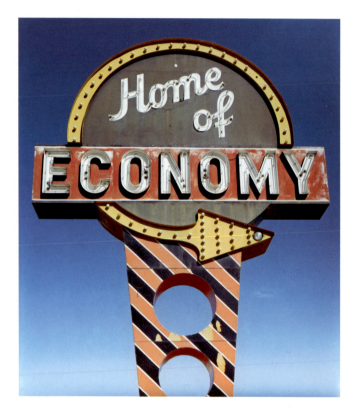

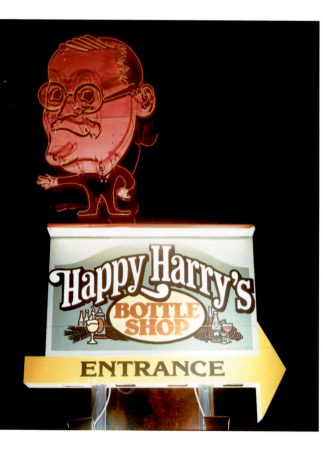

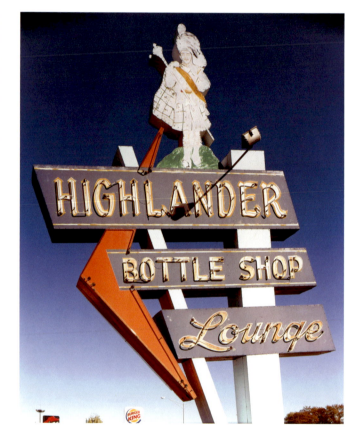

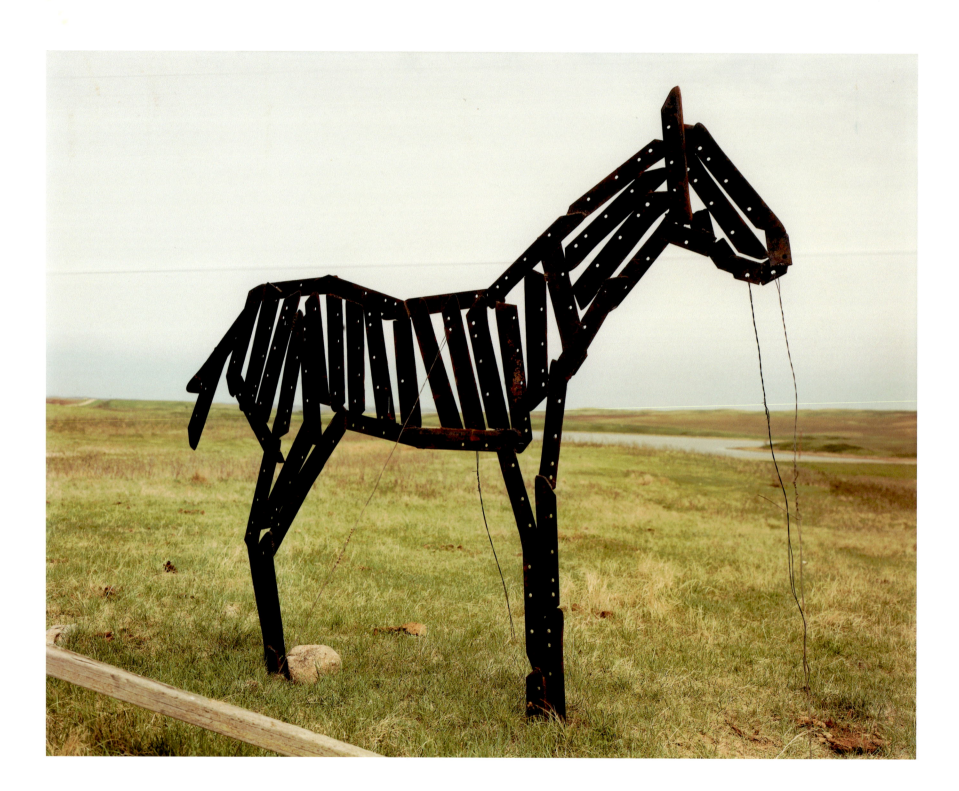

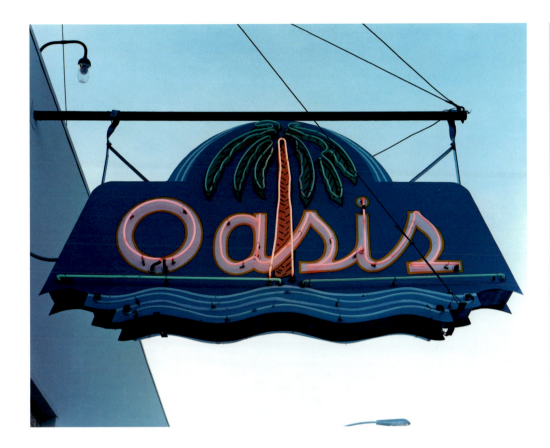

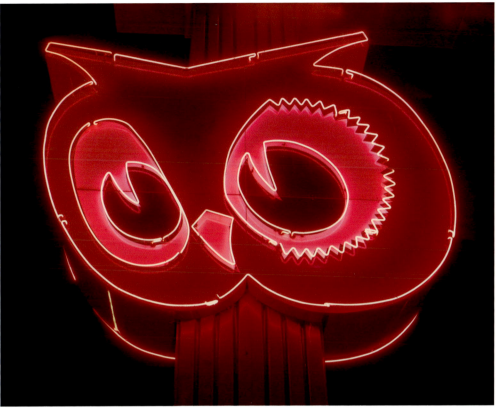

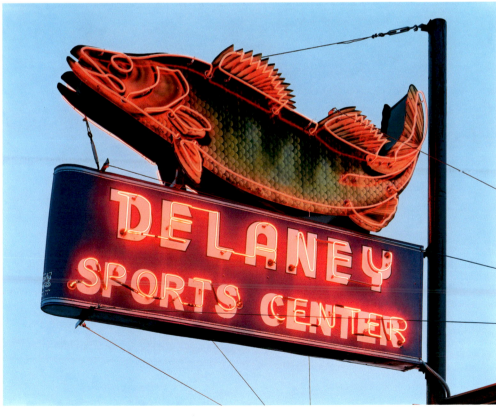

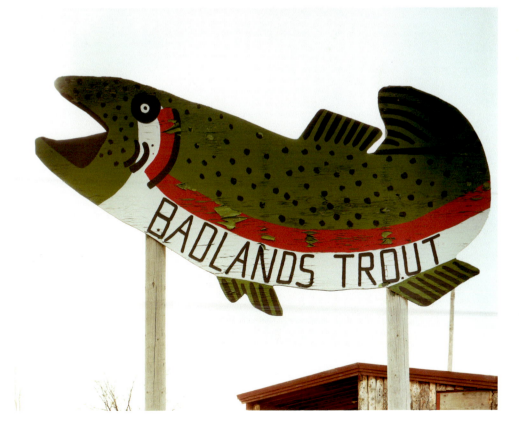

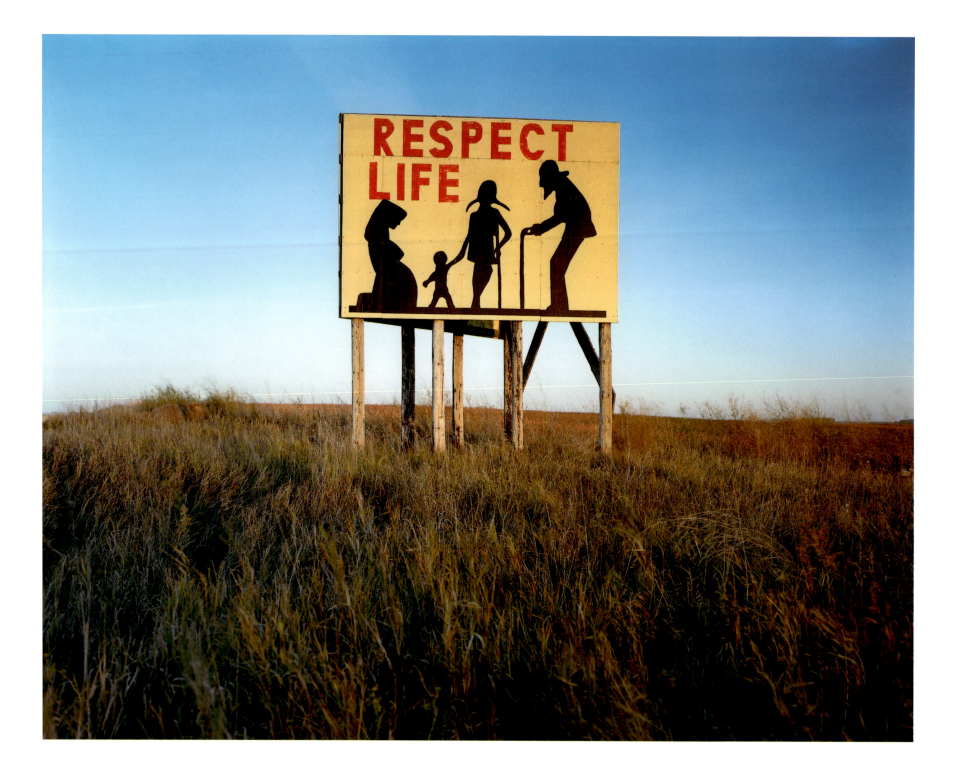

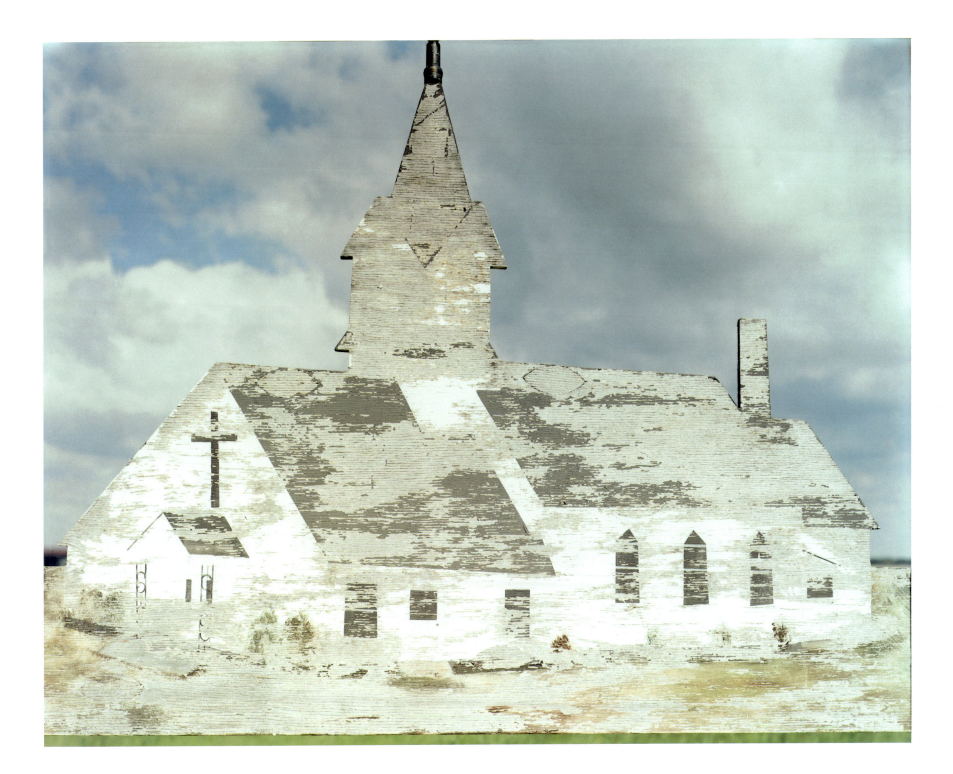

Artists and the Workplace

To a great degree, the North Dakota tradition of self-reliance has been forged in thousands of workshops situated in the corners of barns and basements, of garages and outbuildings. People of all ages spend hours and hours adjusting, building, calibrating, designing, engineering, and fiddling with every kind of device, machine, and material imaginable. While much of the resulting production is insistently practical, the idiosyncratic nature of each person's storage system for tools, parts, and bits, to say nothing of the infinite variations of apparatus installed for specific tasks, make each shop the particular province of its occupant and an artwork in its own right.

North Dakotans spend massive amounts of time driving trucks, tractors, and combines; sitting in duck blinds; checking oil rigs; racing snowmobiles; mending fences; playing golf; shoveling dirt, gravel, or snow; playing or watching hockey; walking their dogs. It is an outdoor kind of place, and the populace is, for the most part, made up of outdoor people; the immense scale and distinct seasons ensure that such is the case. Yet, the overwhelming distances and climactic intensity encourage these same folks to linger amidst the comforts and closeness of their kitchens, coffee shops, bars, lounges, clubs, workshops, and stores. Even the signs along the roads display this twin condition, compelling the traveler to keep on going, yet beckoning to come inside. In so many ways, this duality sums up everything about the state: grand yet intimate, timeless but completely temporal, harsh as howling midwinter winds yet gentle as an extra comforter over fresh, warm sheets.

With the growing season lasting only a fraction of the year, it would seem that there would be plenty of opportunity to tinker, but while there are more than 30,000 farms within its borders, more than half of North Dakotans live in town. In fact, more than fifty percent of the state's total population (almost 350,000) work in non-farm jobs, often as second, even third occupations, and there are many farmers who commute and commuters who farm. Thus, most residents are both inside and outside people, and they seem to put their mark on the locations that they frequent in ways that can be as blatant as the "World's Largest Holstein Cow" or as subtly inviting as the pattern of the place settings at a favorite coffee shop.

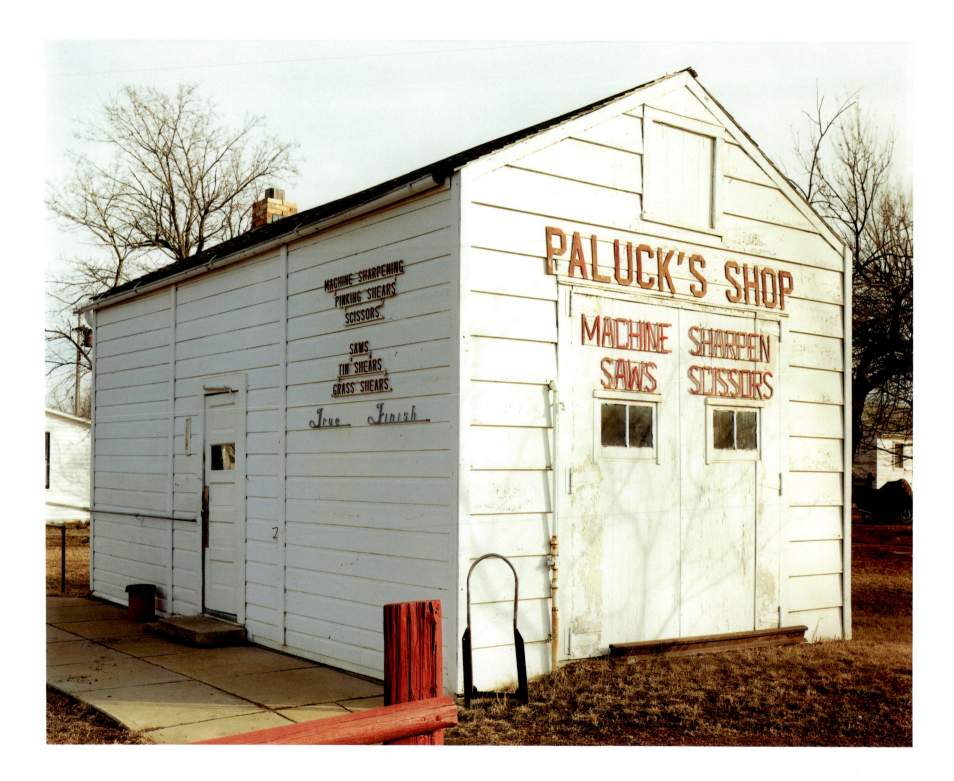

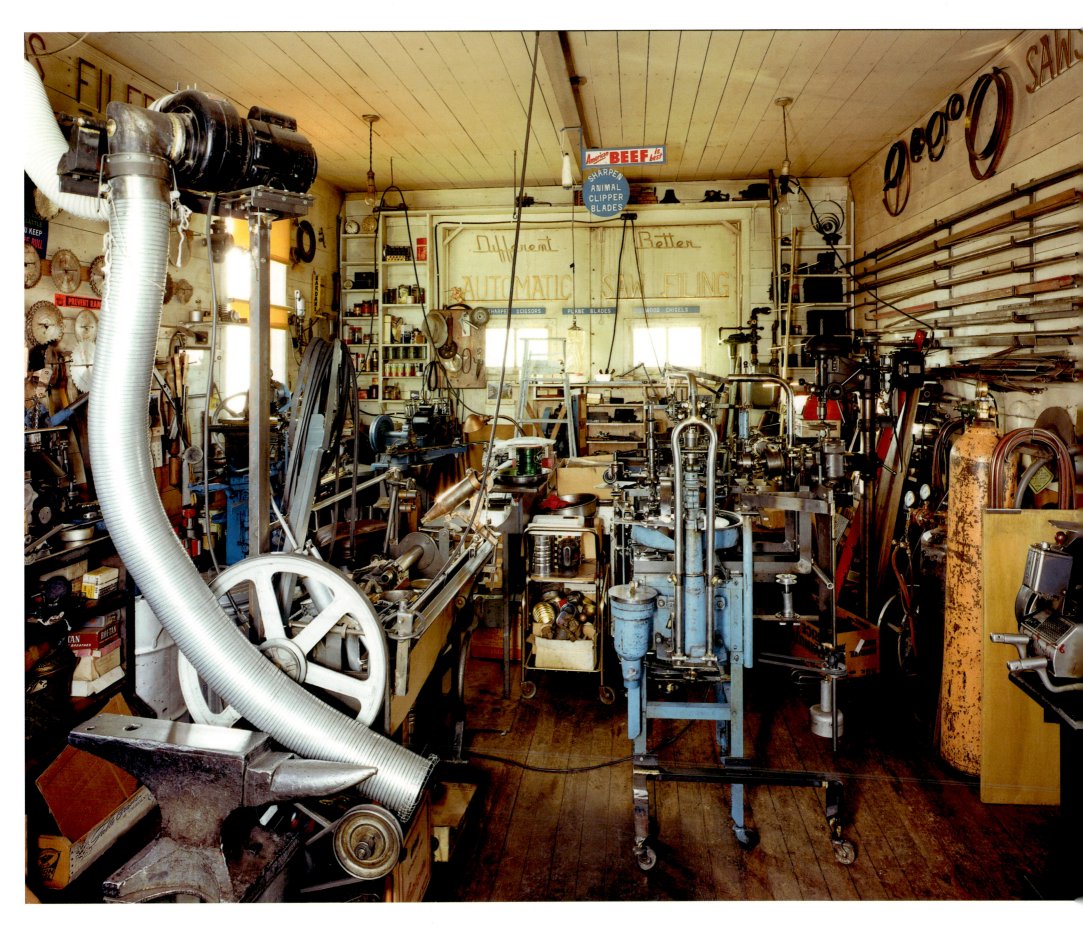

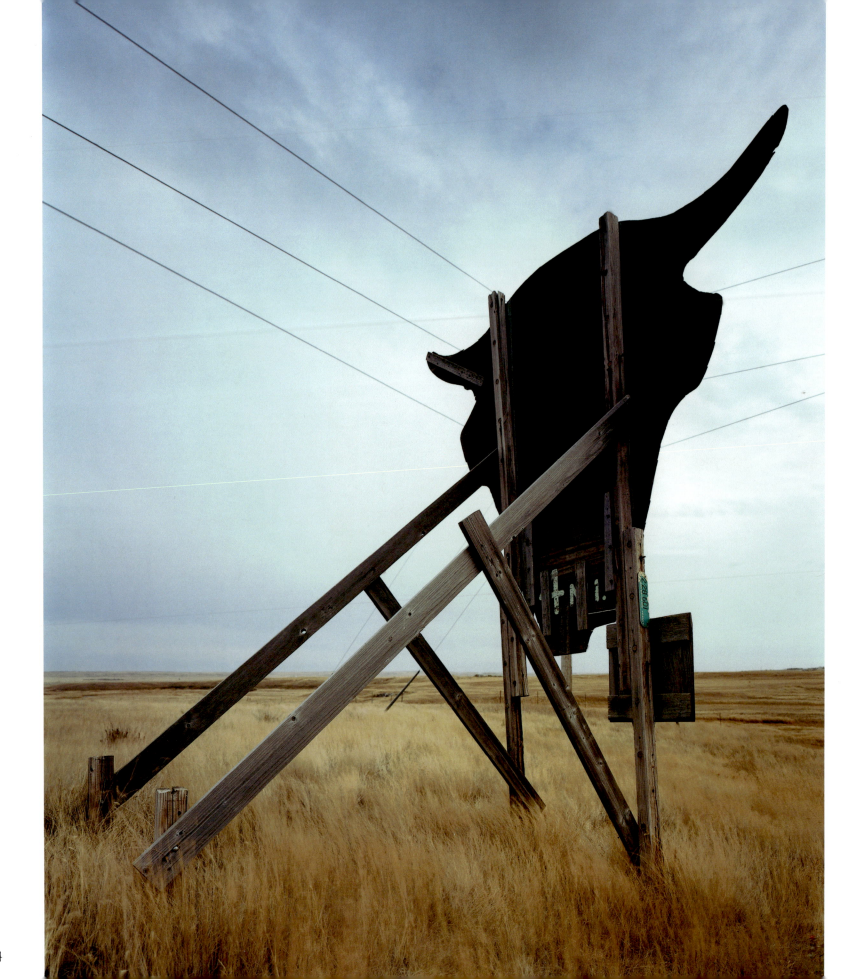

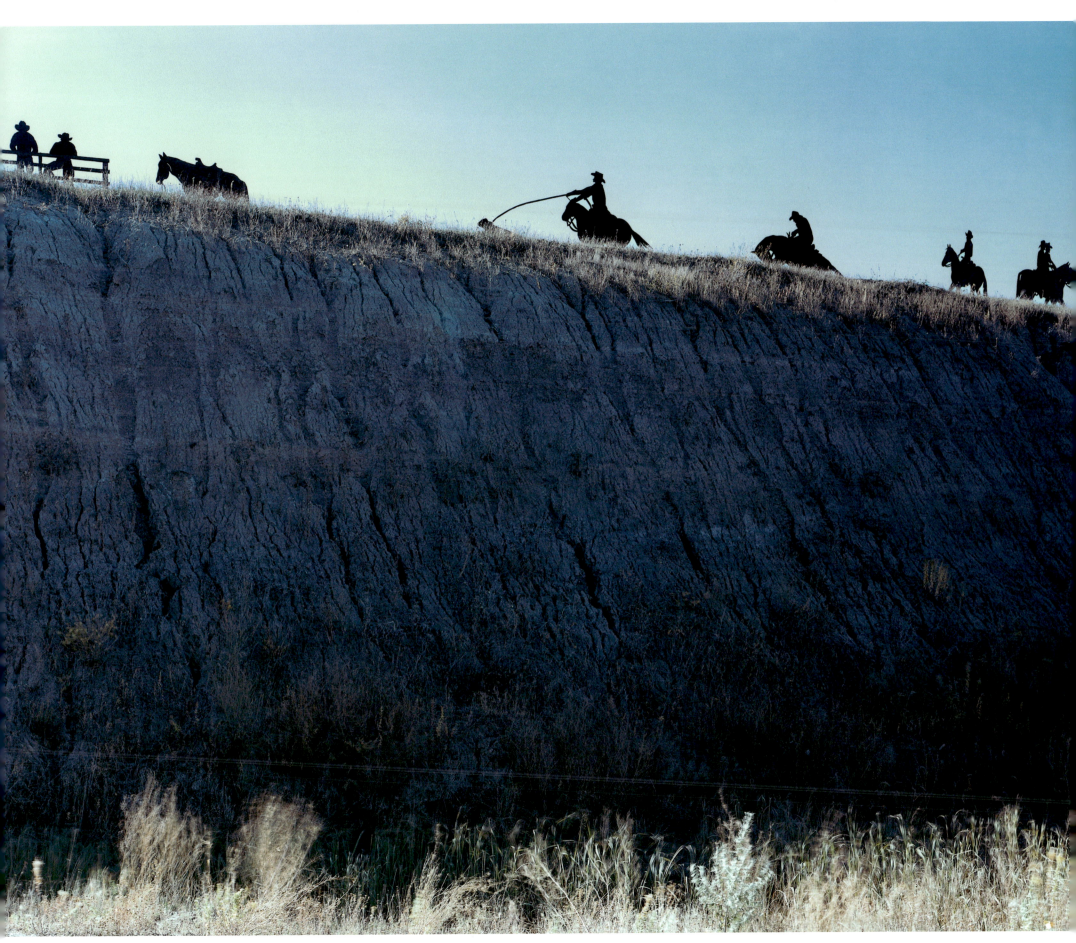

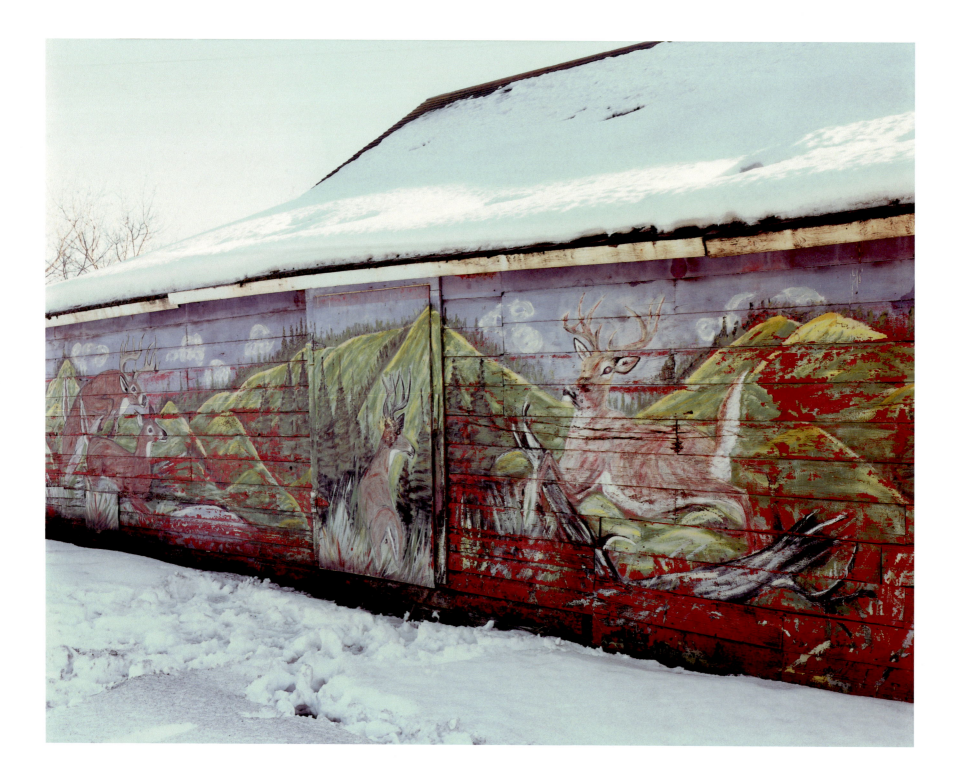

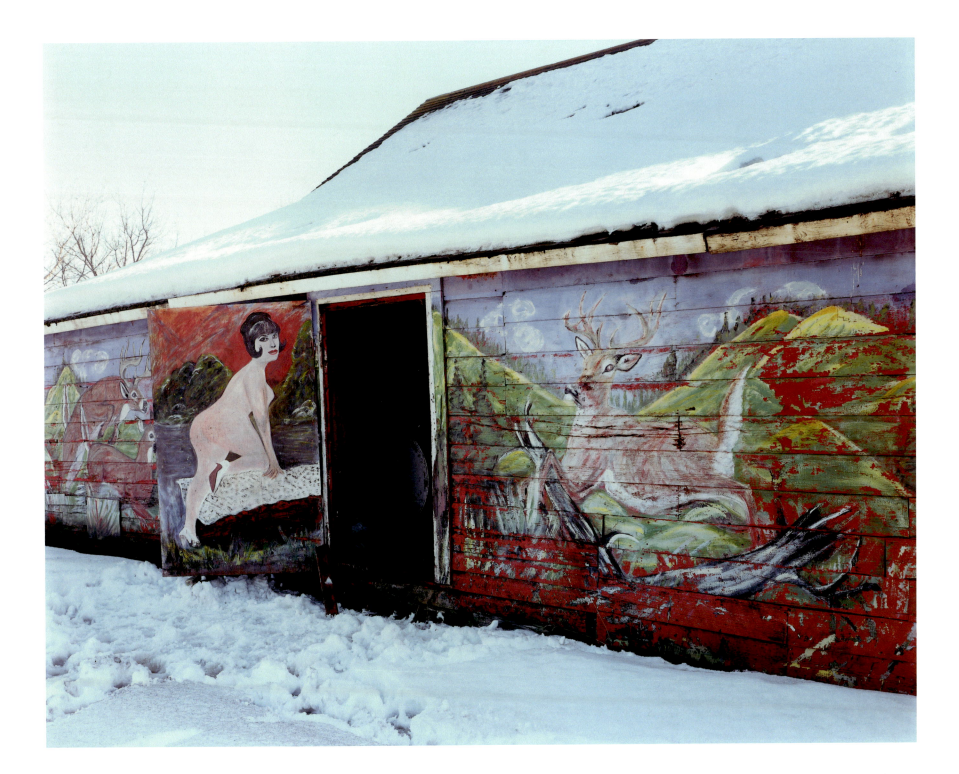

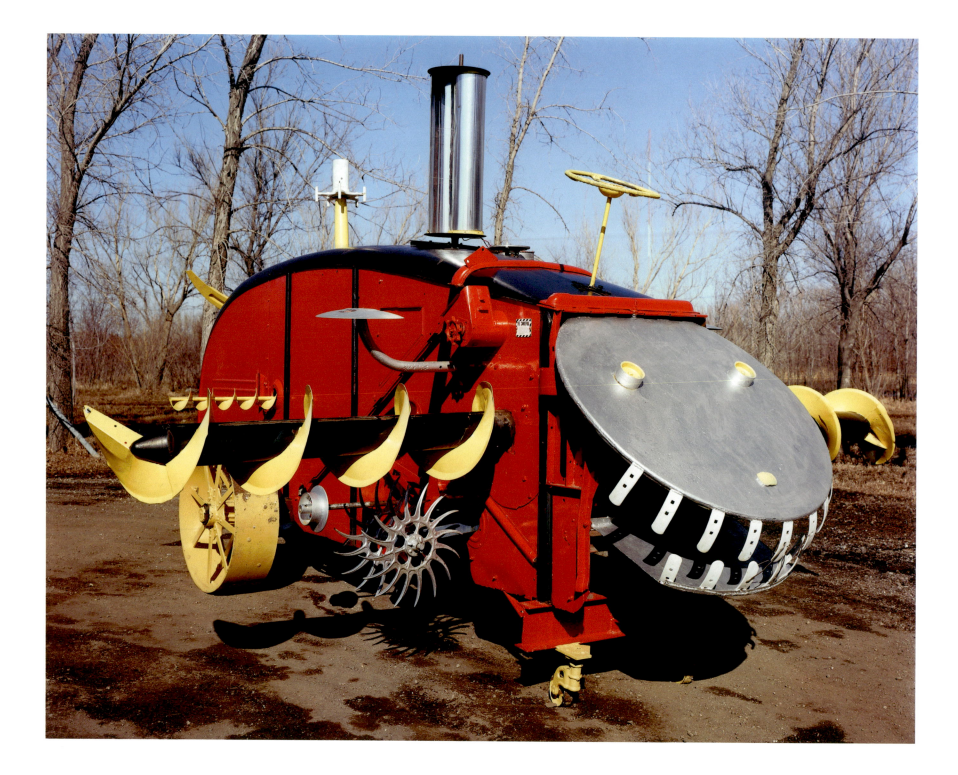

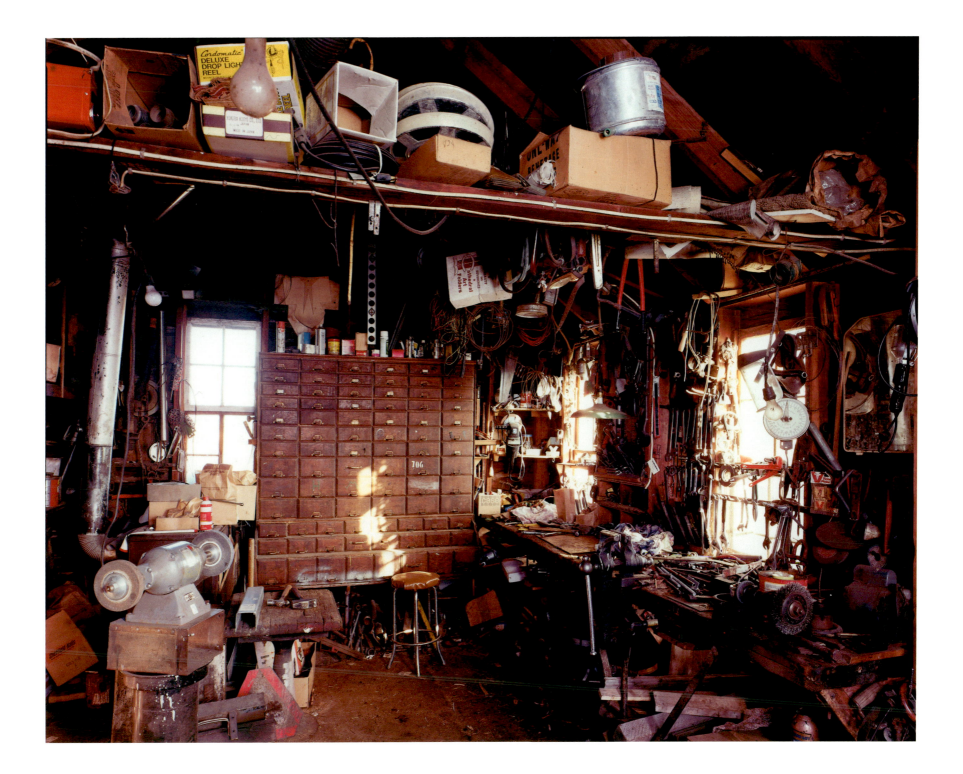

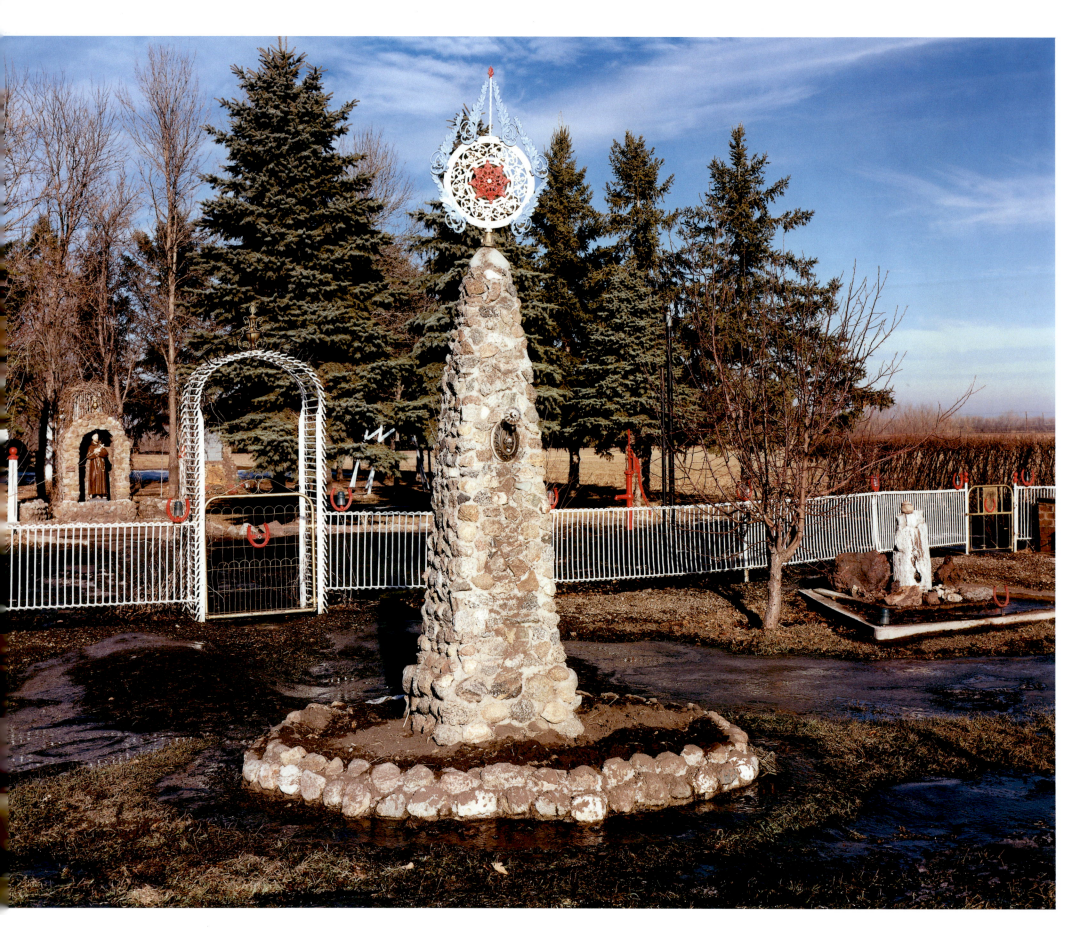

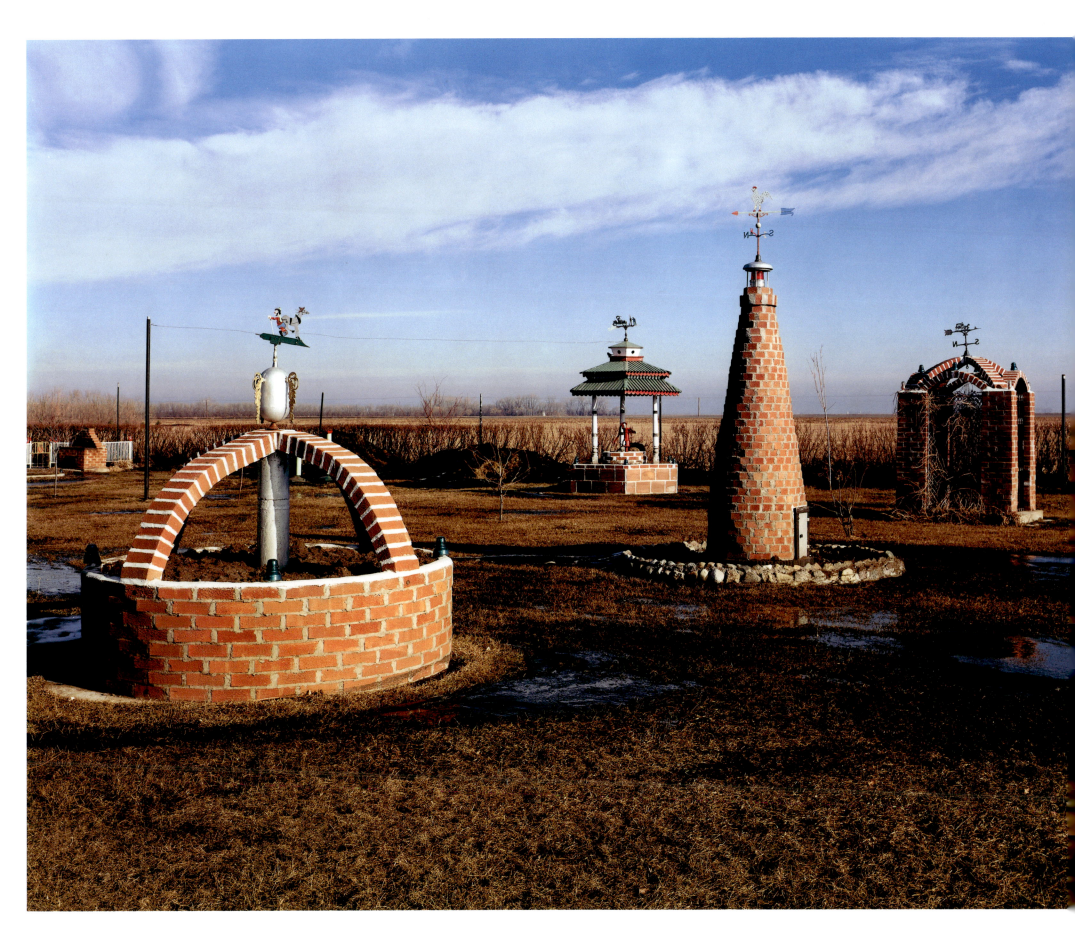

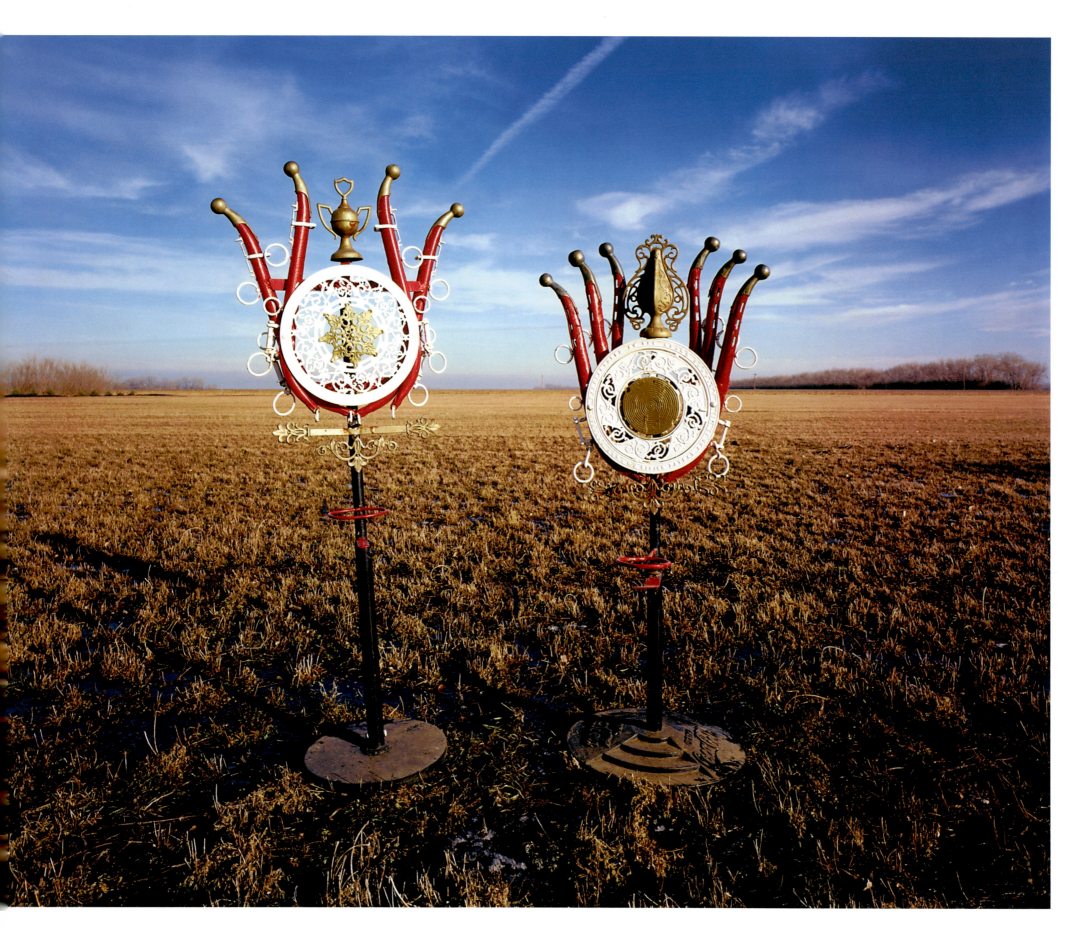

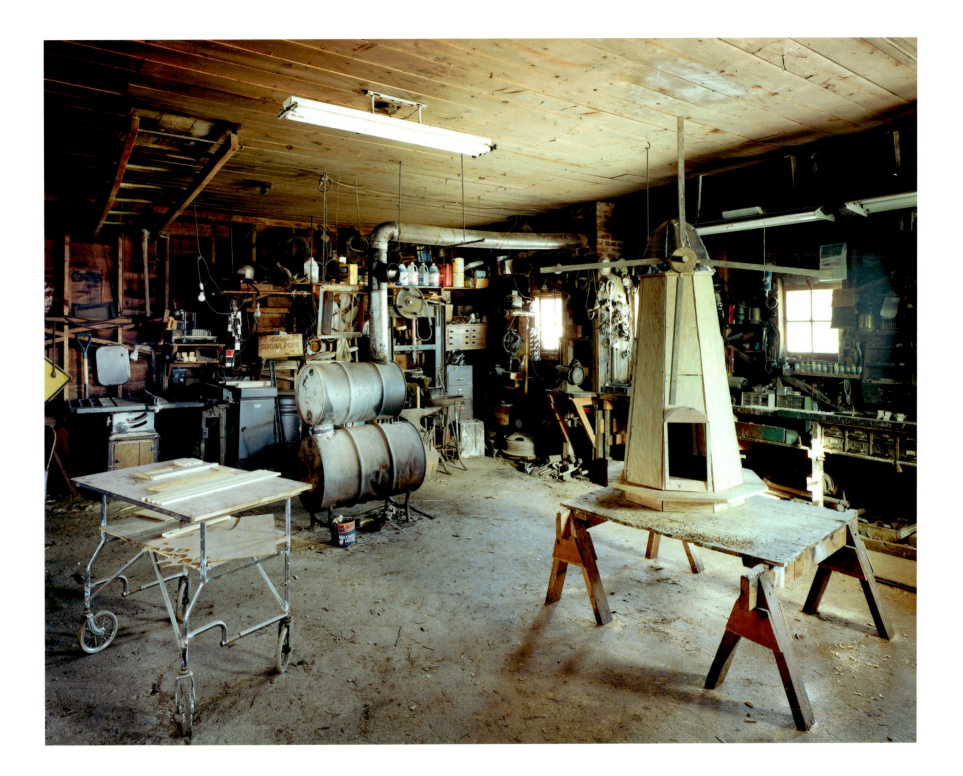

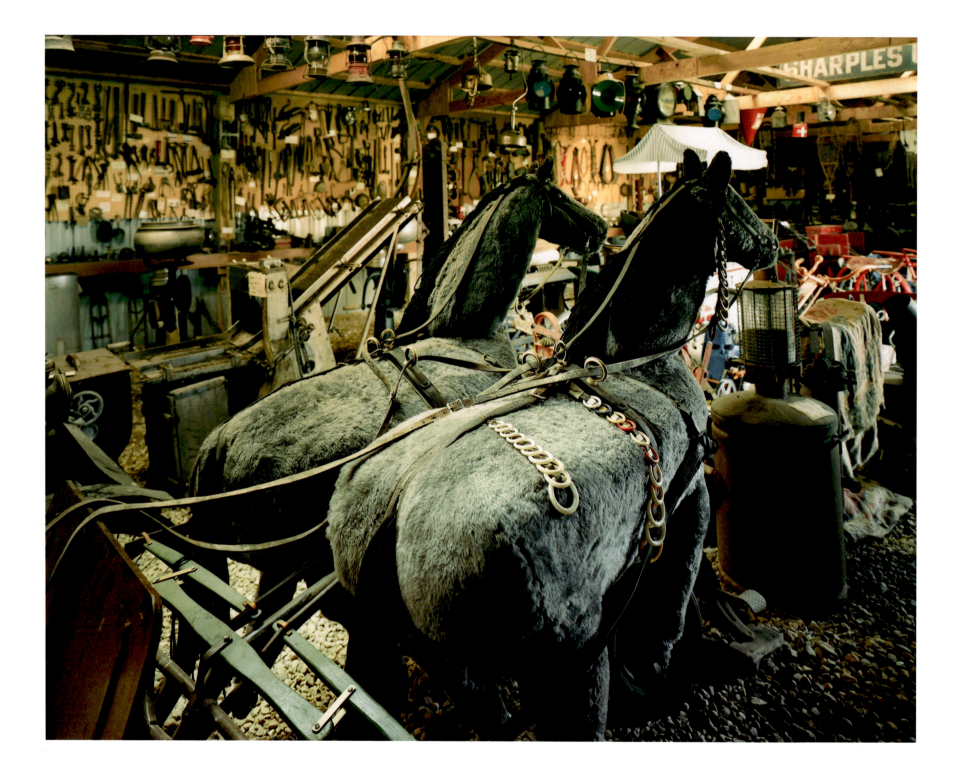

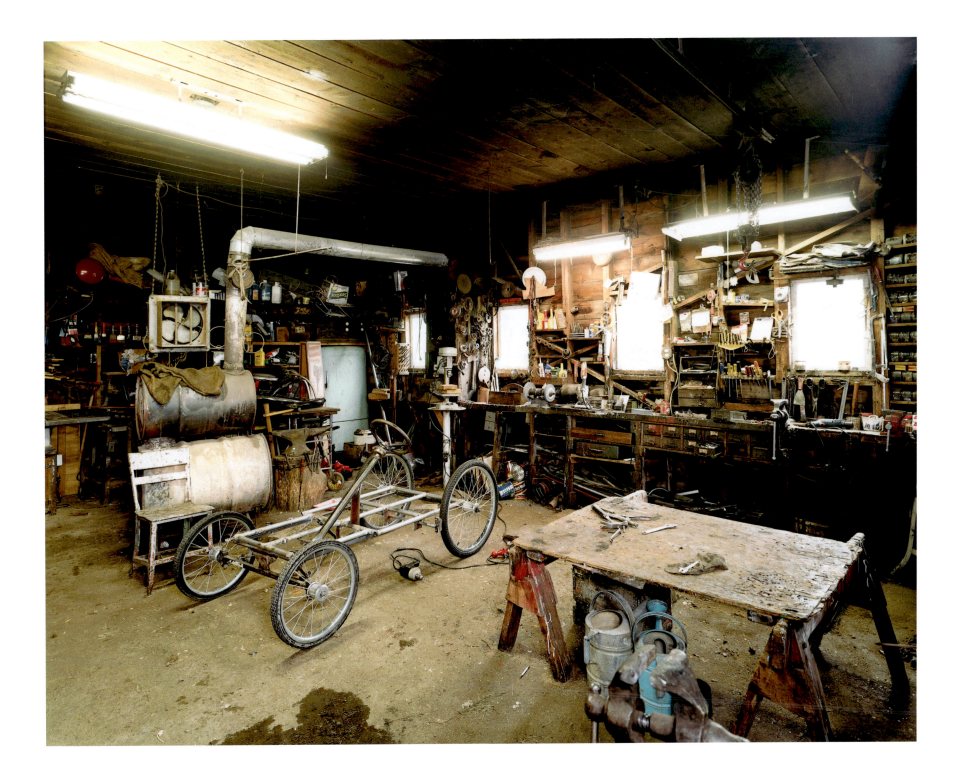

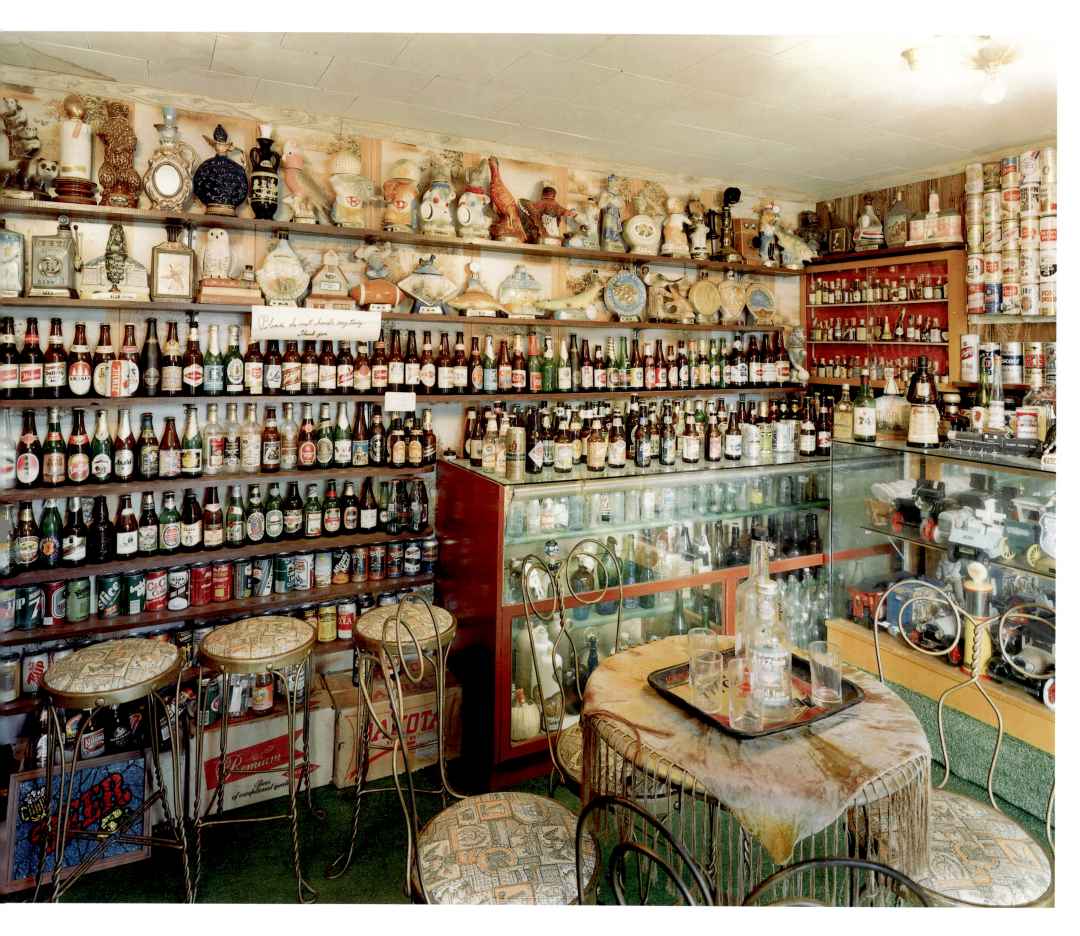

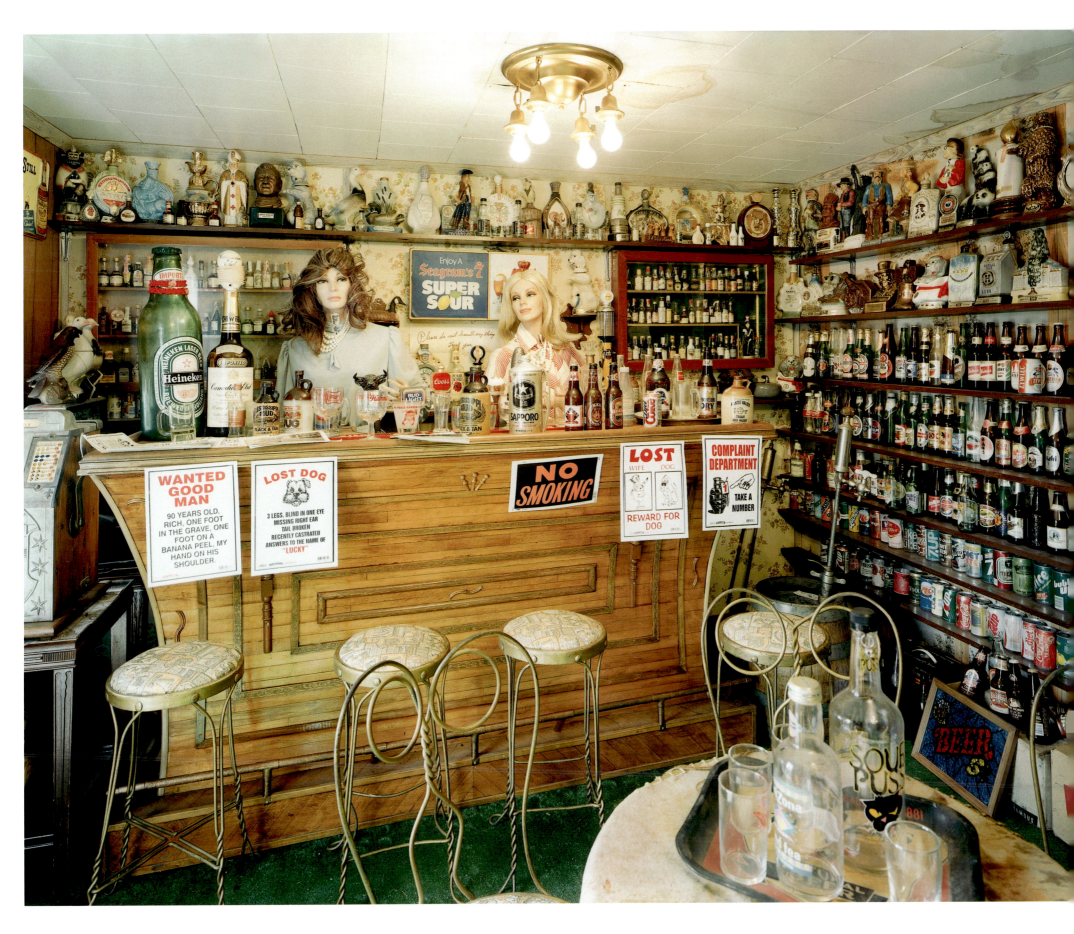

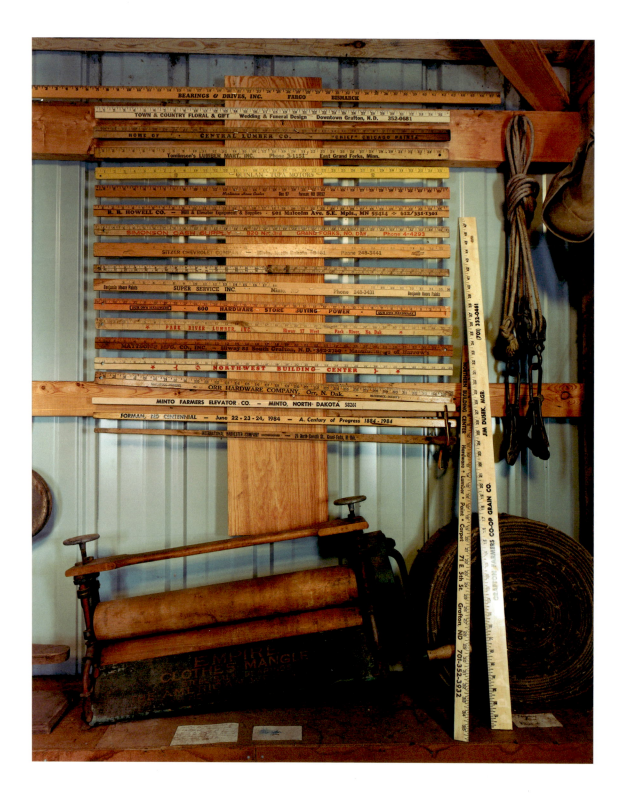

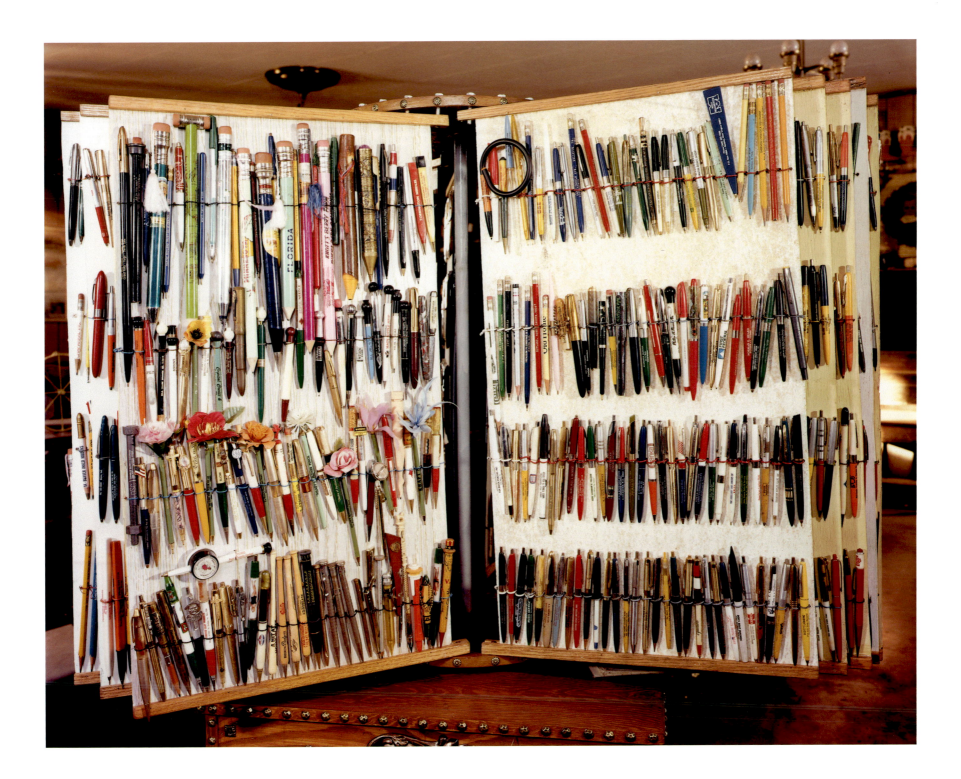

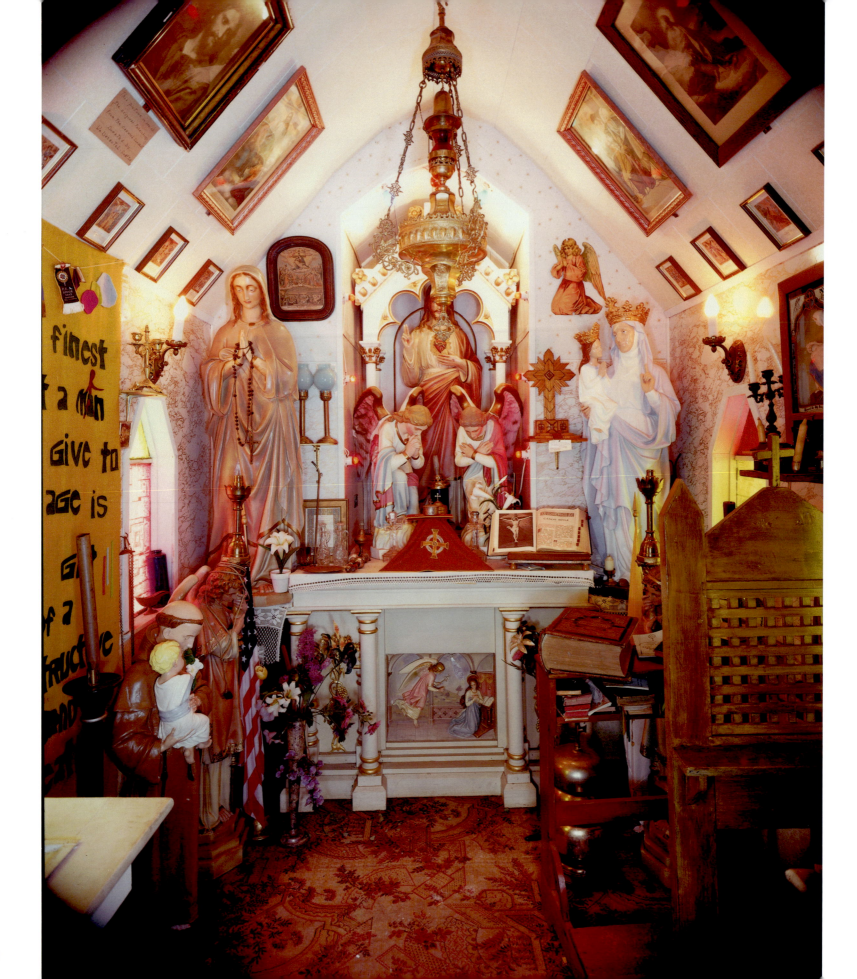

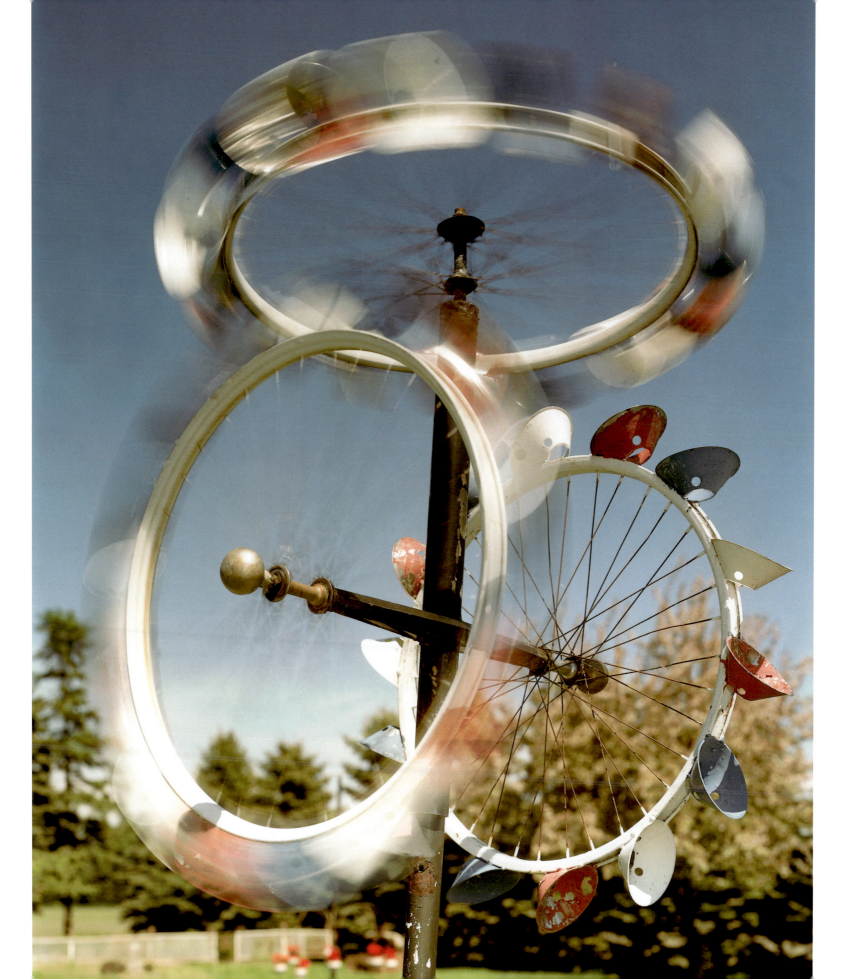

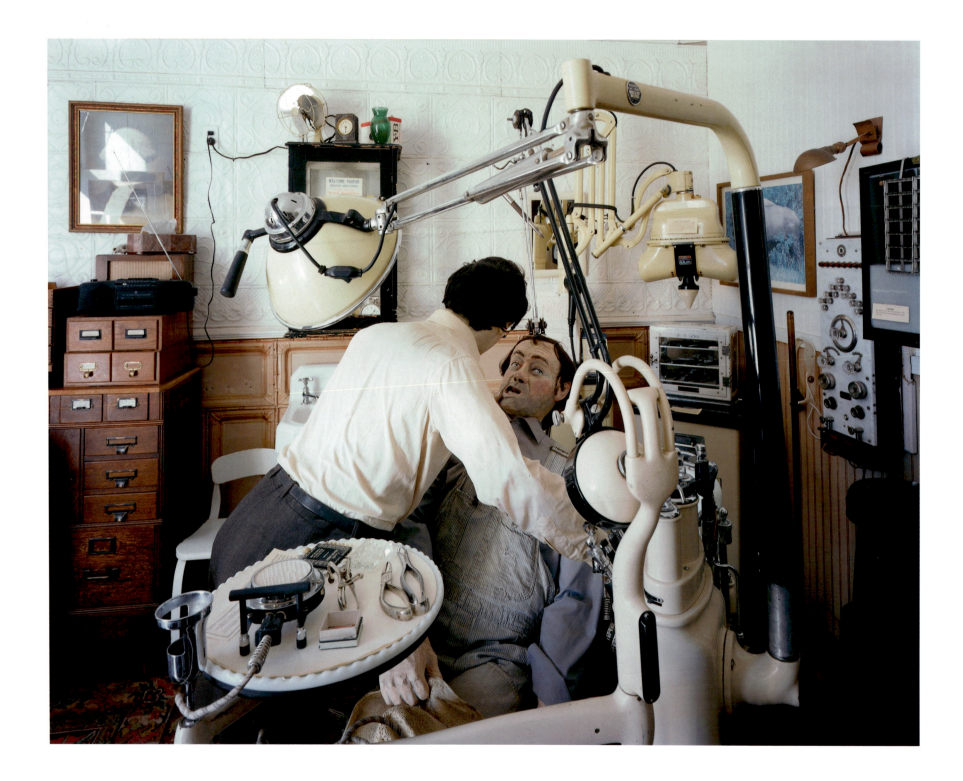

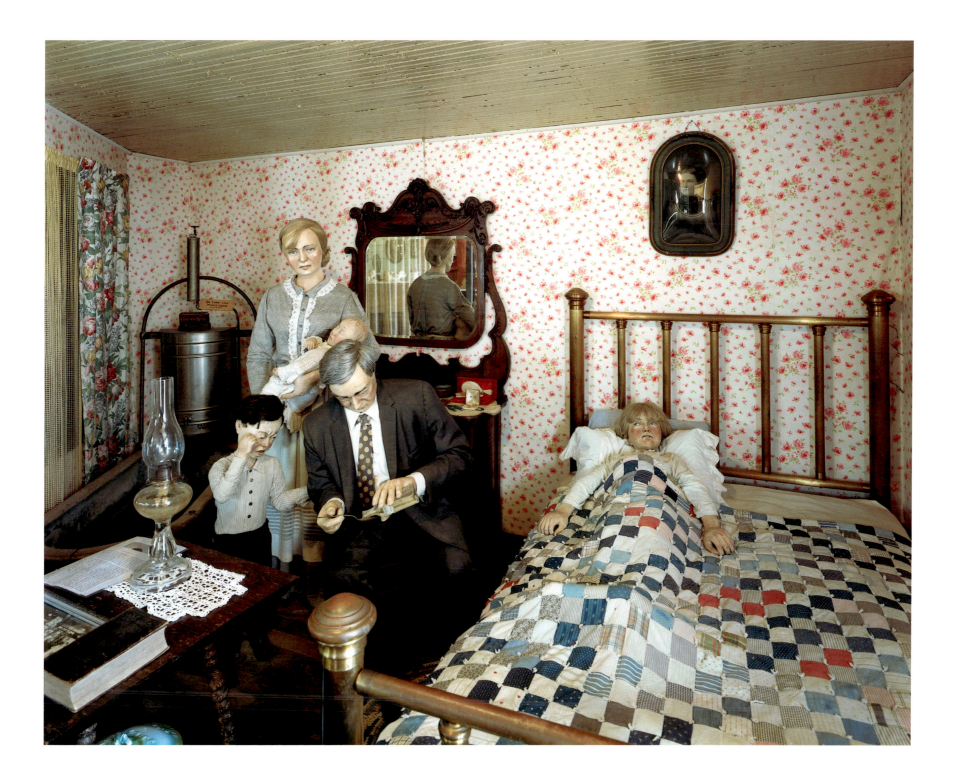

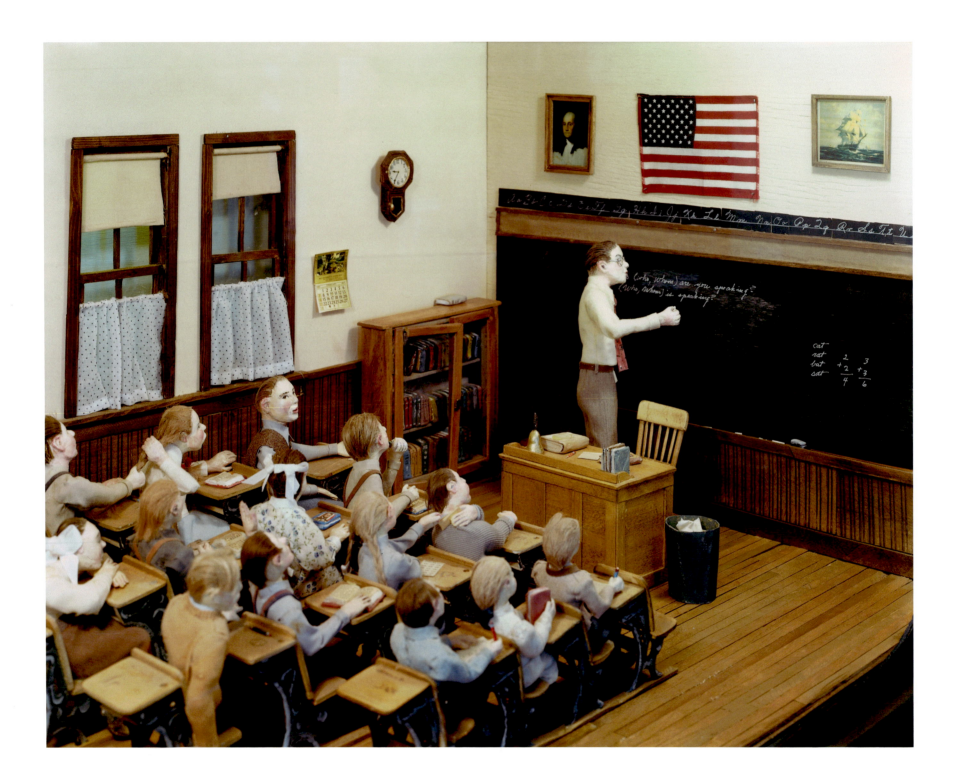

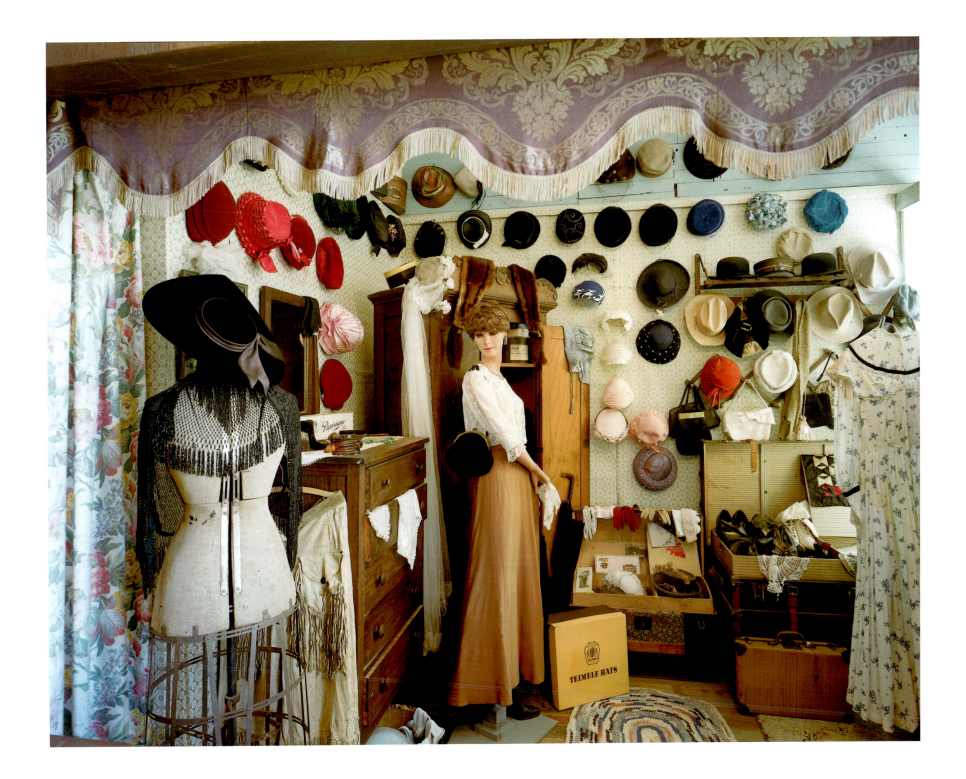

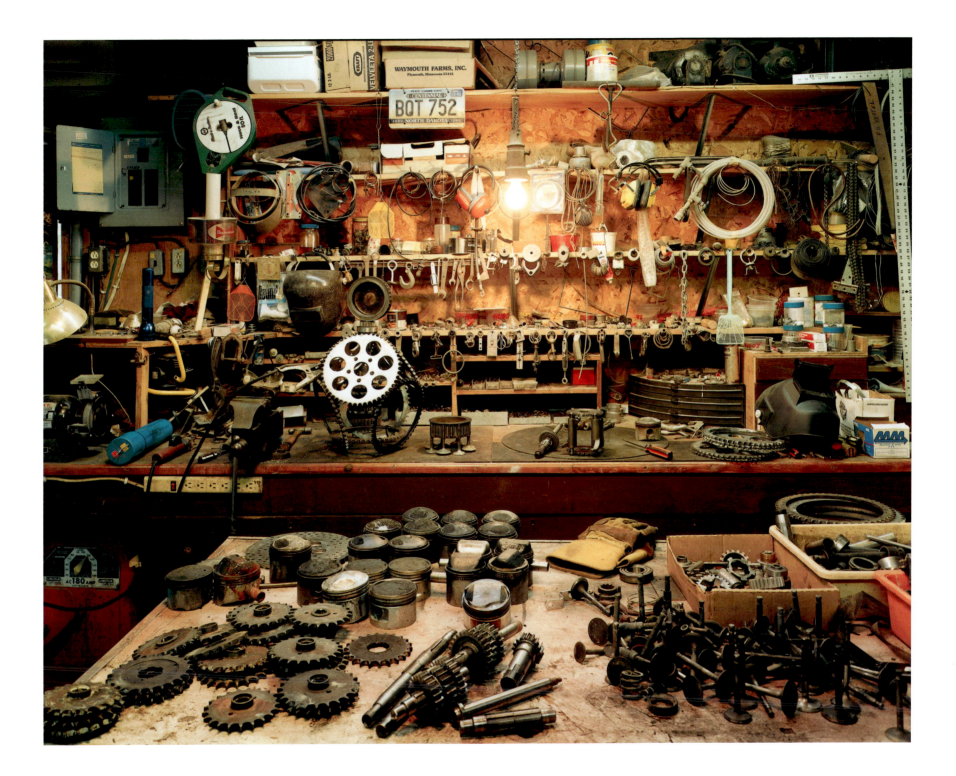

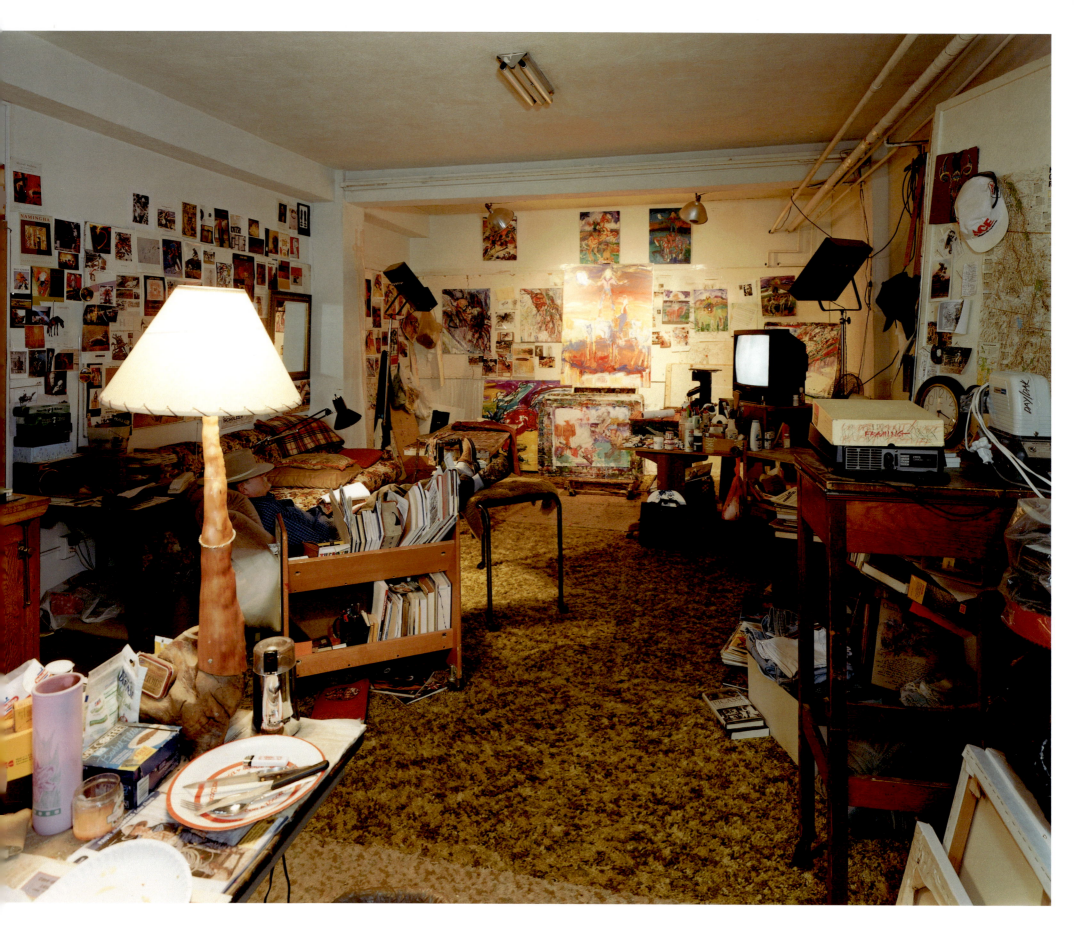

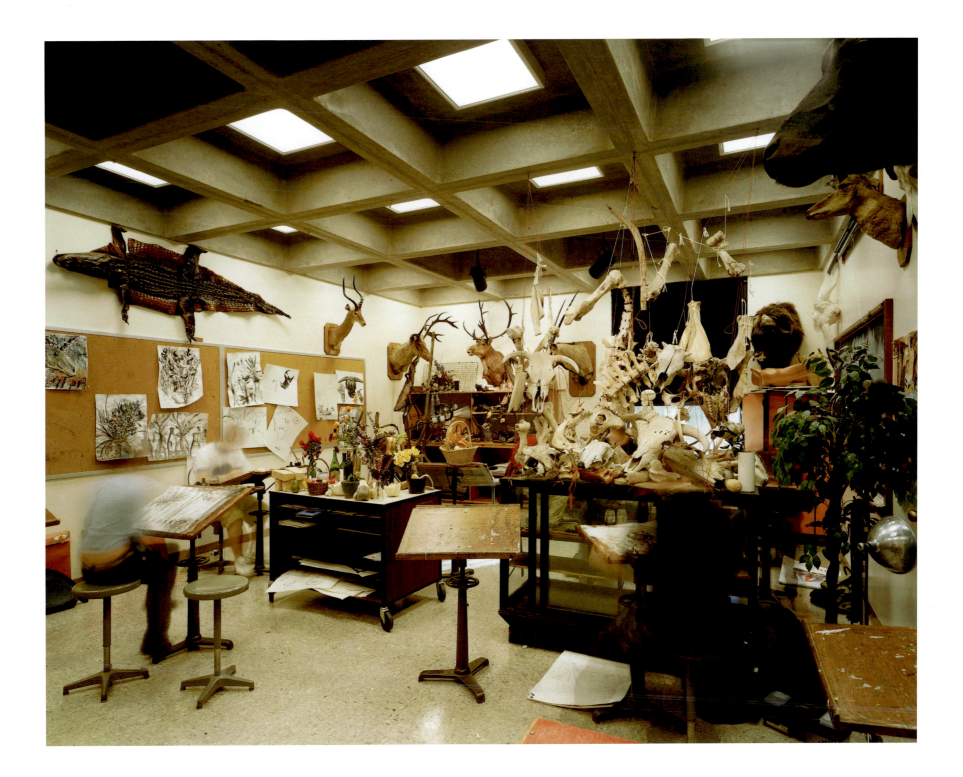

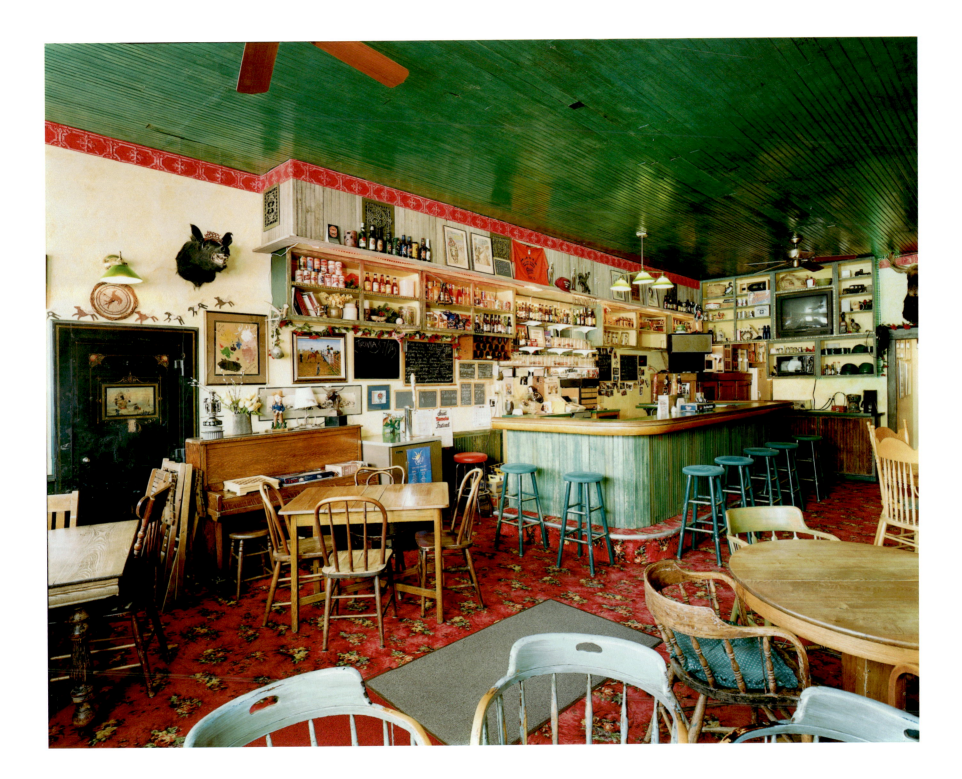

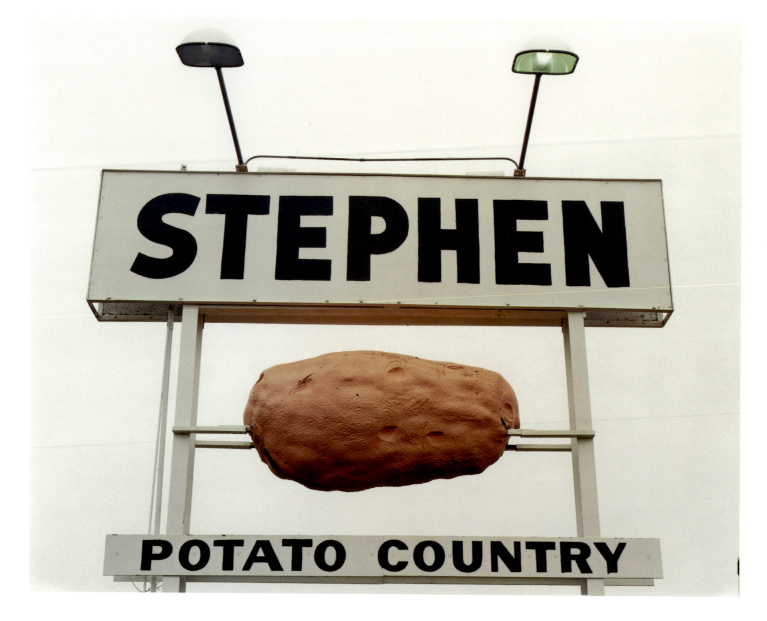

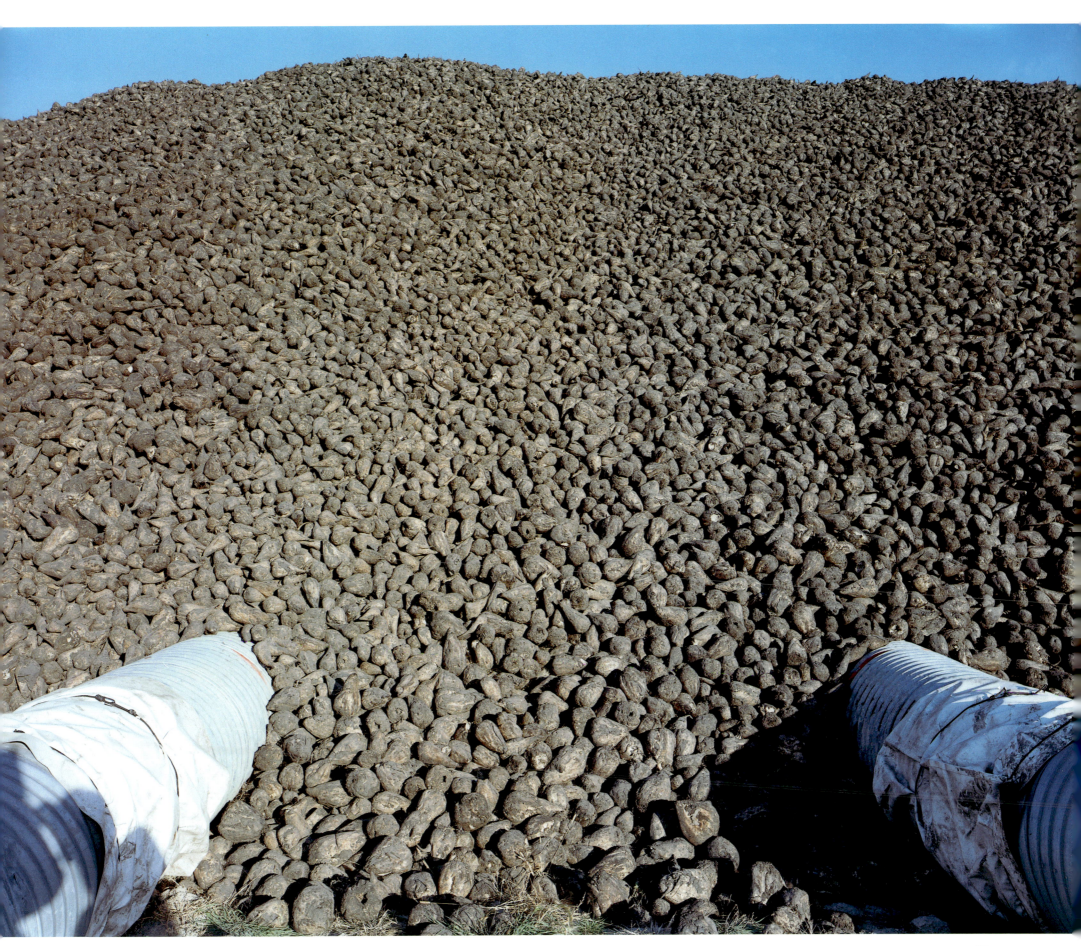

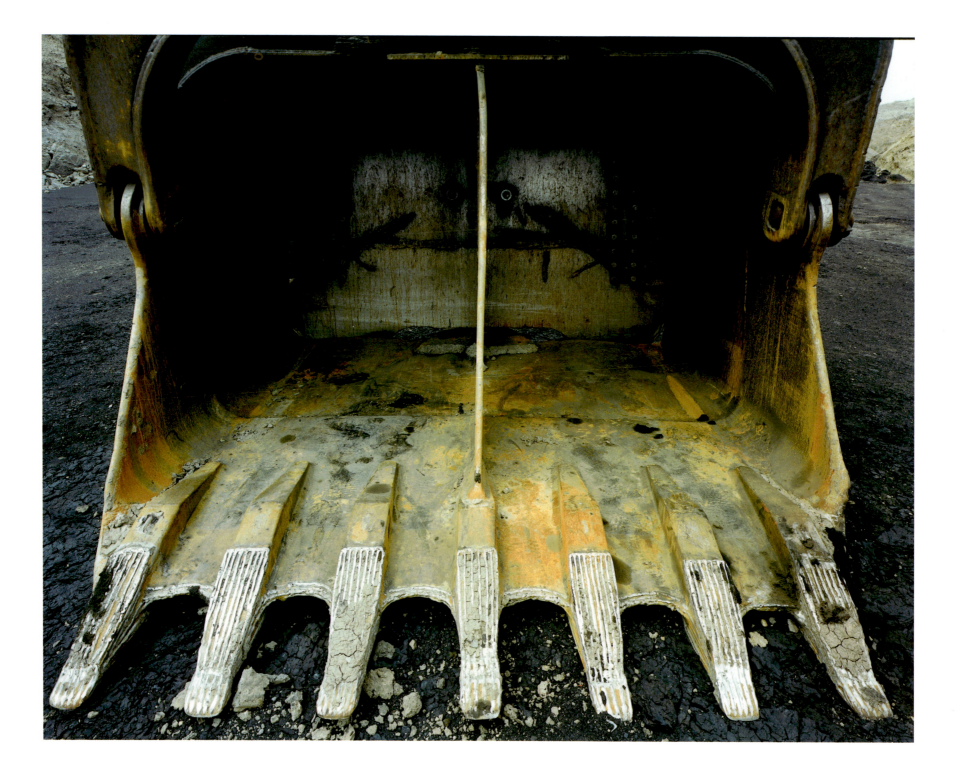

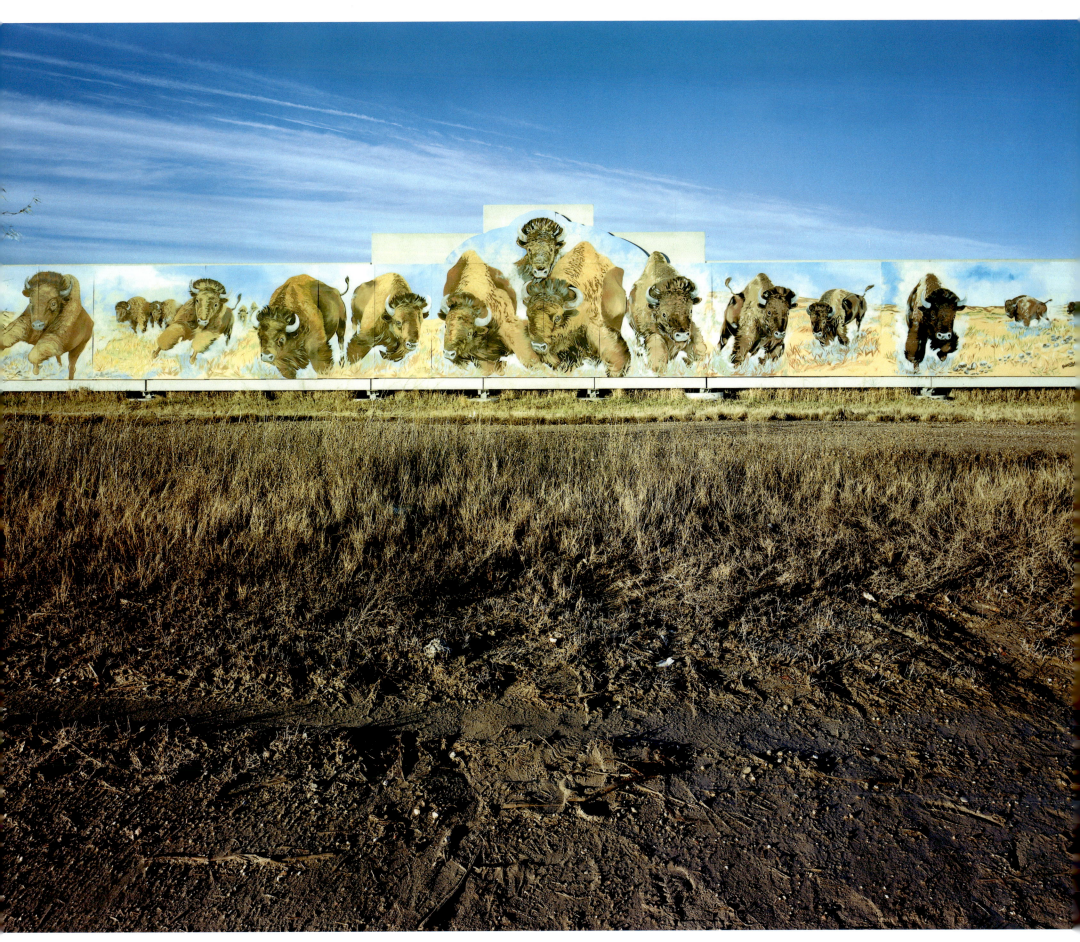

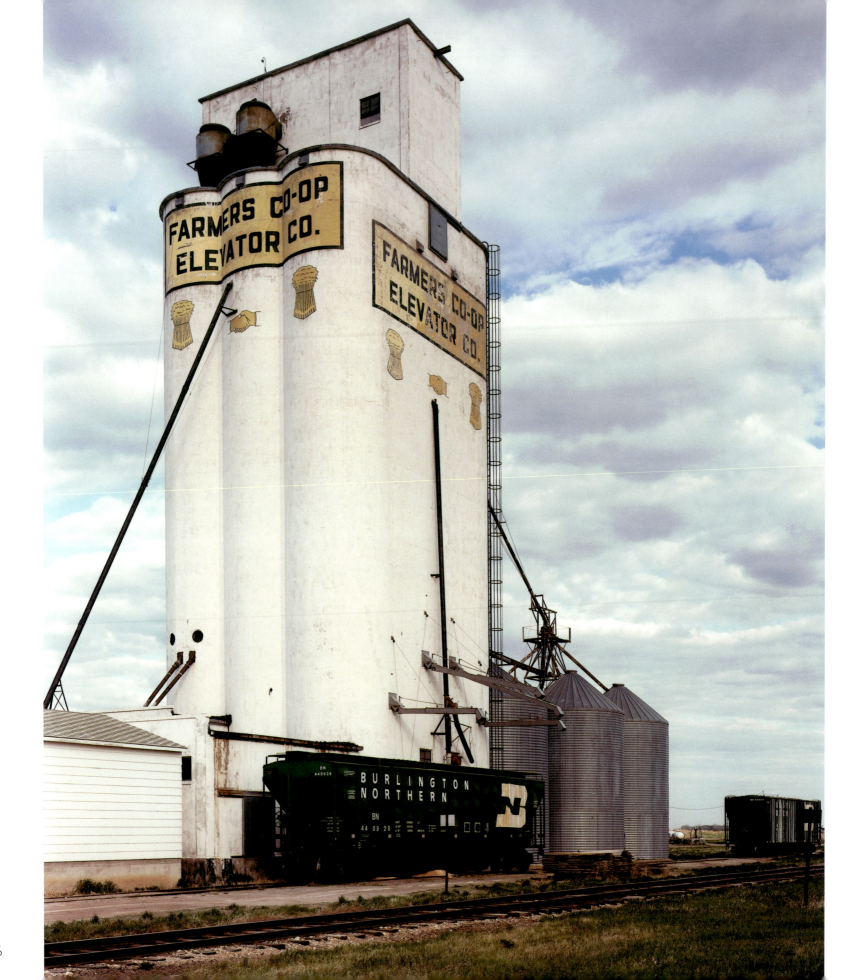

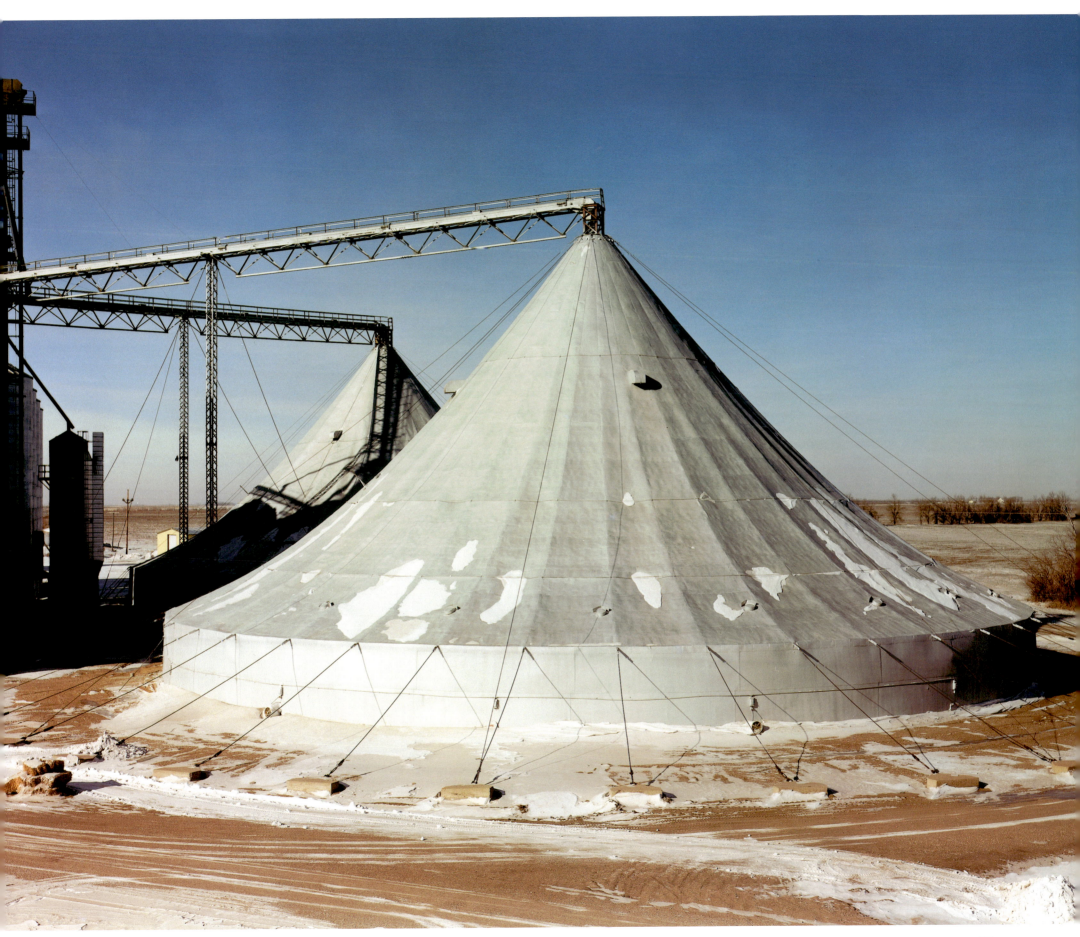

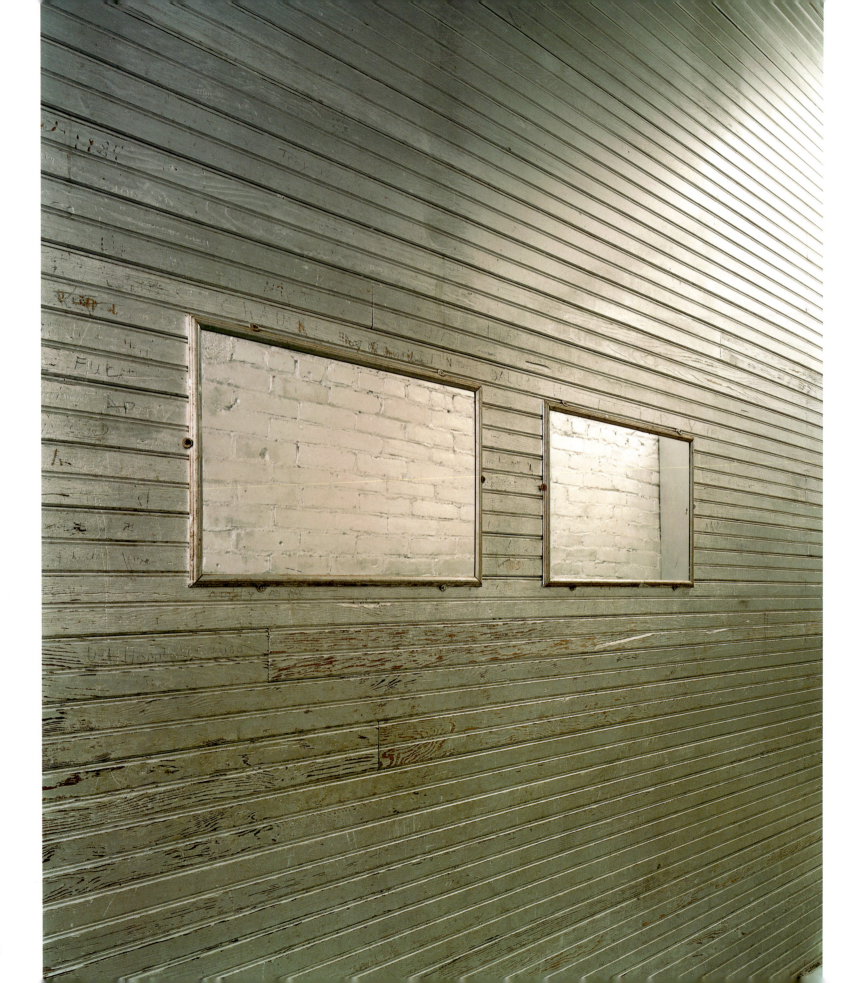

88

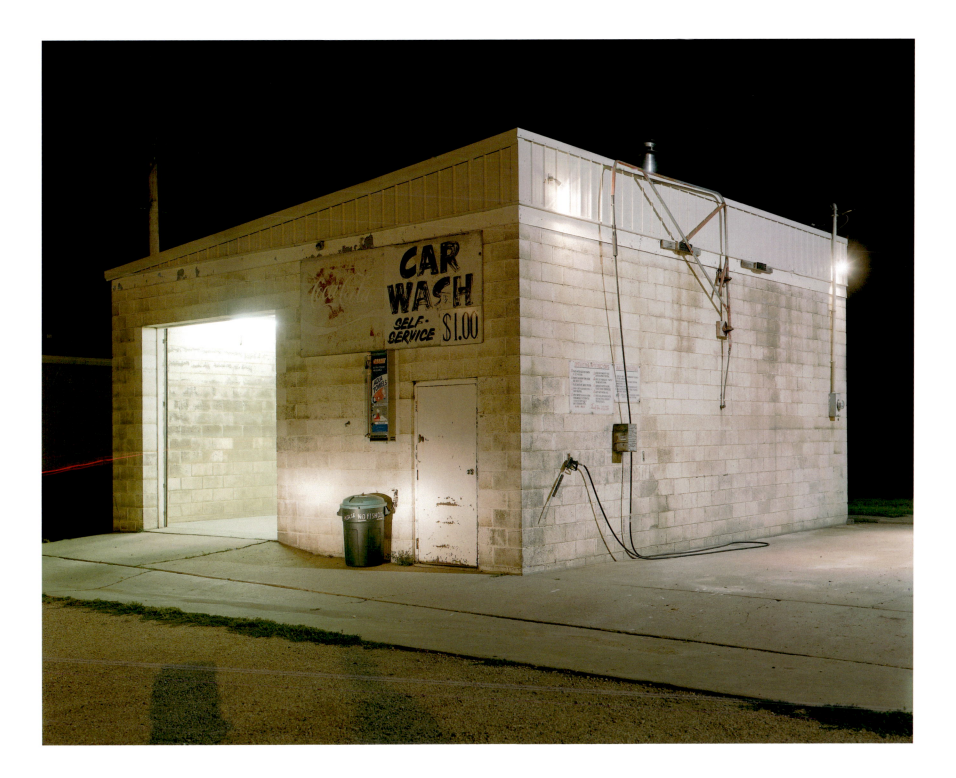

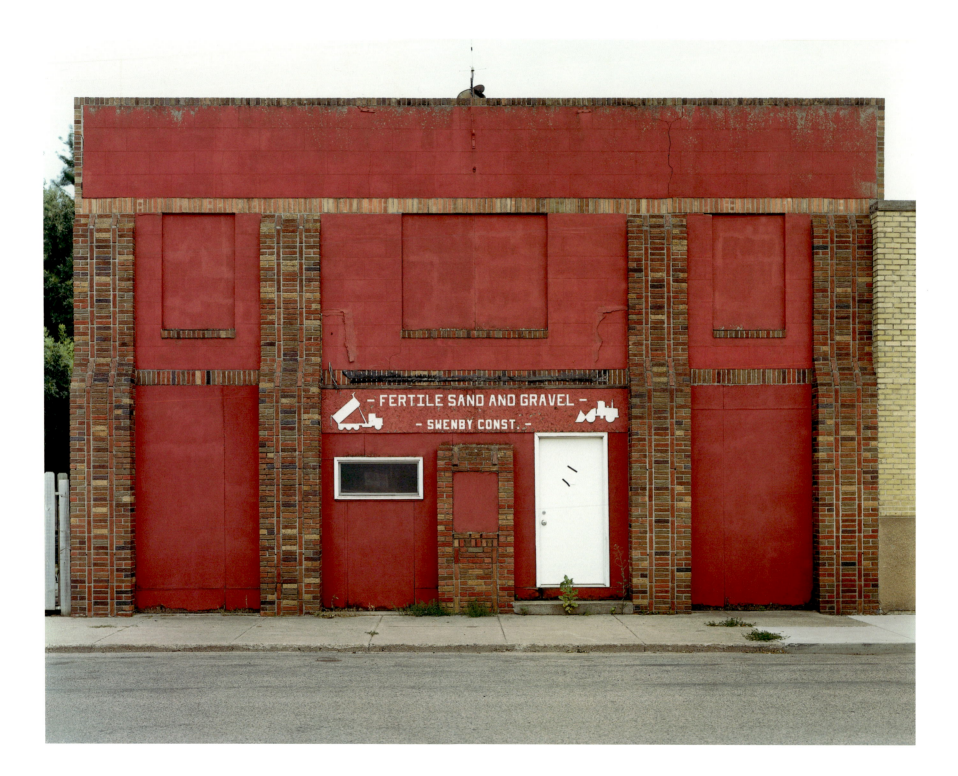

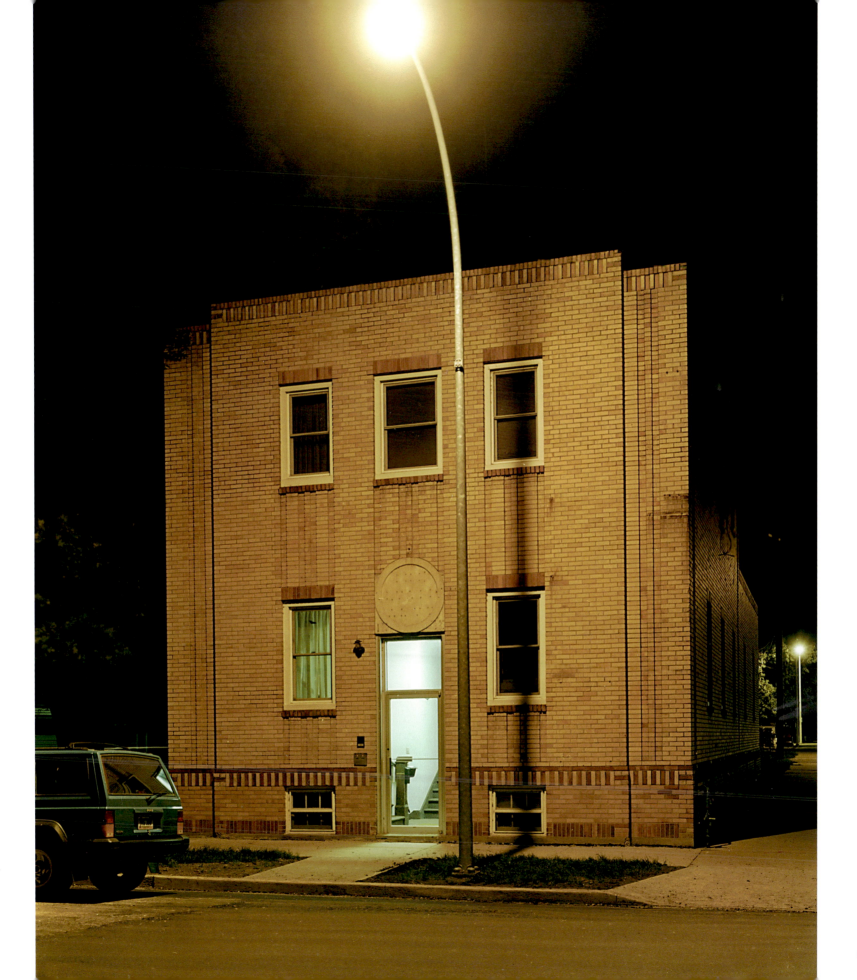

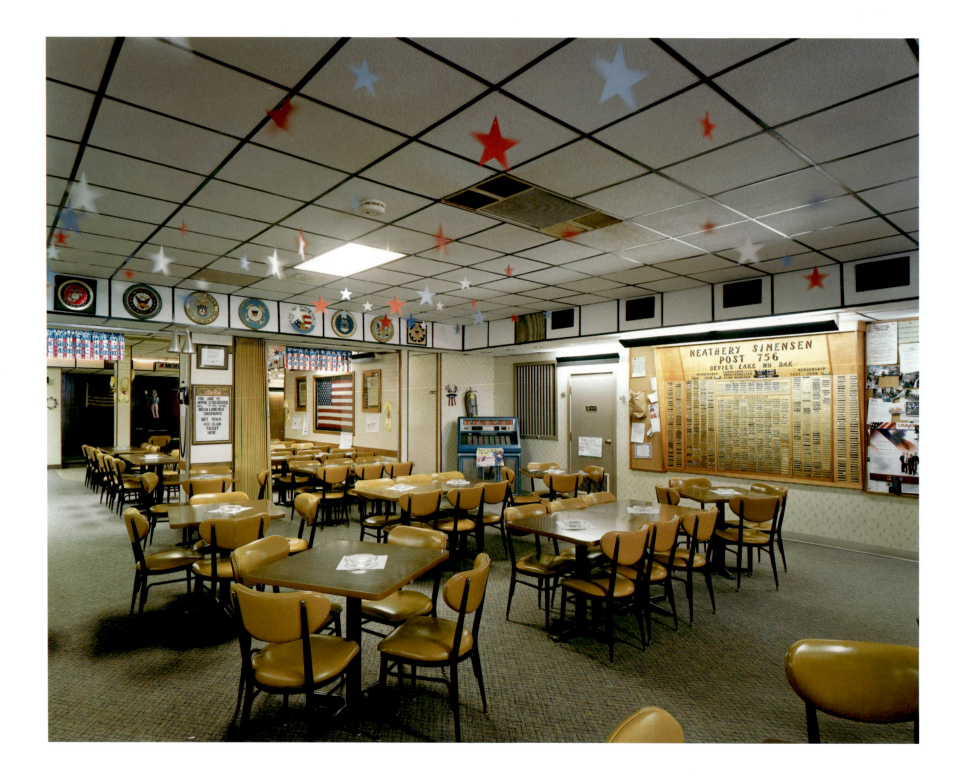

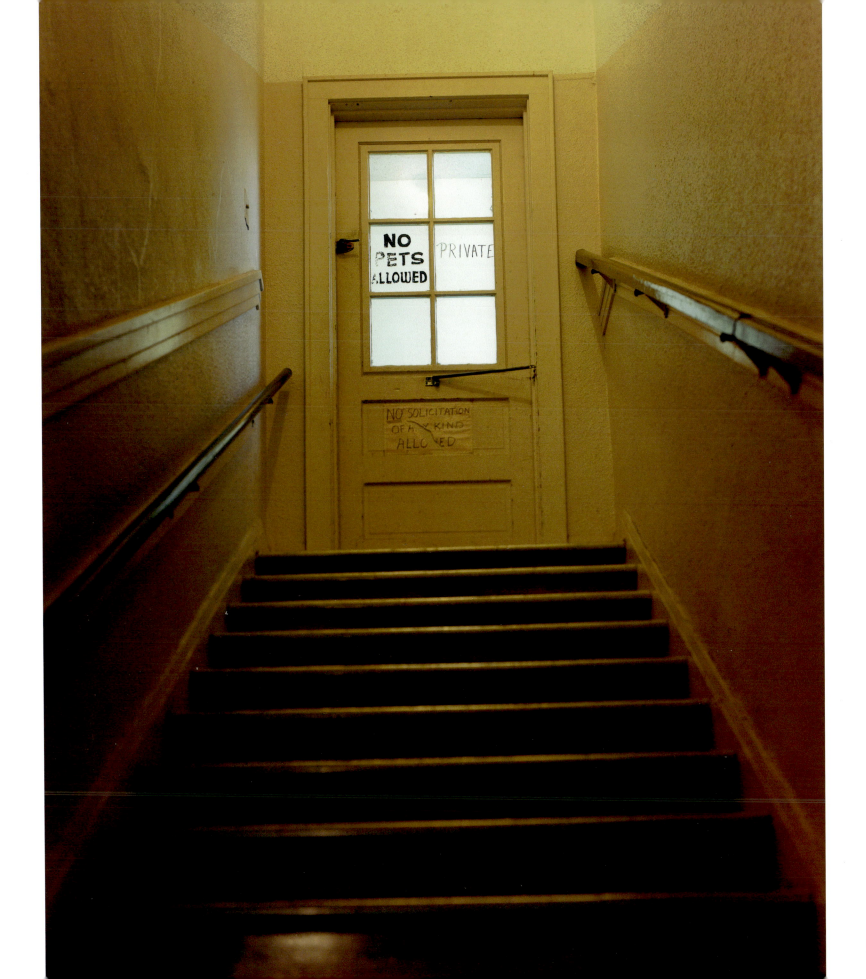

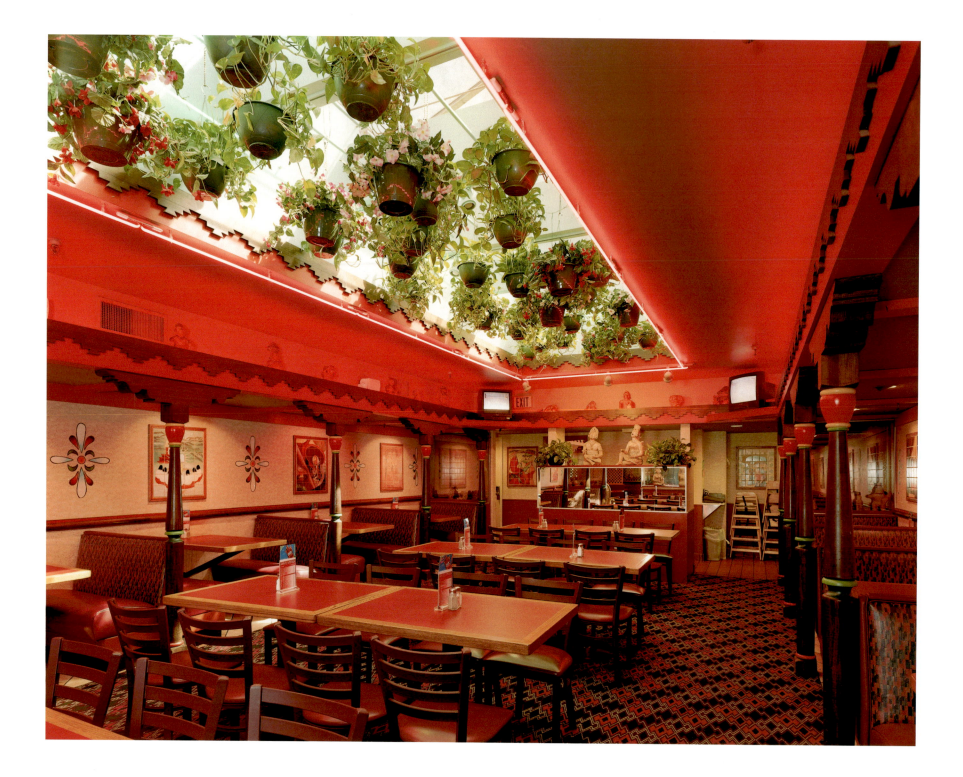

94

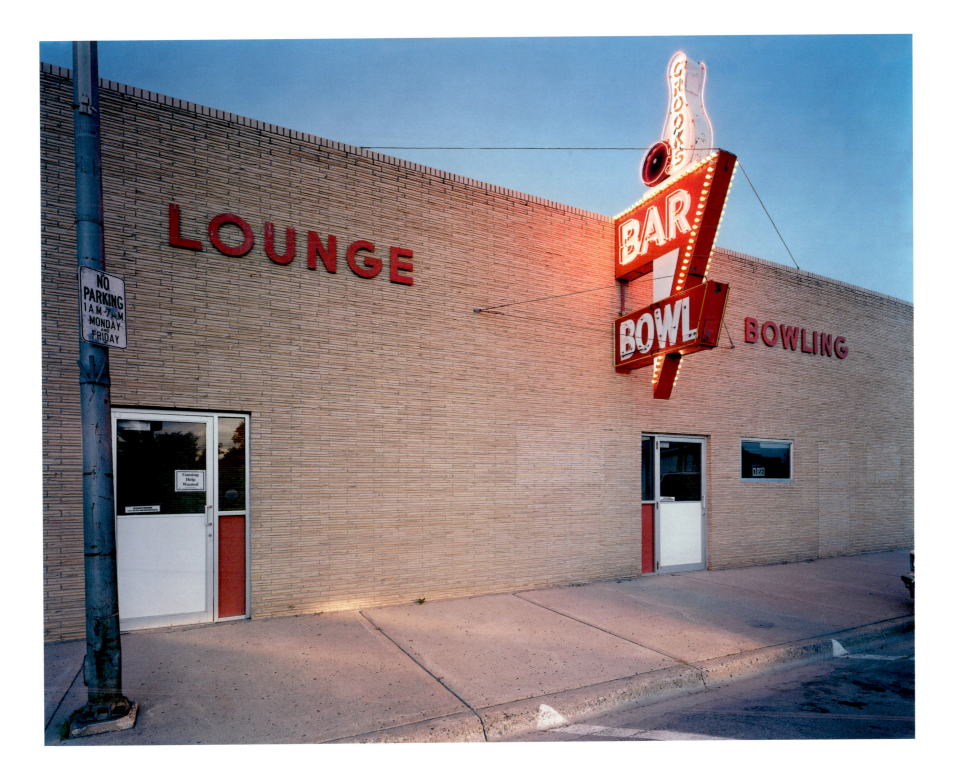

95

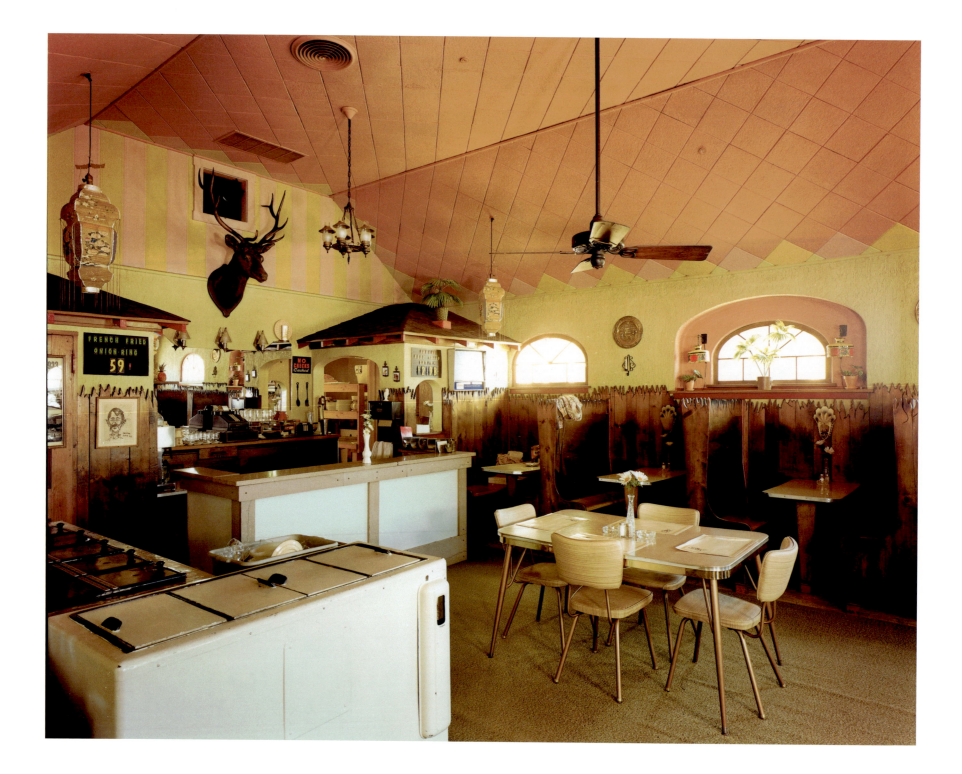

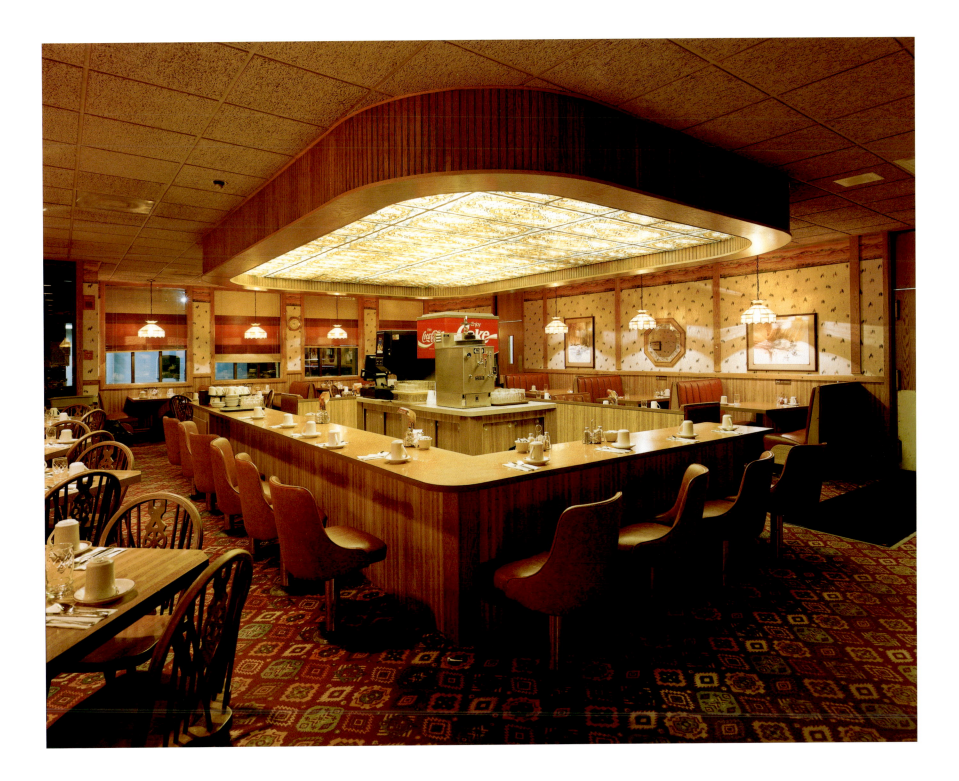

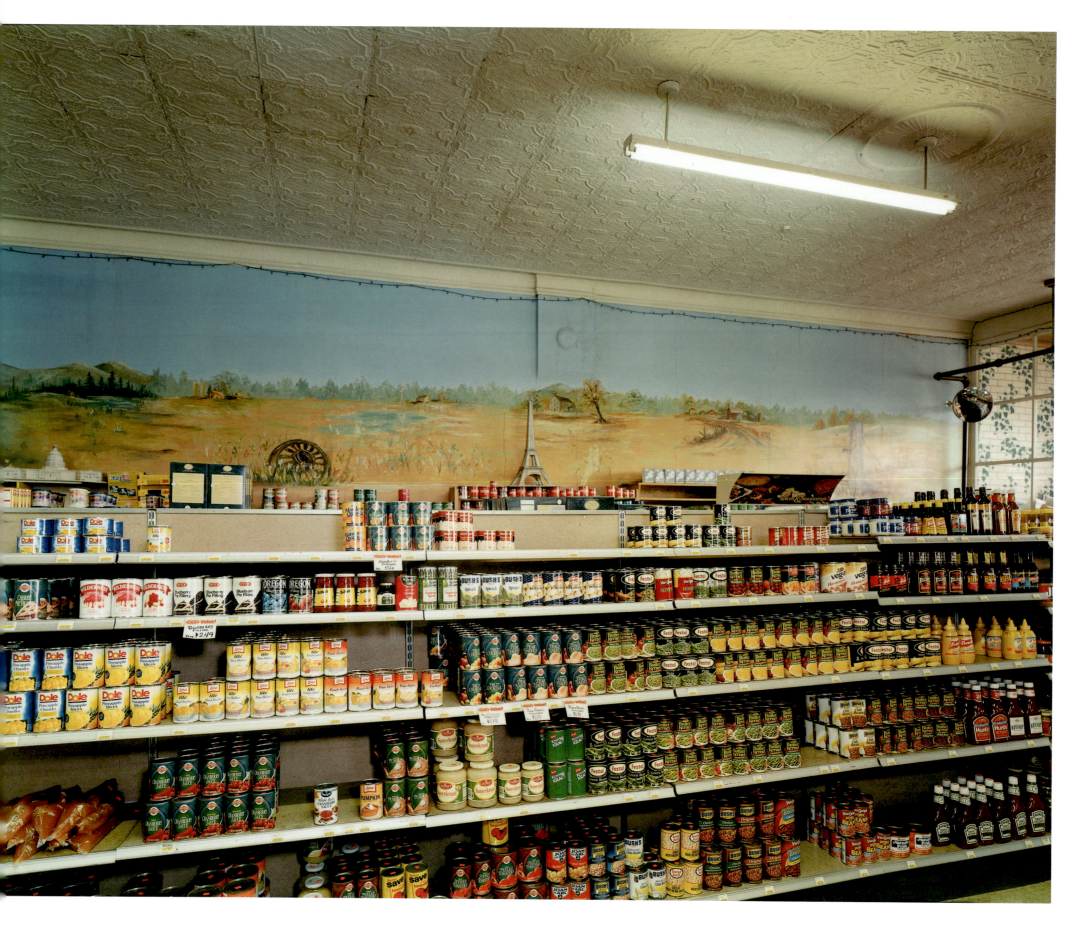

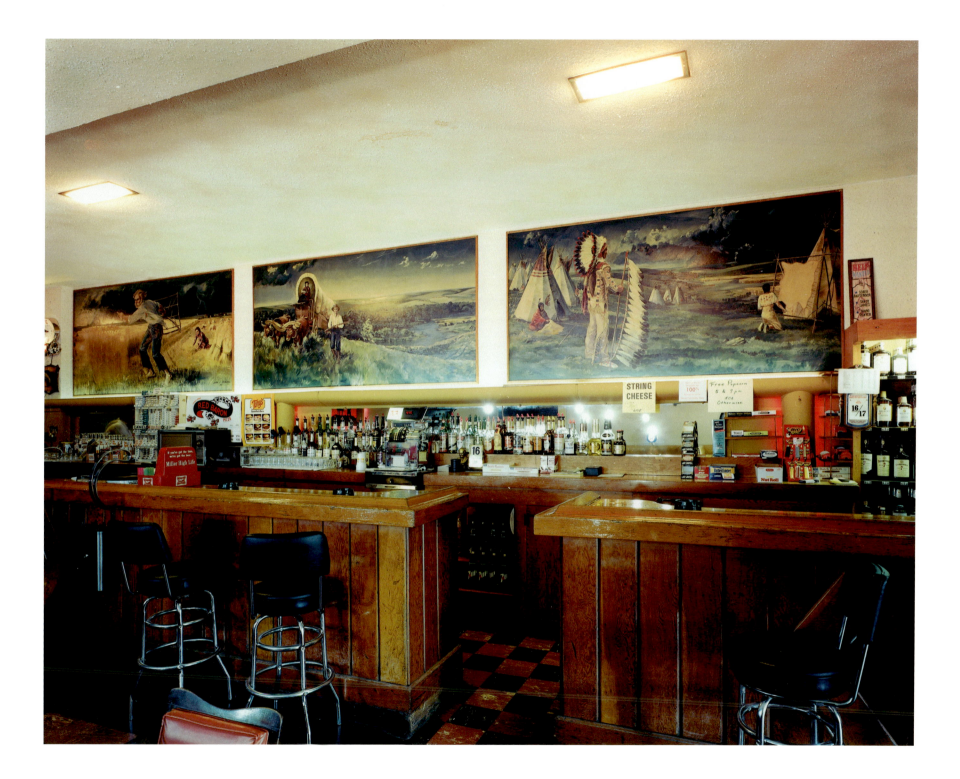

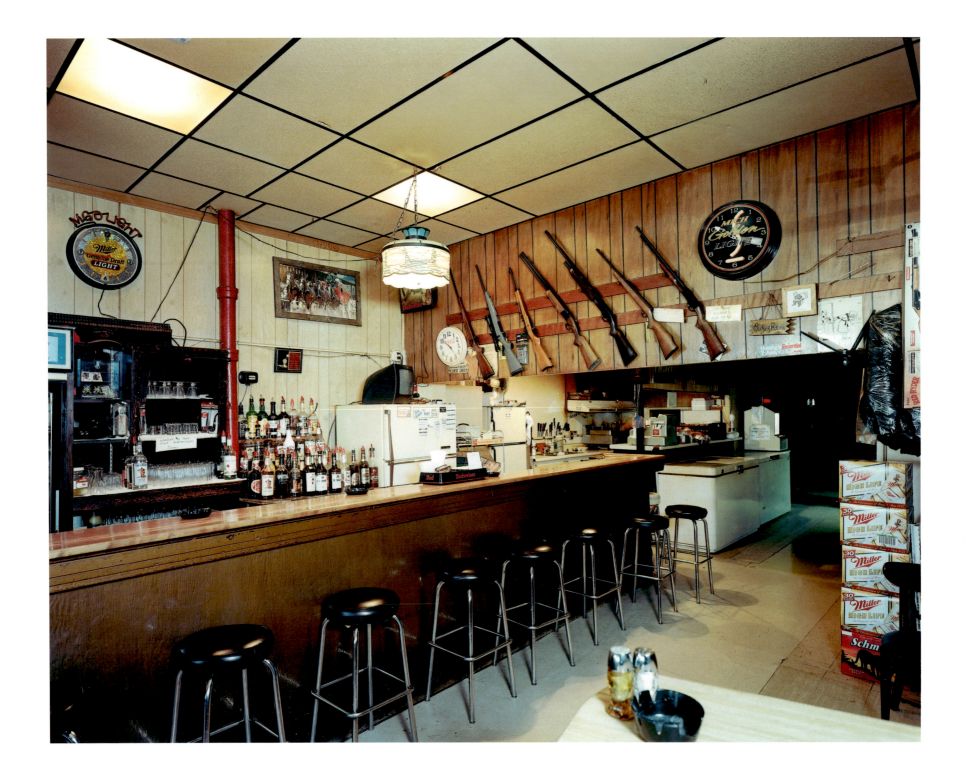

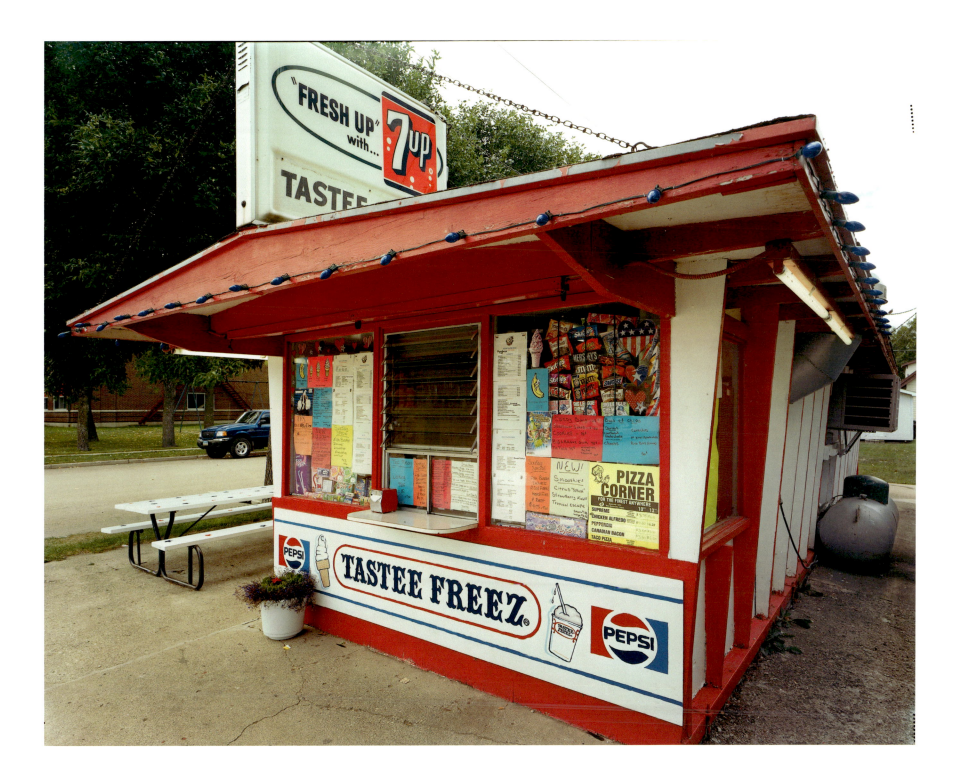

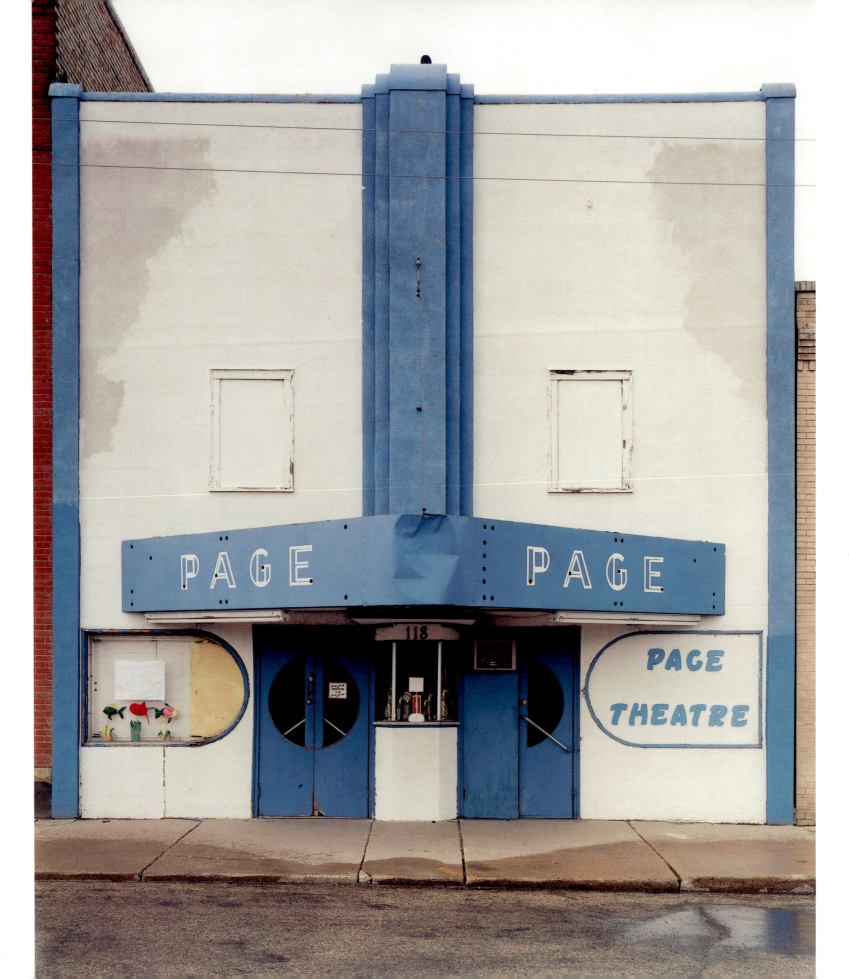

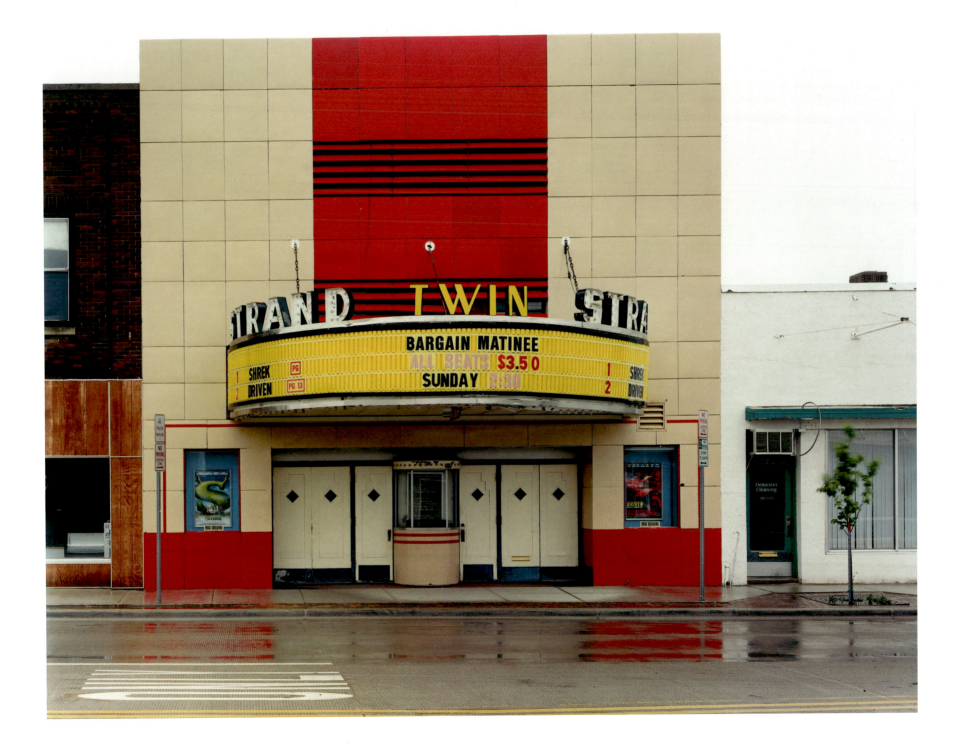

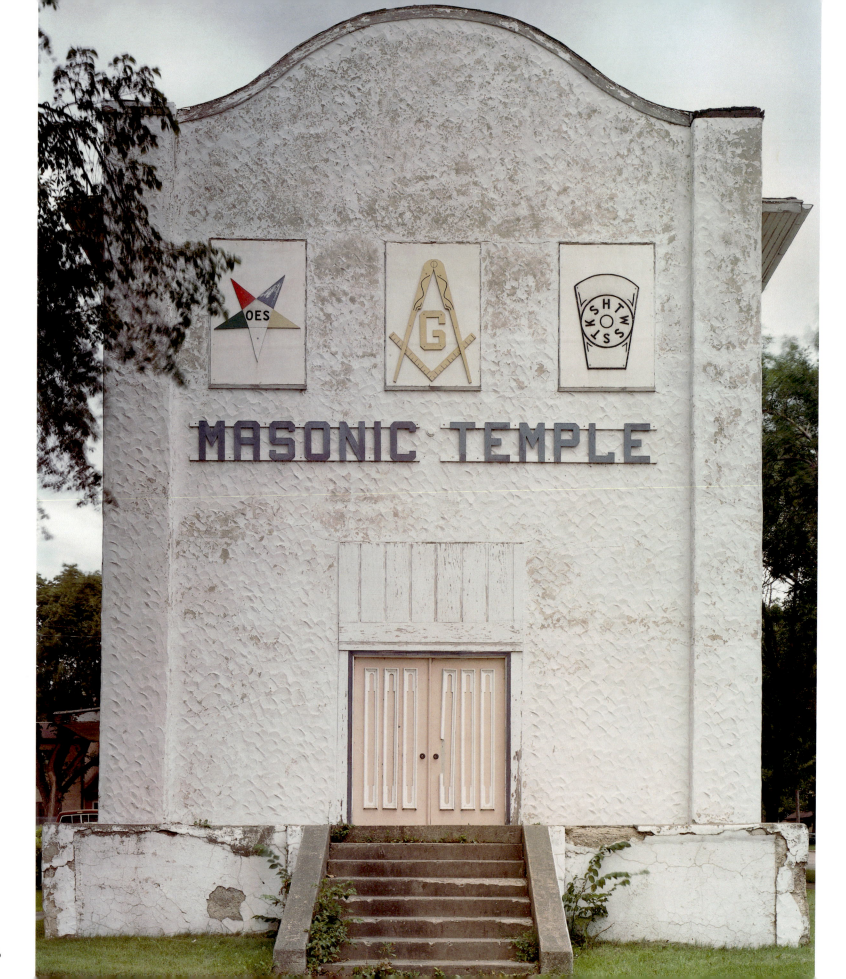

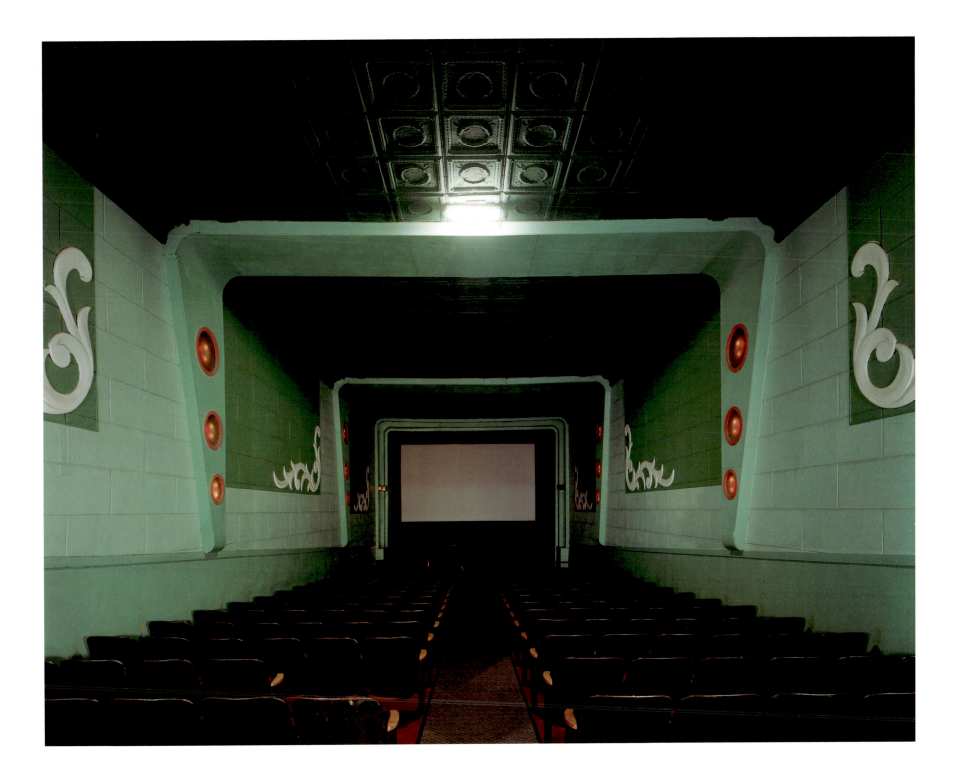

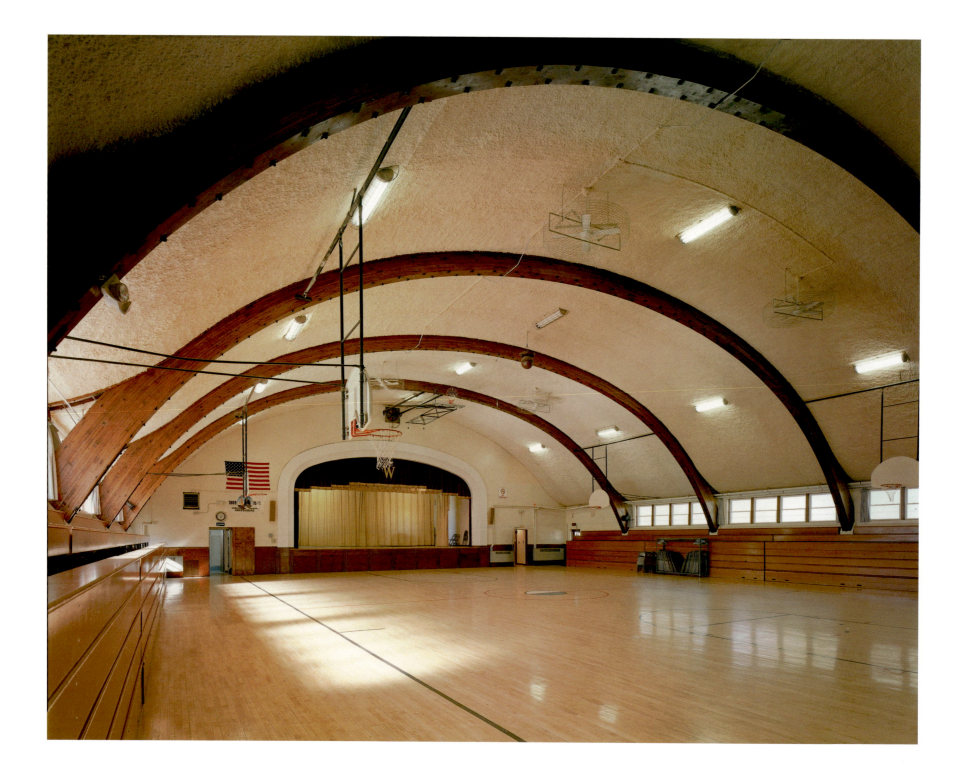

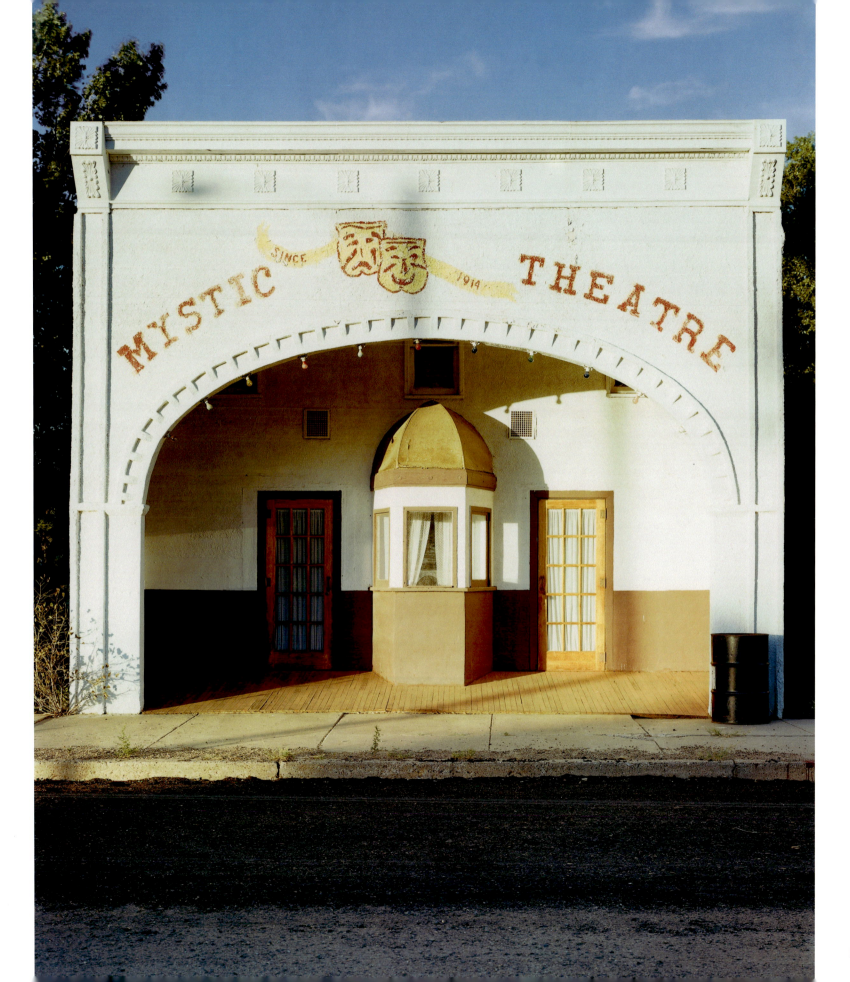

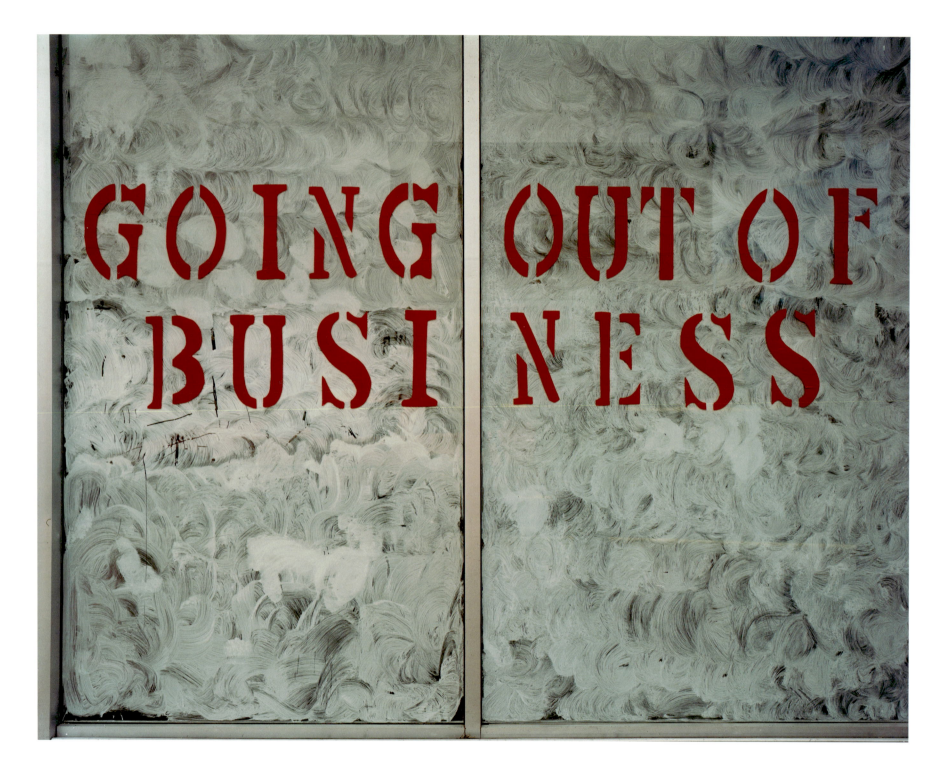

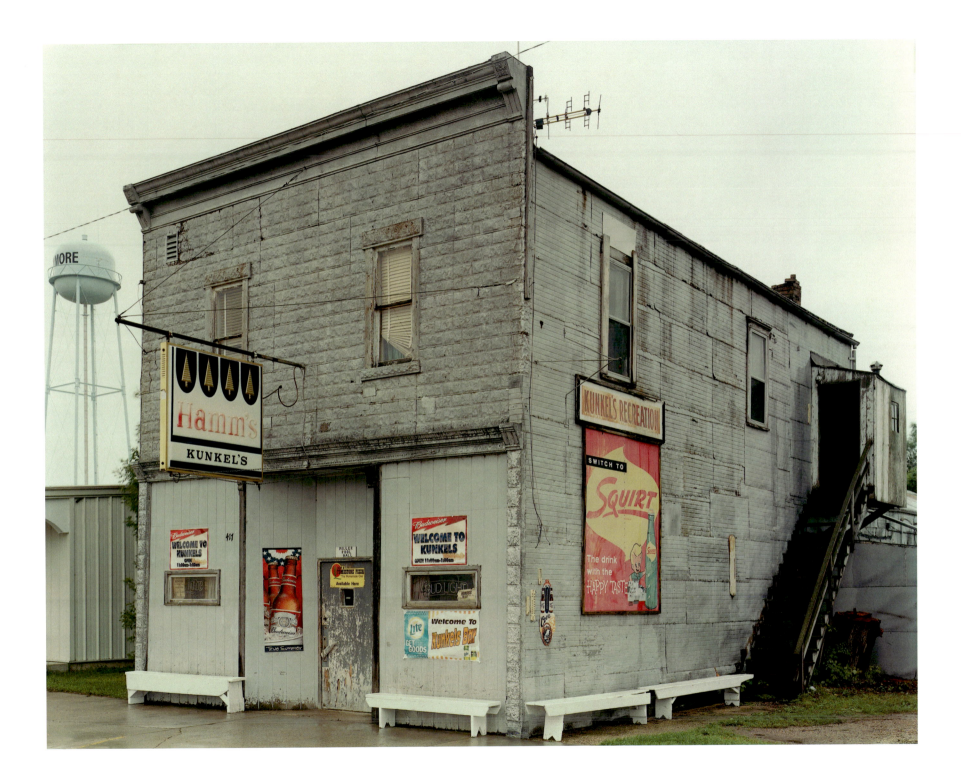

The People and their Ingenuity

From ornate spires, like those of the Warsaw cathedral jutting against the sky, to tiny cut-metal angels balanced atop iron crosses that peek out above the snow, (see Religious Life, on page 165), the need to visibly venerate and memorialize has been a continual, powerful impetus for crafting a presence in the immense North Dakota landscape.

Outsize cement bison and wooden cactuses, metal heifers and plastic Holsteins, stucco potatoes and drain pipes in the form of cans of pop, barn doorways that feature naked schoolteachers and a supper-club entrance through the maw of a ravenous walleye collectively pale as palliatives of the imagination next to palm trees and flamingos flourishing in the Upper Midwest. And while all these and other wonderful curiosities are to be found in every nook and cranny of the 70,704 square miles that encompasses North Dakota, as well as the contiguous environs of Minnesota and South Dakota, the recurrent, symbolically hardy yet realistically doomed image of the pink flamingo and the palm tree (page ii) is an all-pervading index of a definitively sublime resistance to climactic reality.

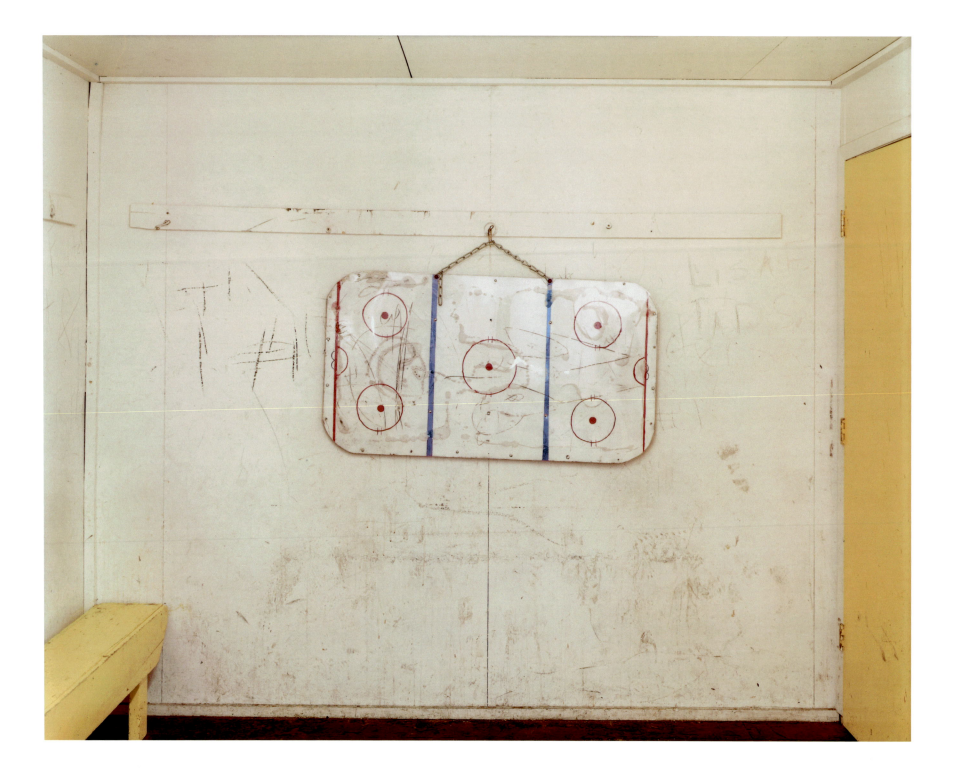

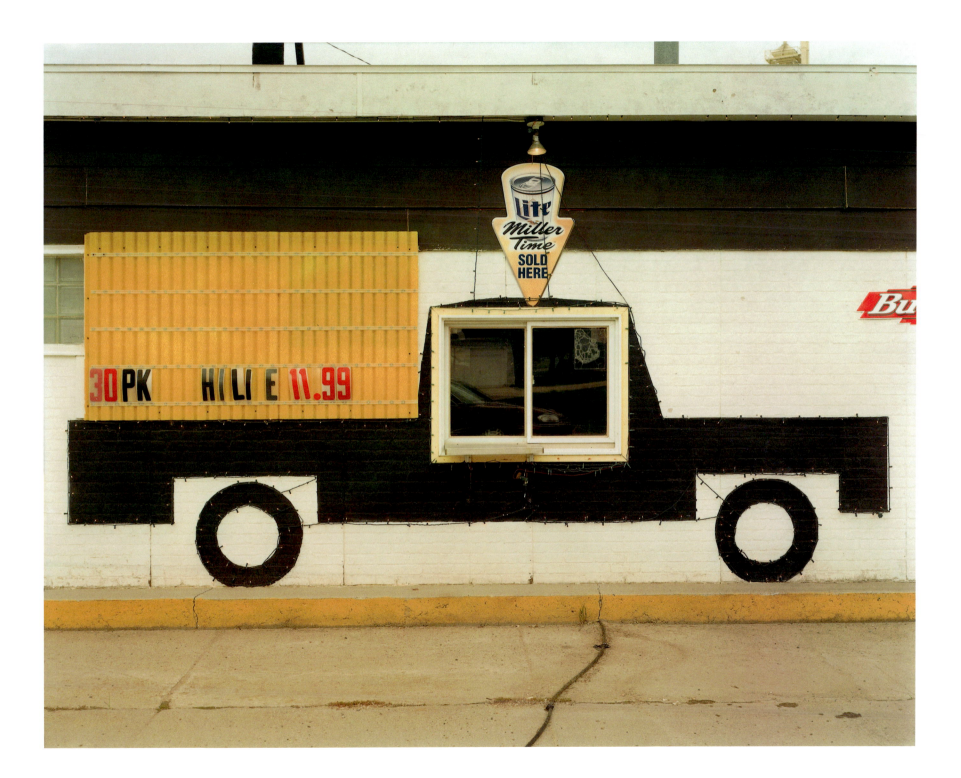

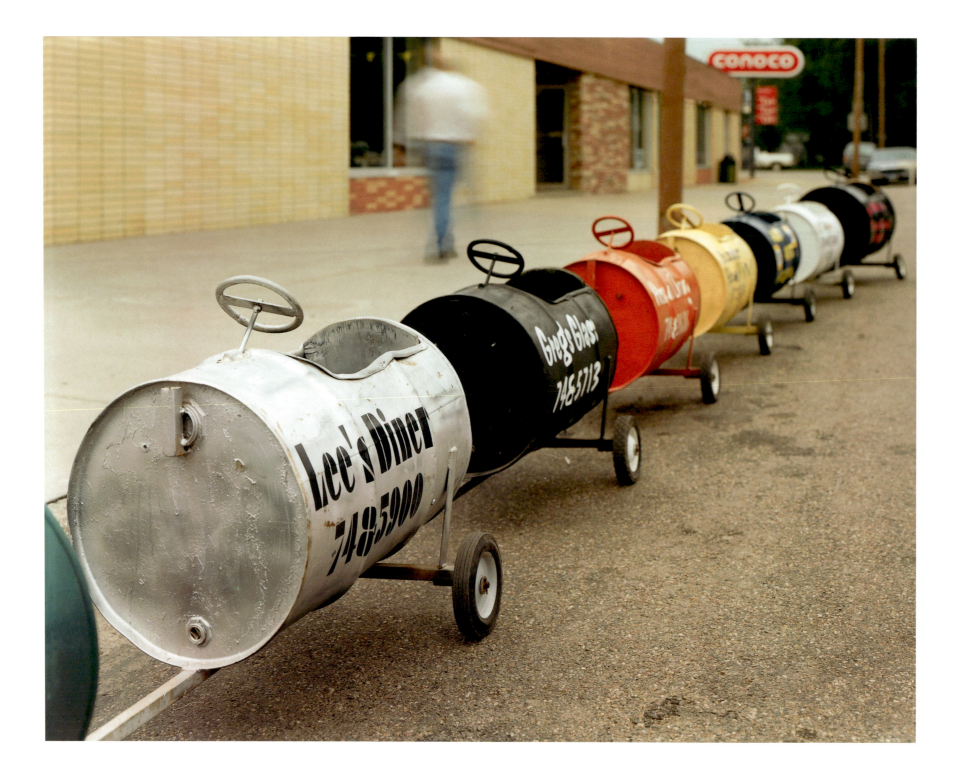

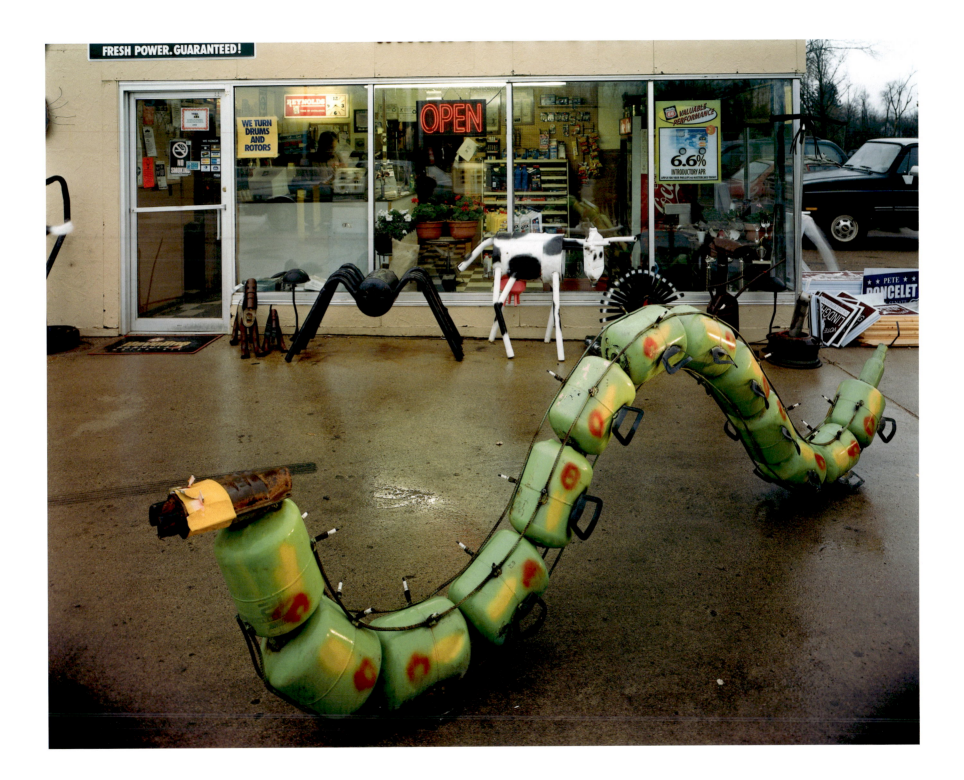

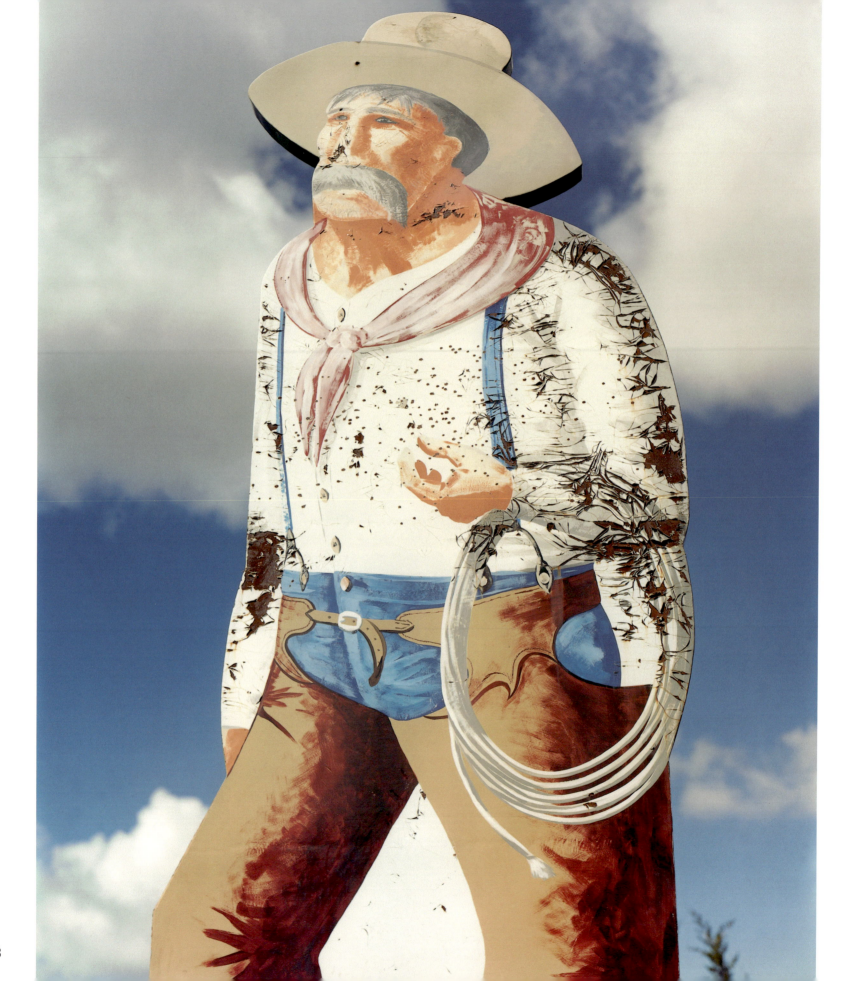

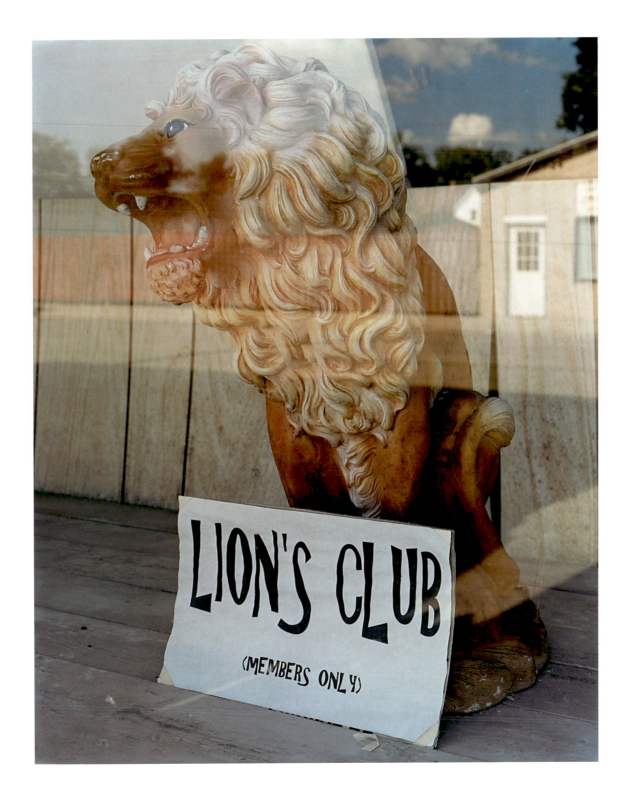

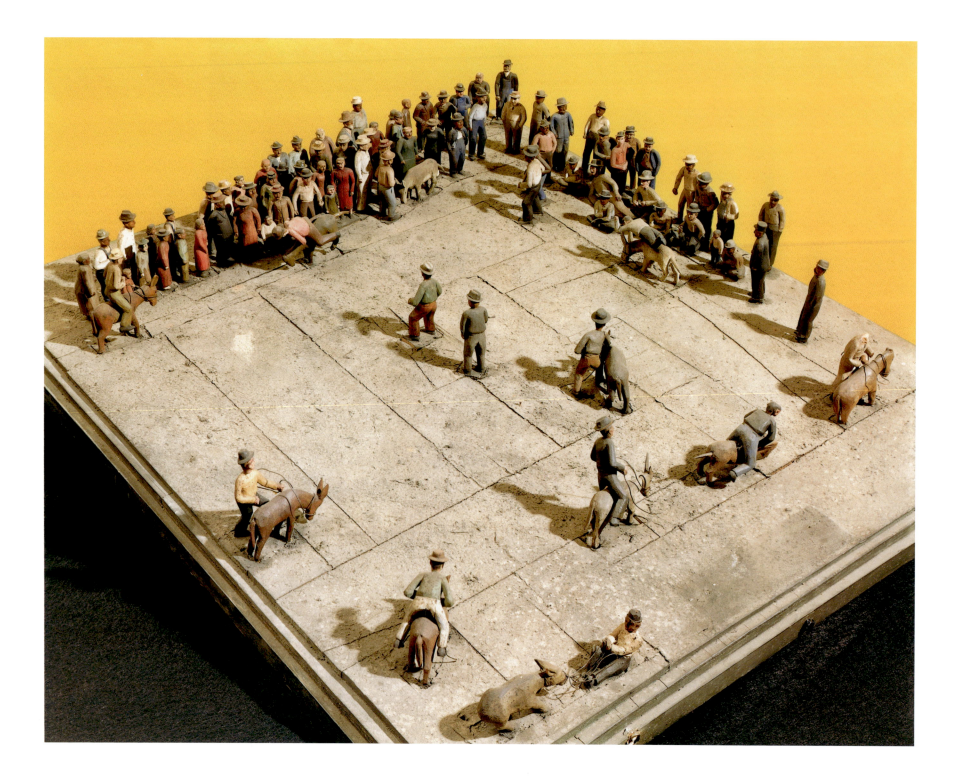

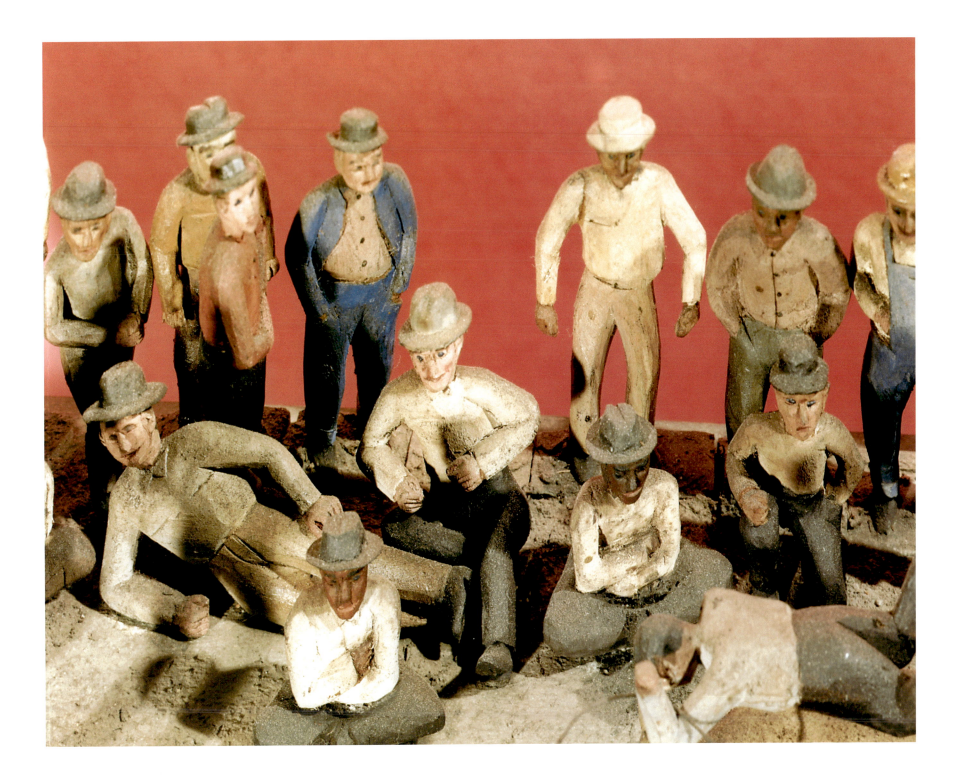

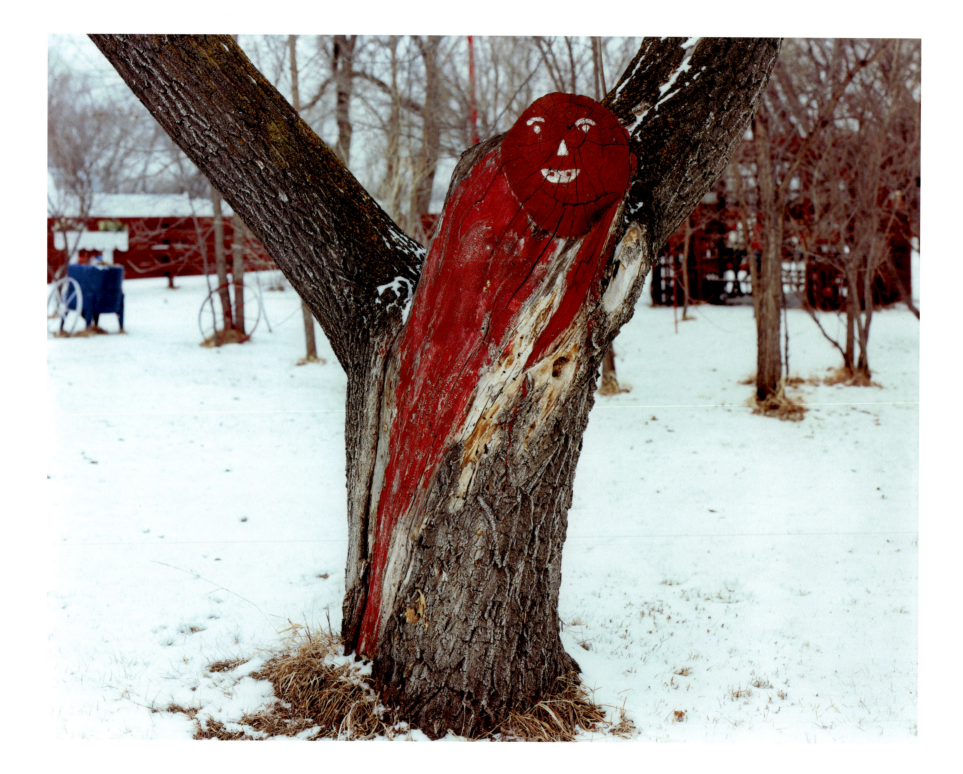

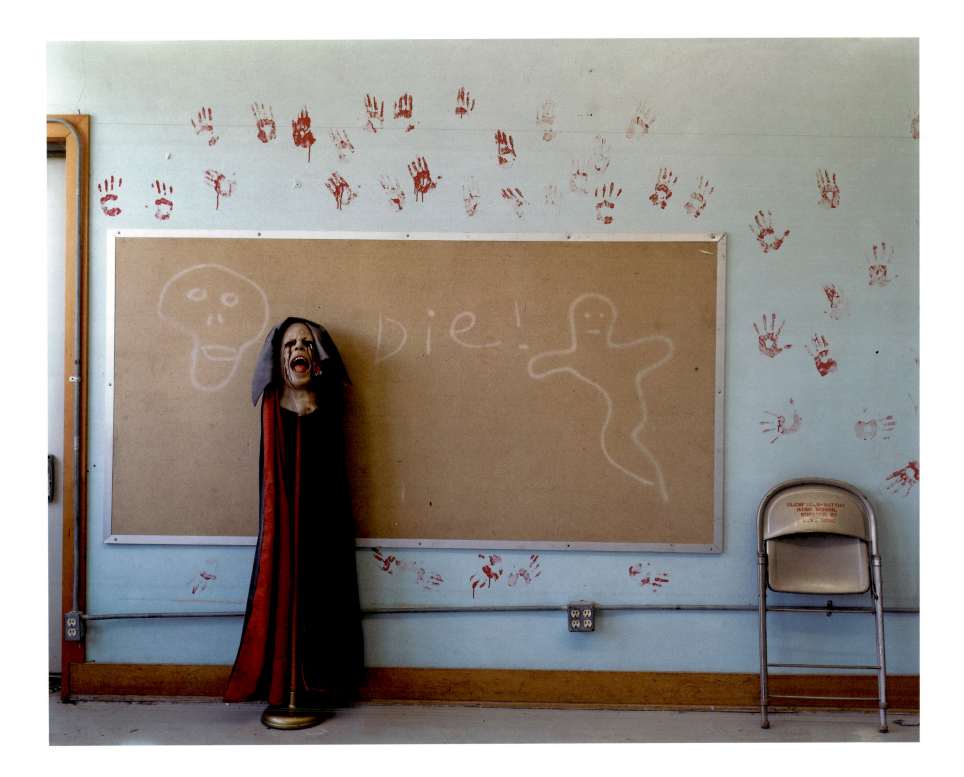

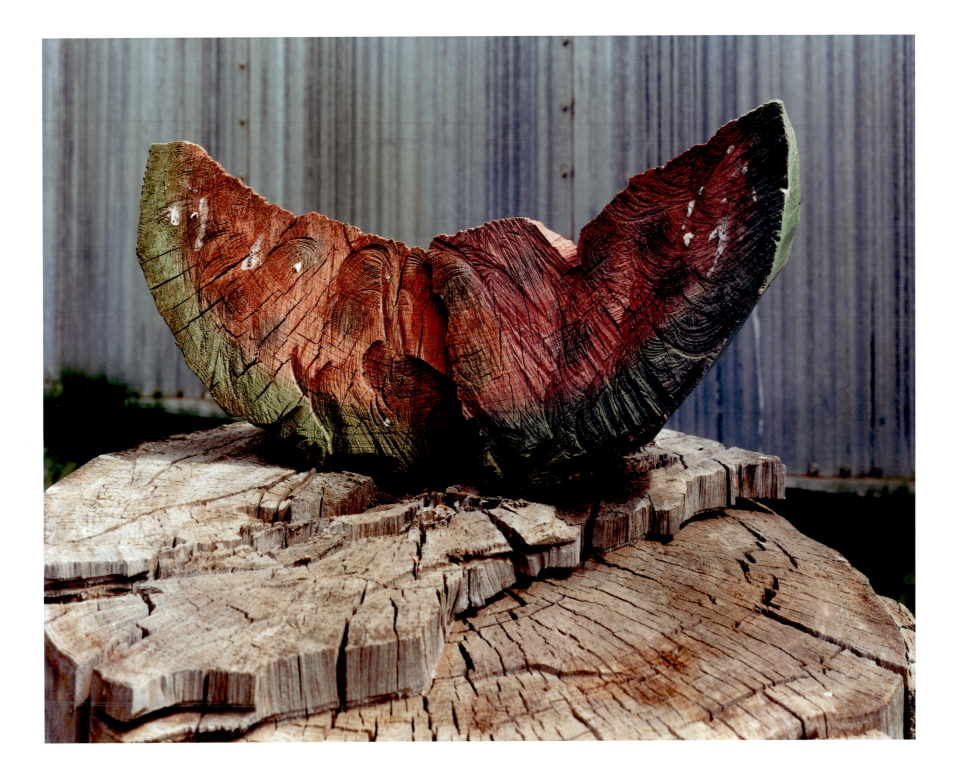

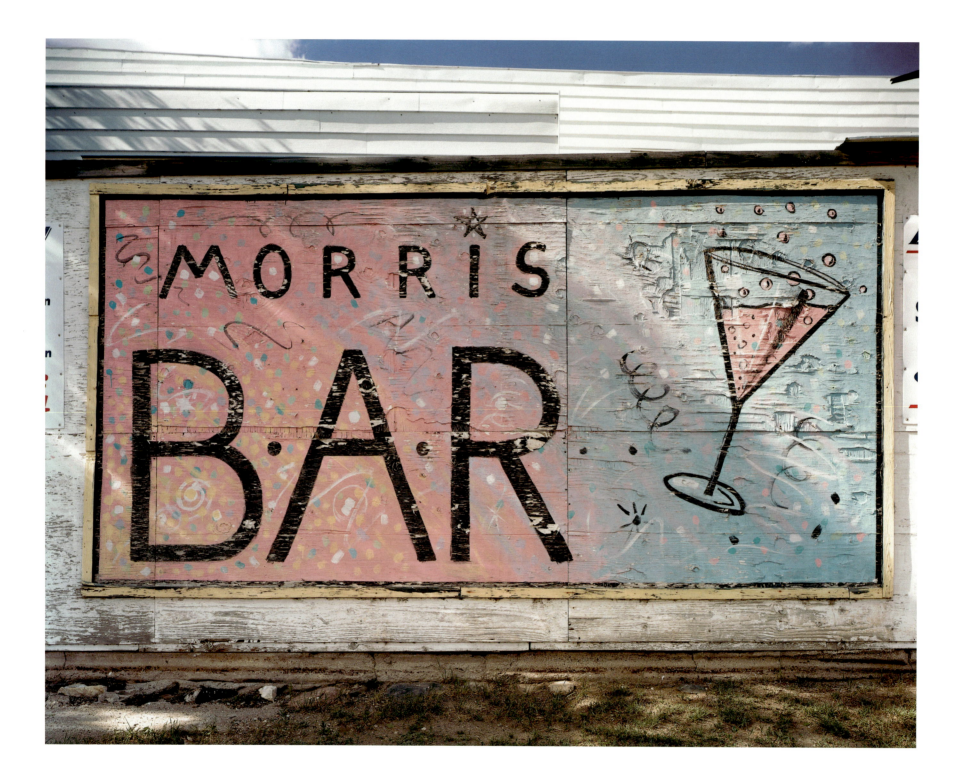

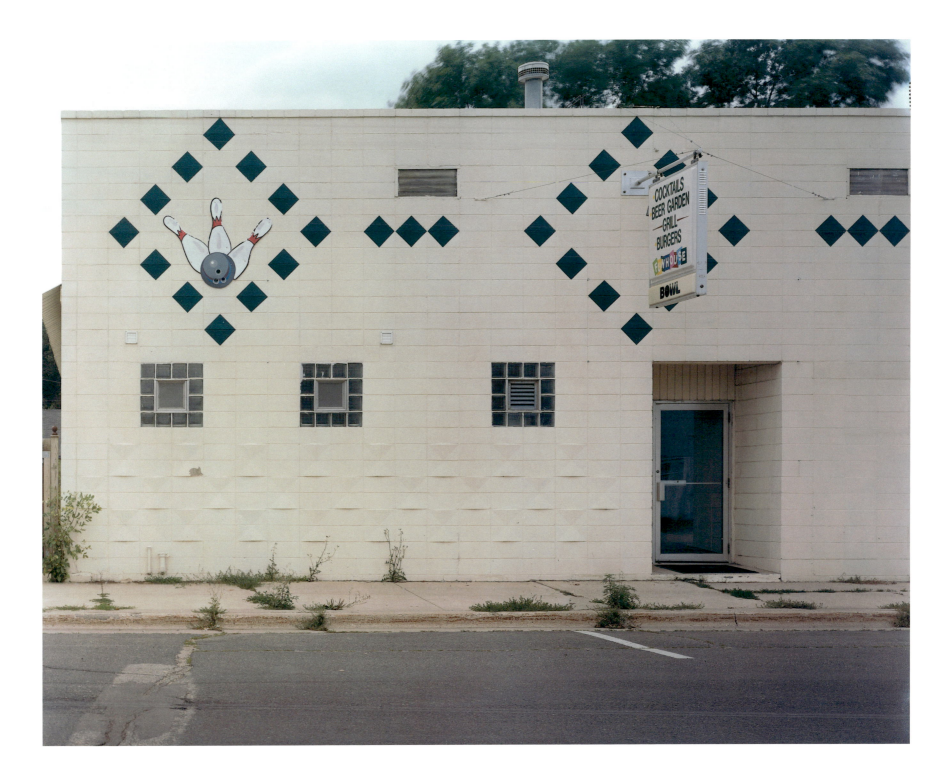

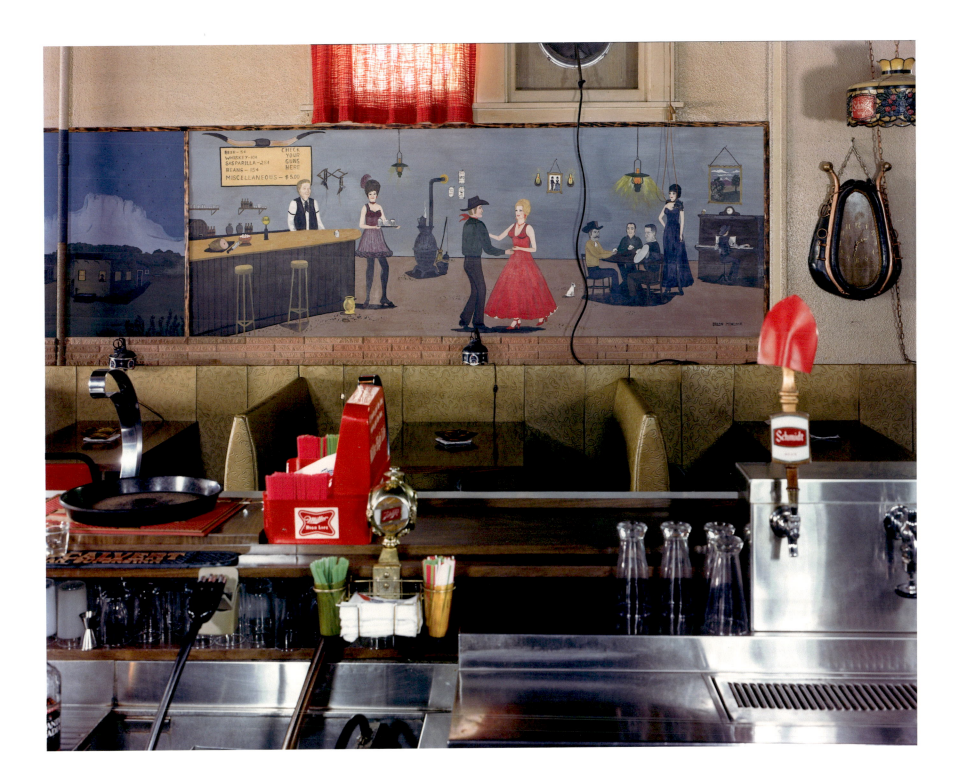

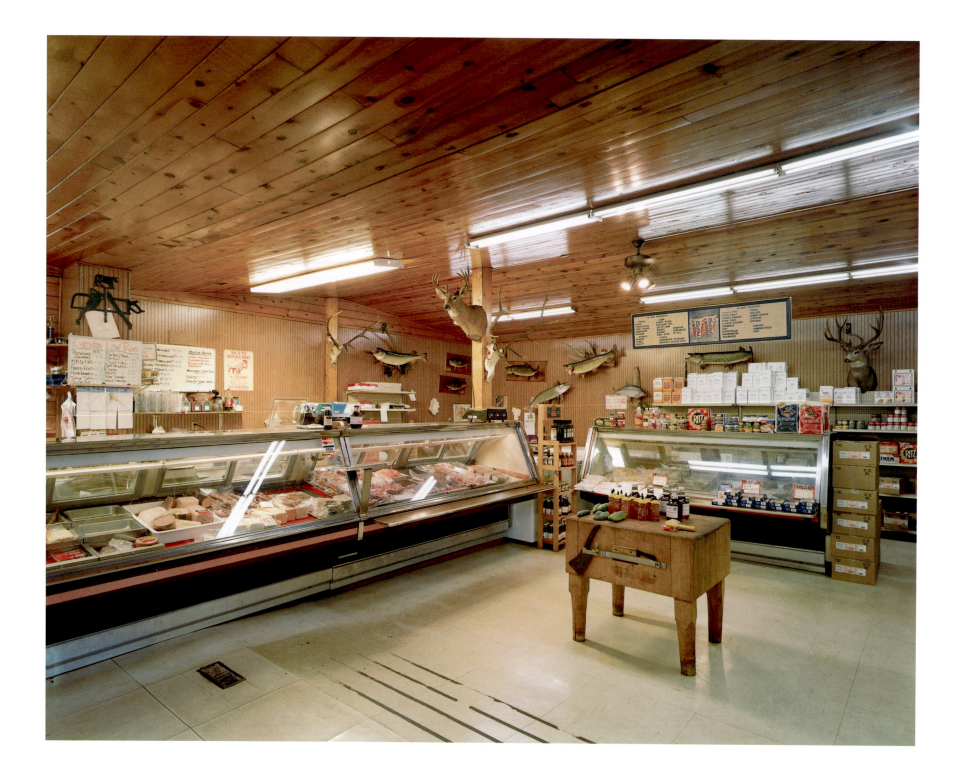

130

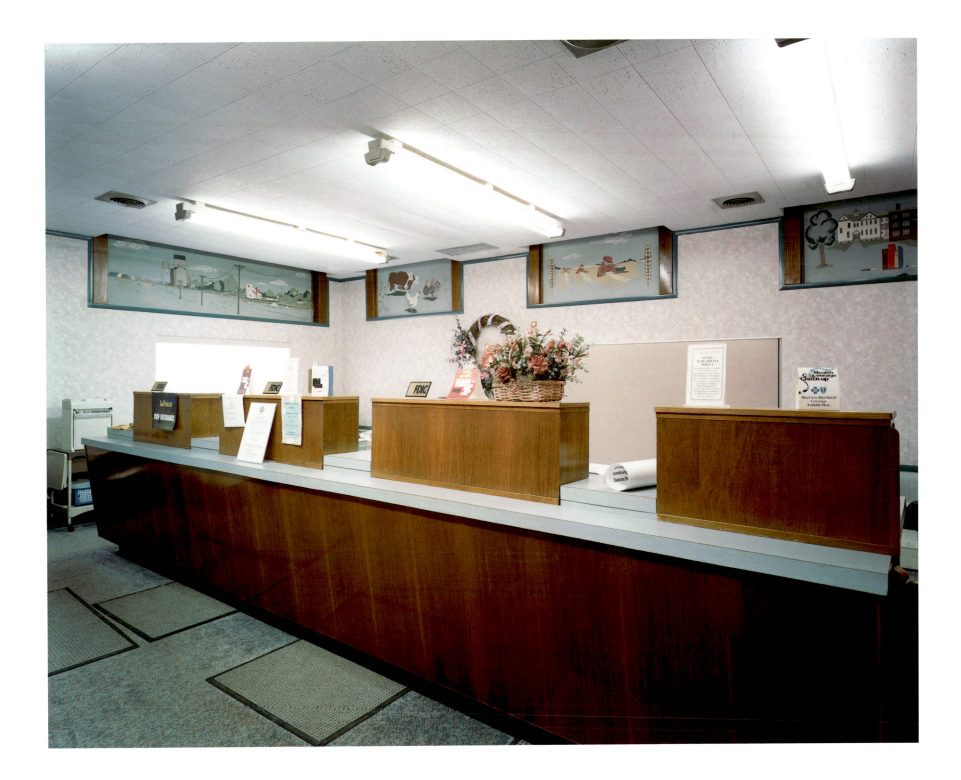

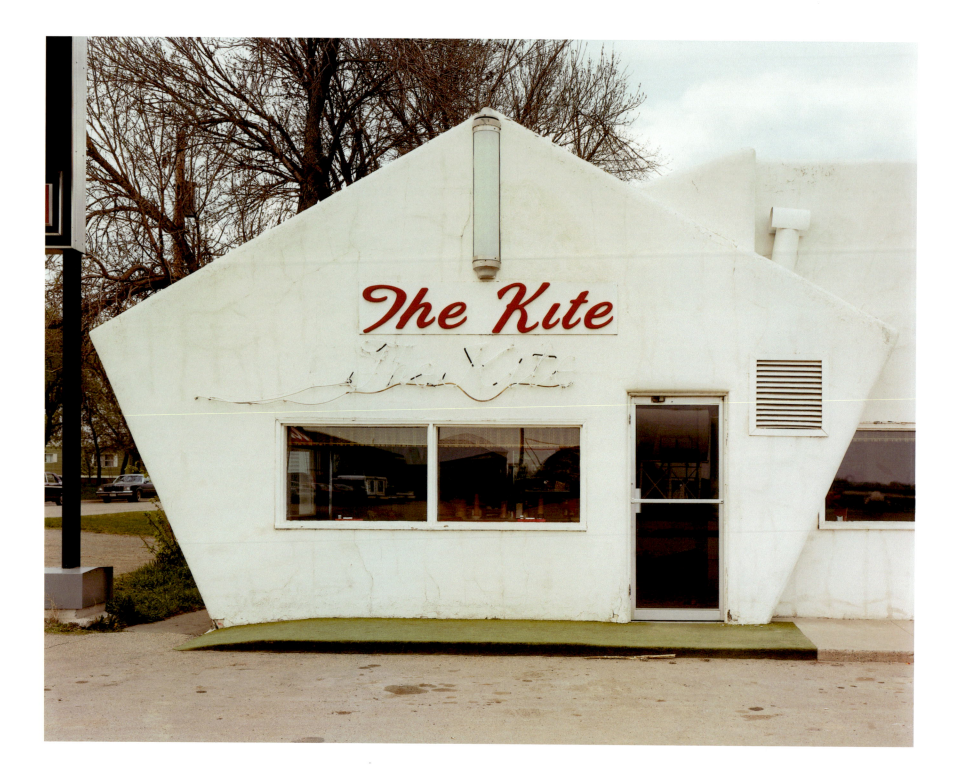

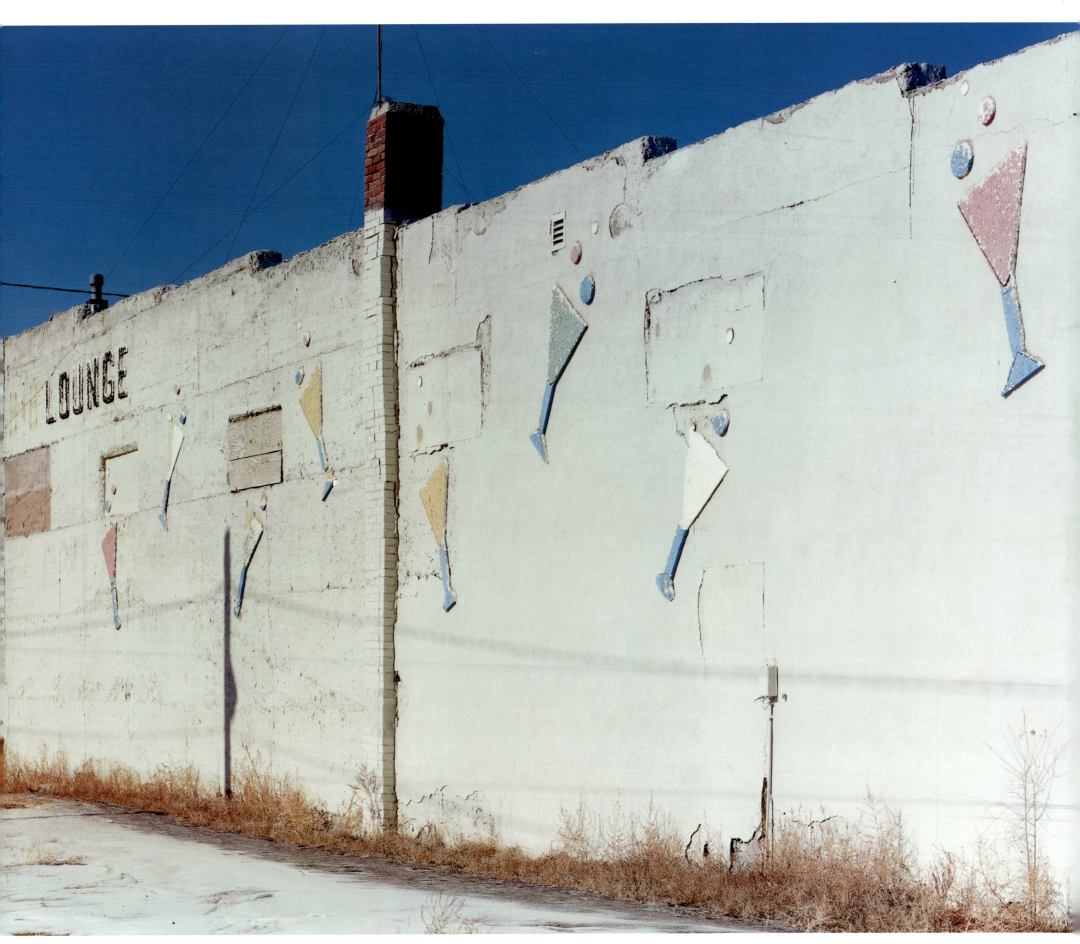

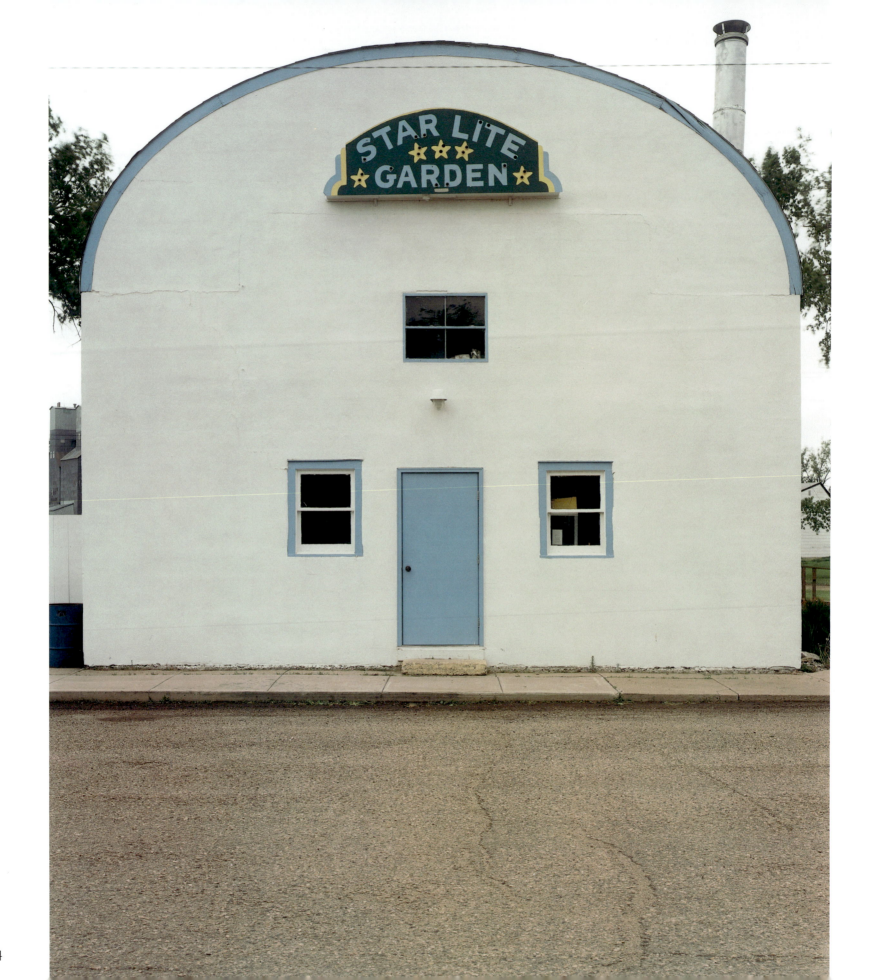

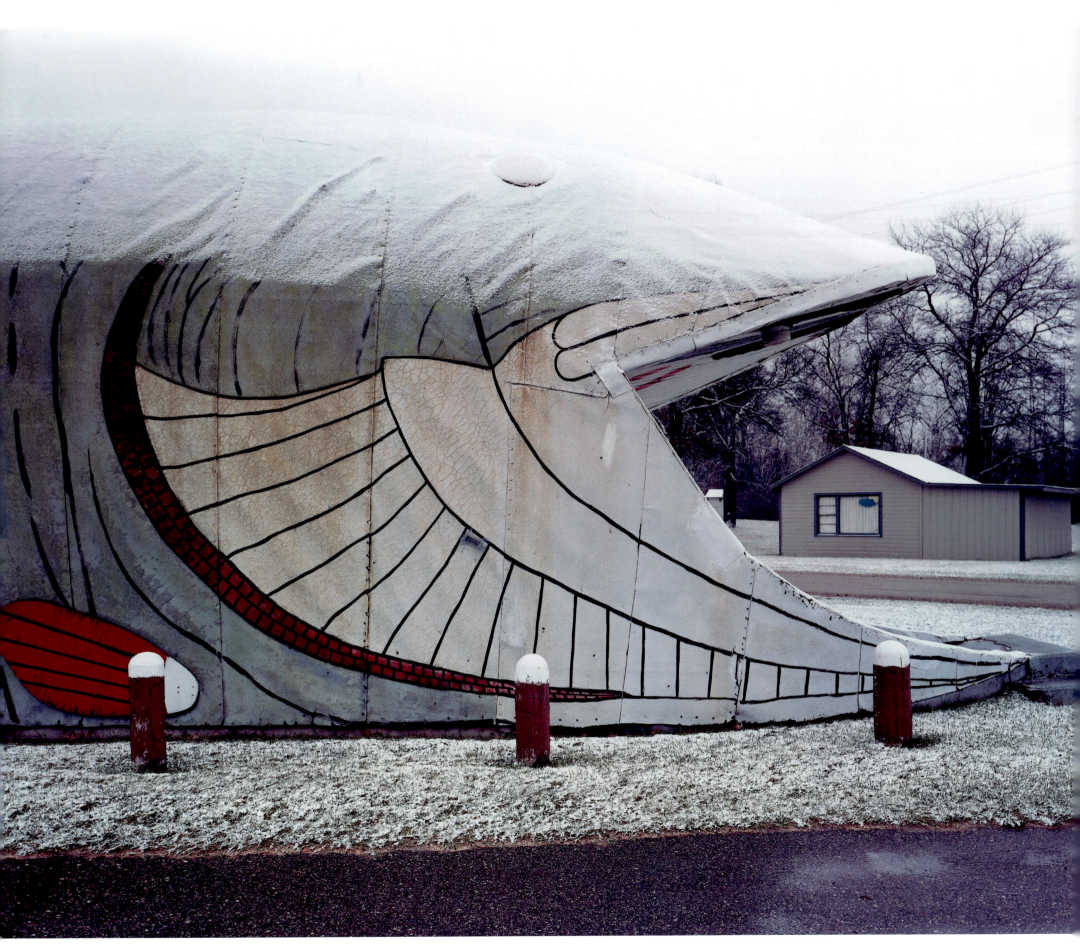

135

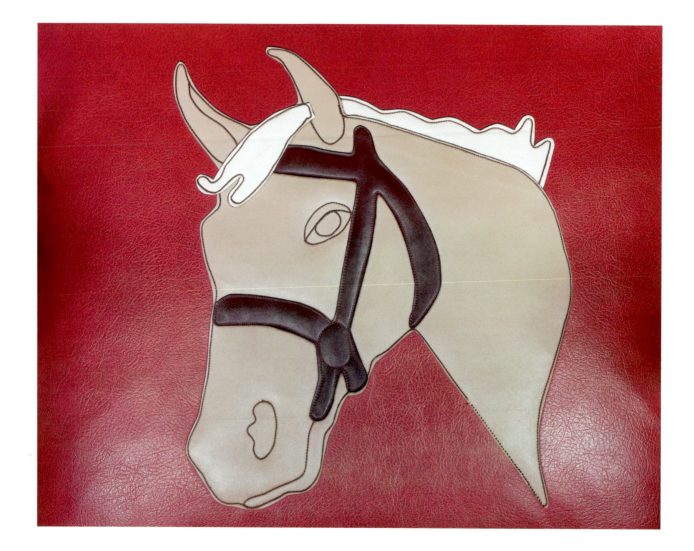

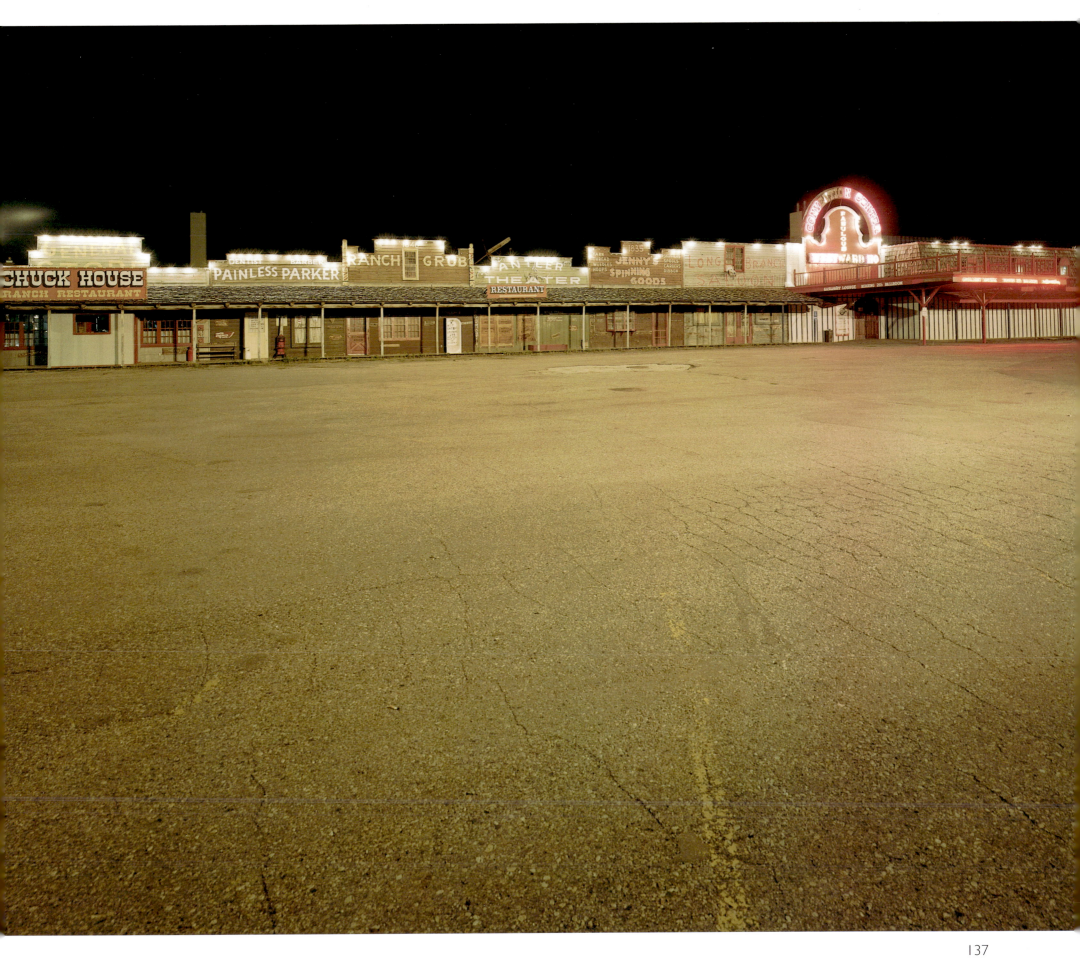

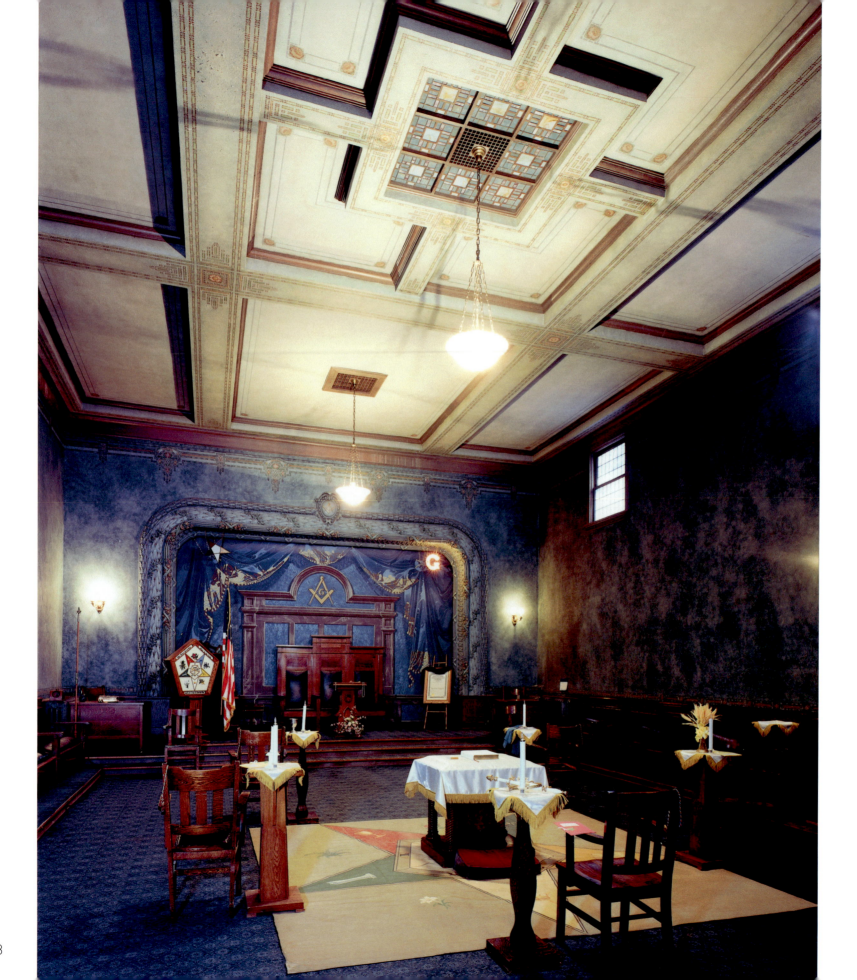

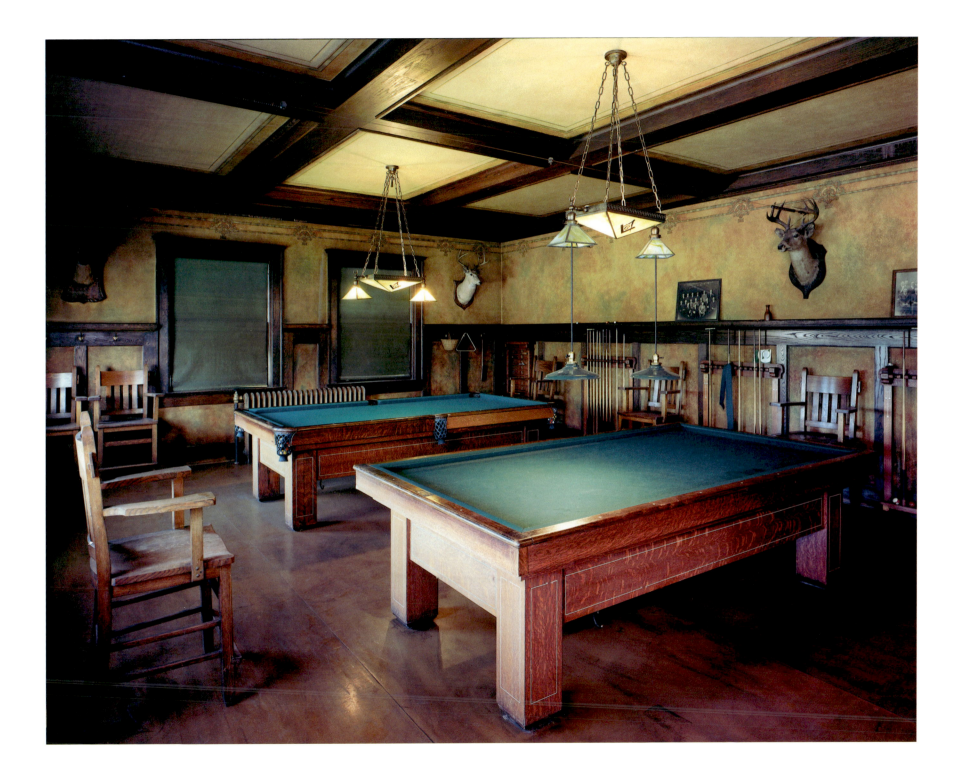

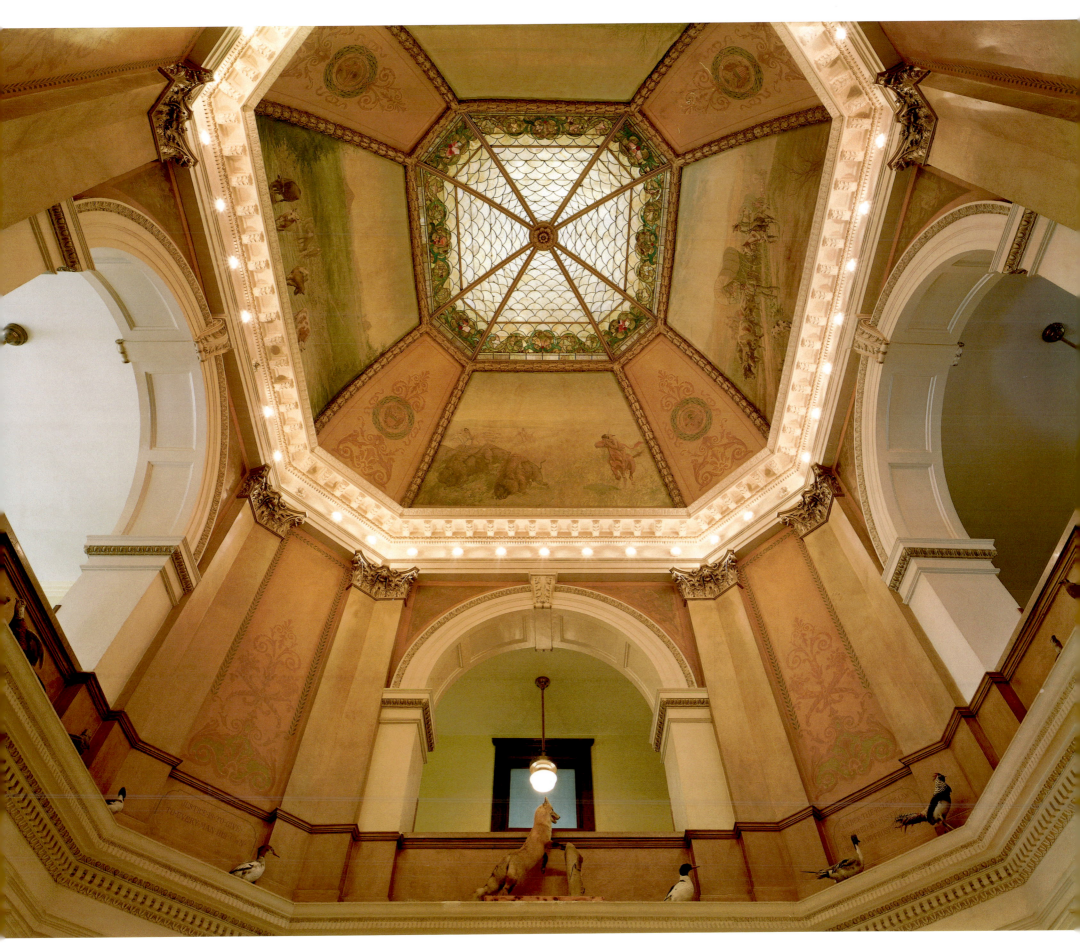

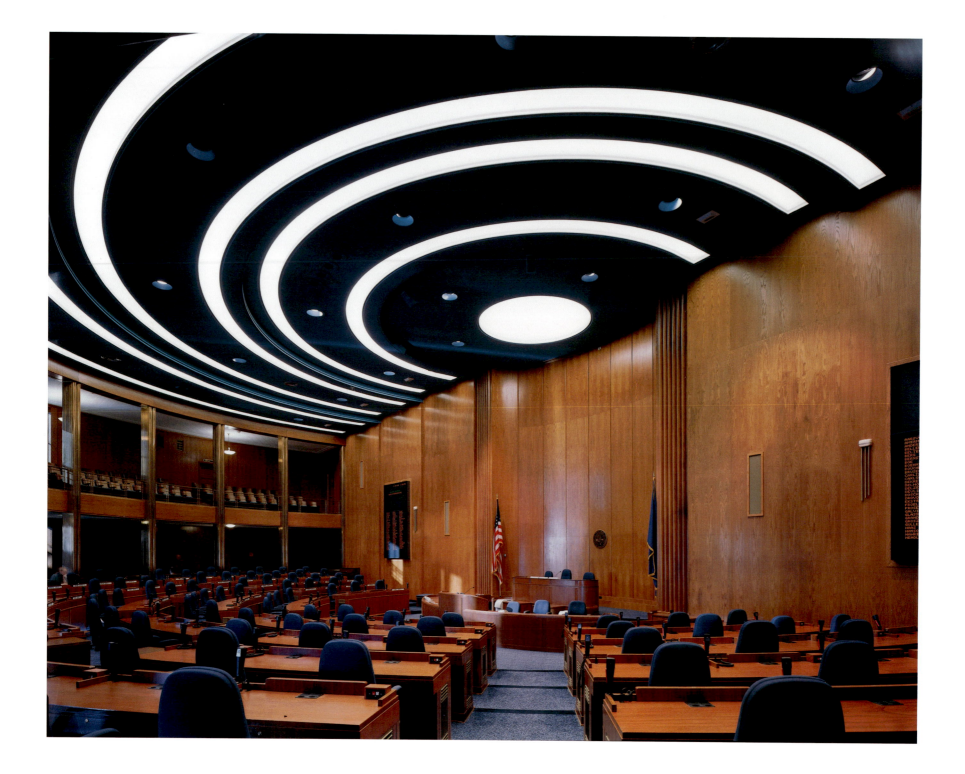

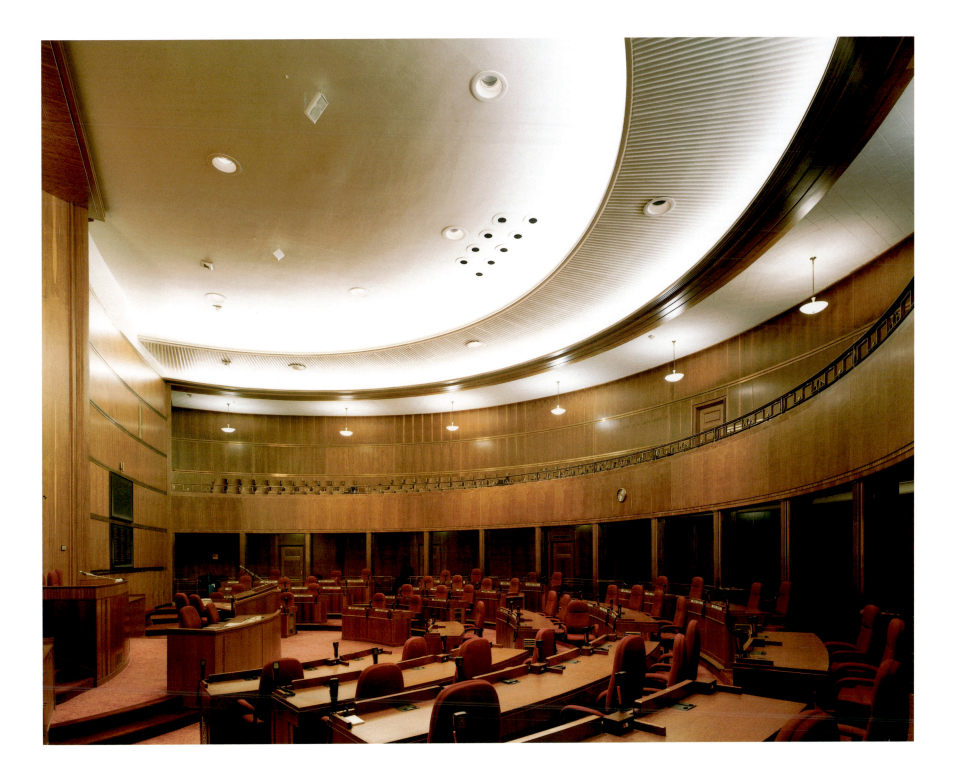

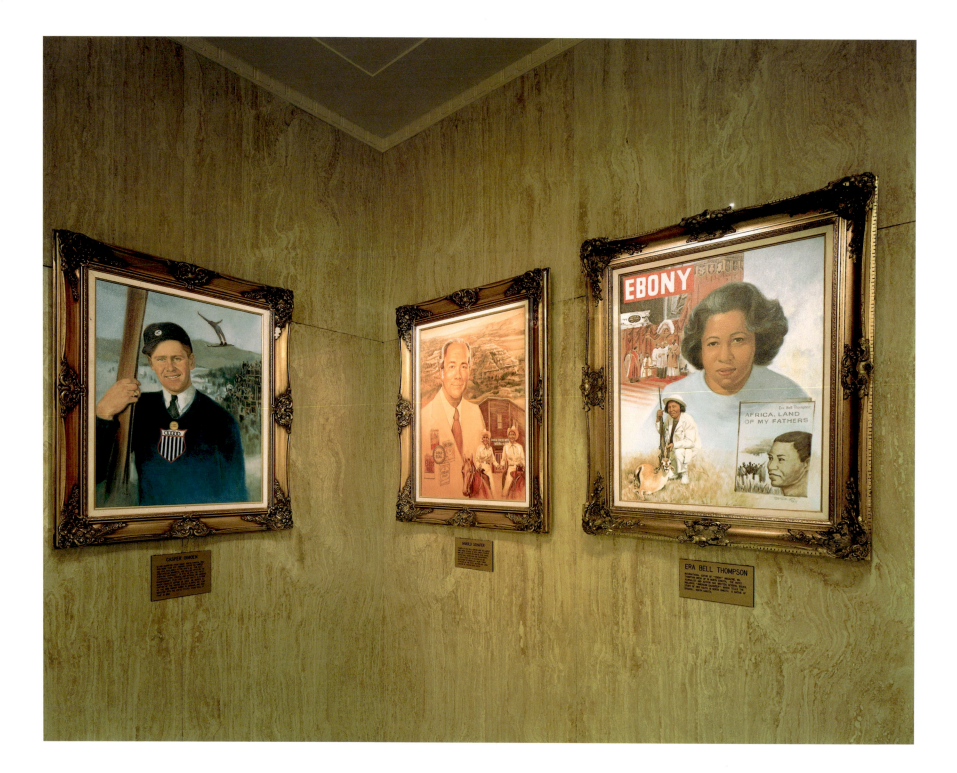

The Seasons

Spring In addition to placing objects on the land itself, North Dakotans often create competitions that celebrate the inexorably slow passage of the seasons. There are raffles to guess the number of inches of rainfall over a harvest cycle, lotteries regarding the depth of a winter's worth of snow, sweepstakes on the number of goals the University of North Dakota hockey team might score over a full campaign. For a number of years, the boosters of Max have sought to raise funds for local projects by setting a section of highway culvert pipe, wrapped in the banner of the sponsoring soft drink brand, in the middle of a frozen pond by highway US 83. Starting a few days after New Year's, people place bets at the nearby Texaco station as to when the faux pop container might sink into the slowly thawing ice, serving as an outsized harbinger of spring.

Summer In the city, the term "harvest" often calls up images of chilly nights, pumpkin zombies, decorative dried corn cobs, and other autumnal icons. But in North Dakota the first growth of hay matures in the midst of high summer with alfalfa getting cut three times between June and August. Passages of the harvest season become visible in a variety of ways. Huge bailers chug along in the sunset's gloom—sometimes using the global positioning system—in their race to finish haying by the end of July. On the rolling ranchlands of the western half of North Dakota, the season is often acknowledged by assembling multiple hay bales into sculpture and placing them in a conspicuous spot, usually along the highway. These can be as fanciful as an outsized Raggedy Ann and Andy or as practical as a John Deere tractor, made completely to scale.

Fall Drivers in the Red River valley take particular care in September when fully laden potato trucks speed between fields and warehouses. What were section-sized tapestries of yellow sunflowers in the summer become acres of seedless, drooping hulks during October. In November, the curtain rings down with the incongruous sight of mountains of sugar beets, humming air conditioners at their cores to prevent spontaneous combustion within.

Winter The eastern quarter of North Dakota is as fine a spot for farming as exists in the world, sharing that appellation with places such as the pampas of Argentina, the grasslands of Brazil, or the breadbasket of the Ukraine. Part of the reason for the astonishing fertility of the region is that much of it lies on a gigantic glacial lake bed that has served to collect and mix rich, finely ground mineral deposits with centuries of decaying vegetation to continually enrich dark, fecund topsoil. Row upon row of WPA-planted shelterbelts have helped to minimize the losses from the incessant wind, but when winter arrives their naked branches offer scant protection. Because of the low temperatures and humidity, the snow is often as light and powdery as the loose soil. Gusting, swirling winter winds pick up and combine the two elements to create a microscopically pulverized, airborne emery board called "snirt," a regional term derived from snow and dirt, much as smoke and fog combine to form "smog."

Wind-driven snirt can penetrate a keyhole, sweep under a front door, or invade the workings of an air-conditioning unit in a nanosecond. The rasping, ultimately debilitating powder can foul an engine, wreck the finish on floors and furniture, or coat the clothing of the hapless occupant of the windward side of a car, creating a fluffy, frigid, latte-colored half-parka of snow and dirt.

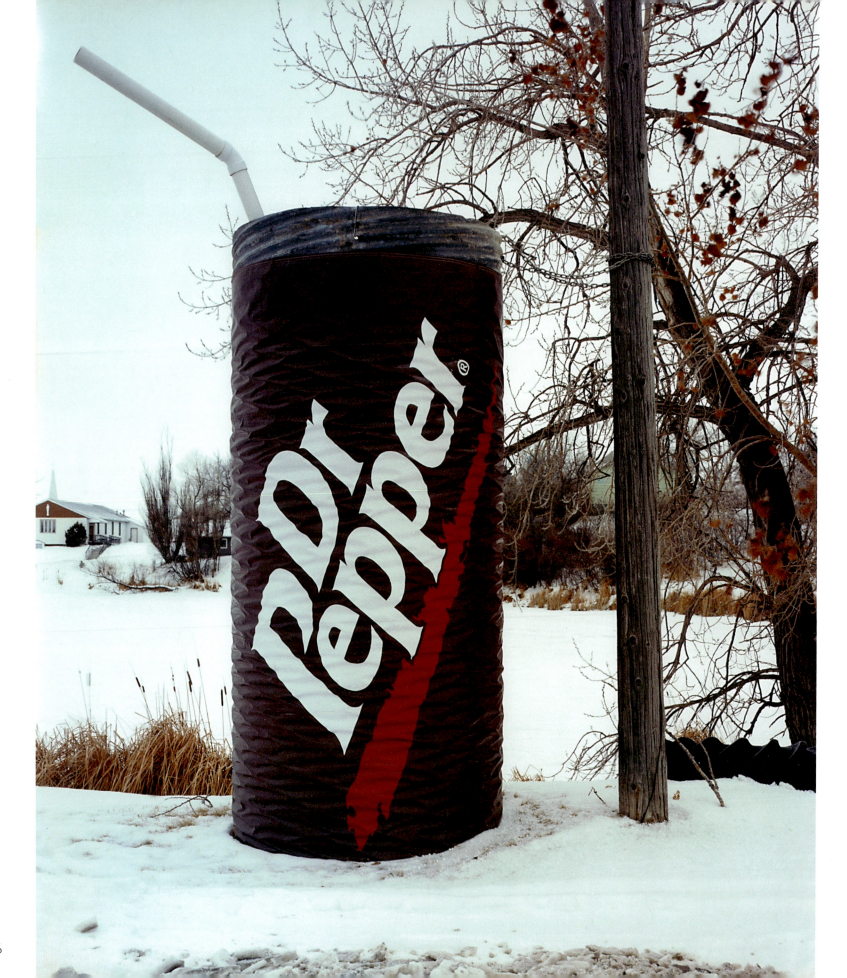

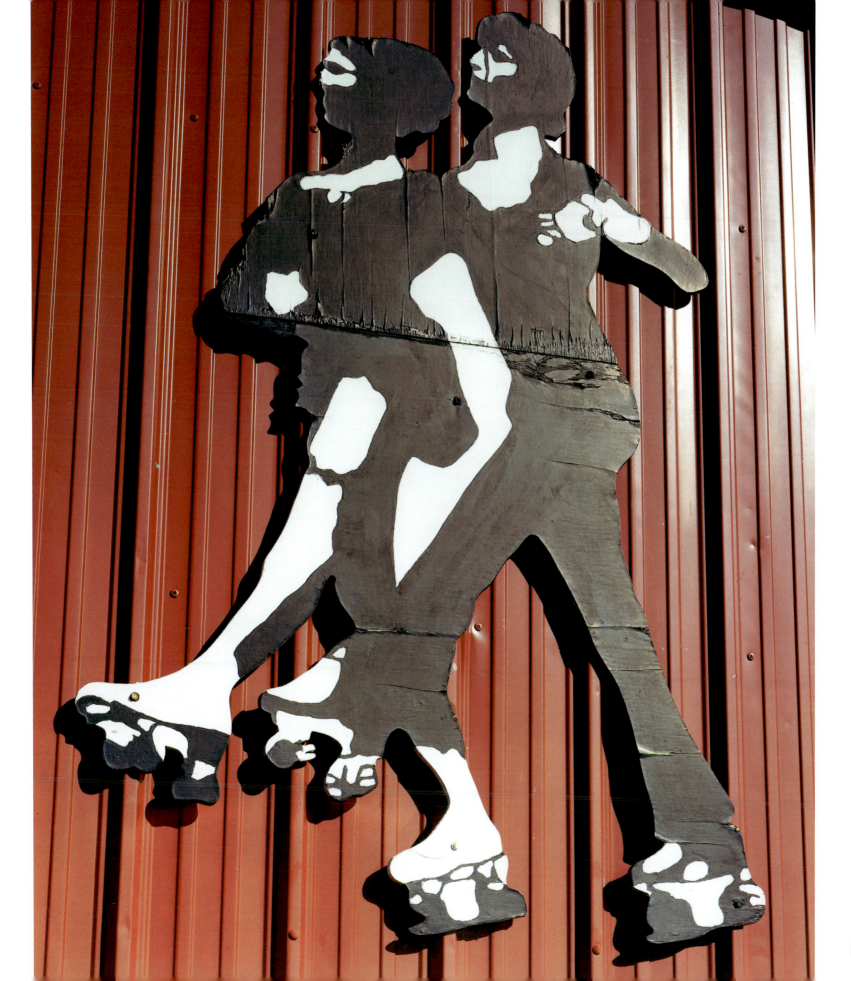

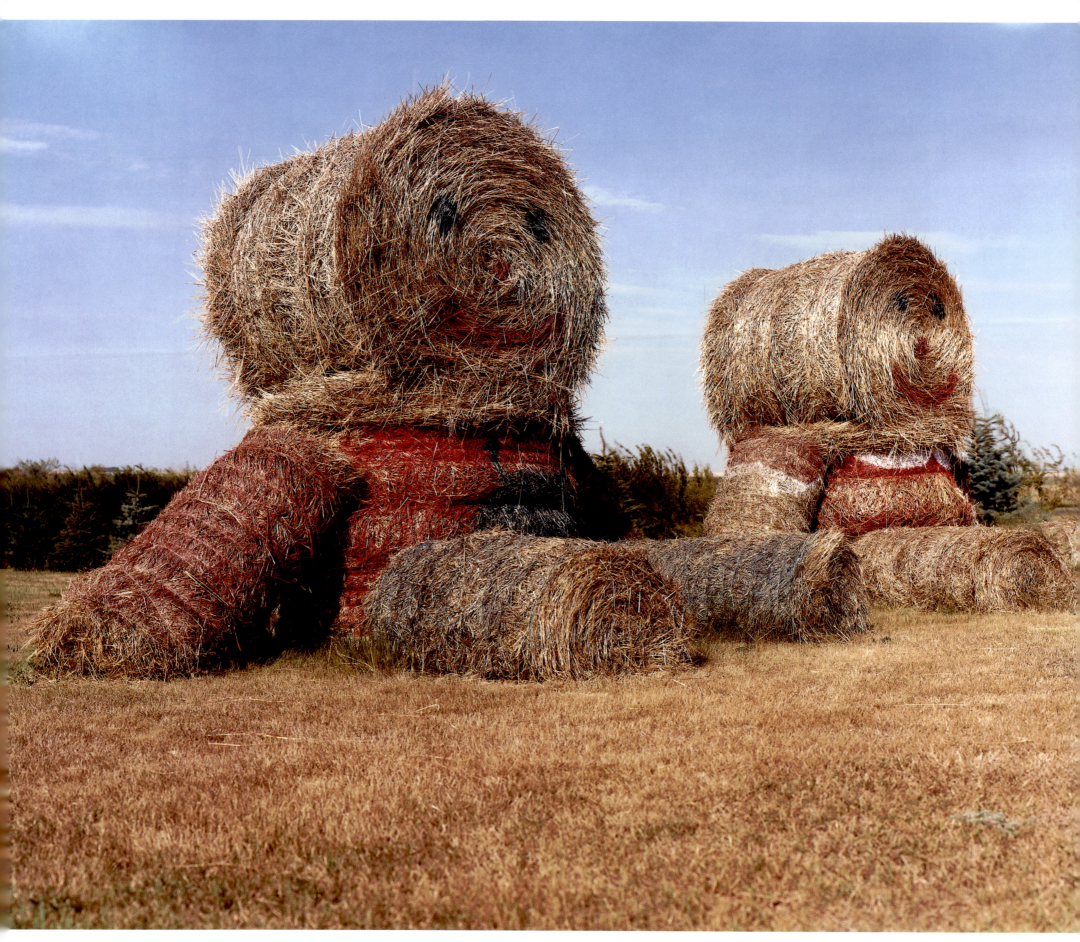

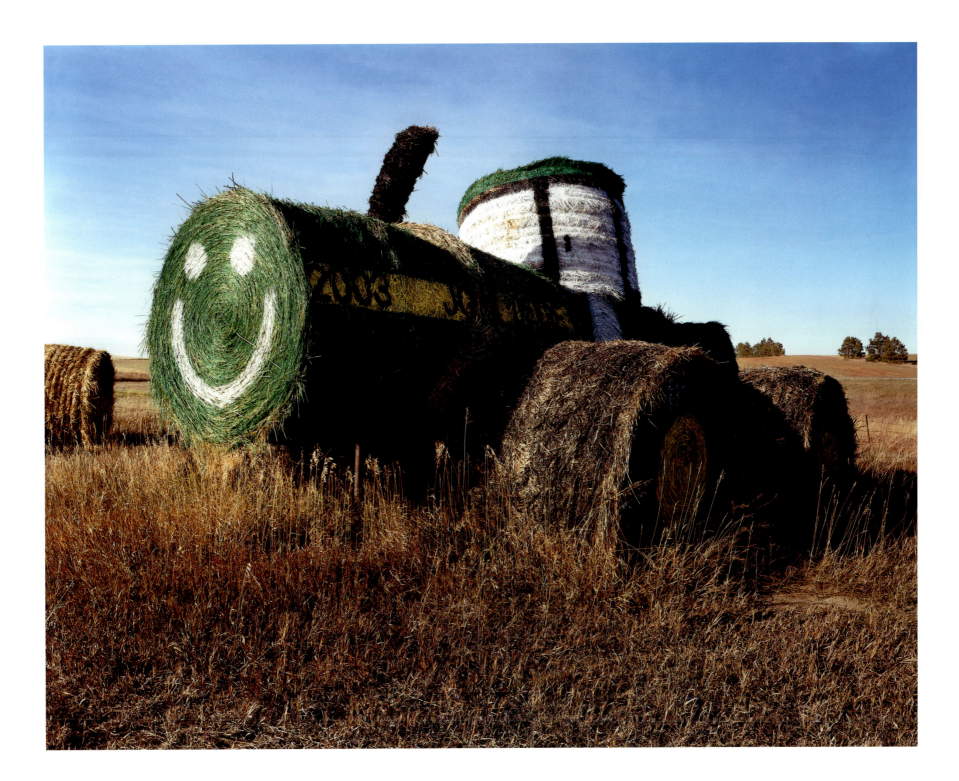

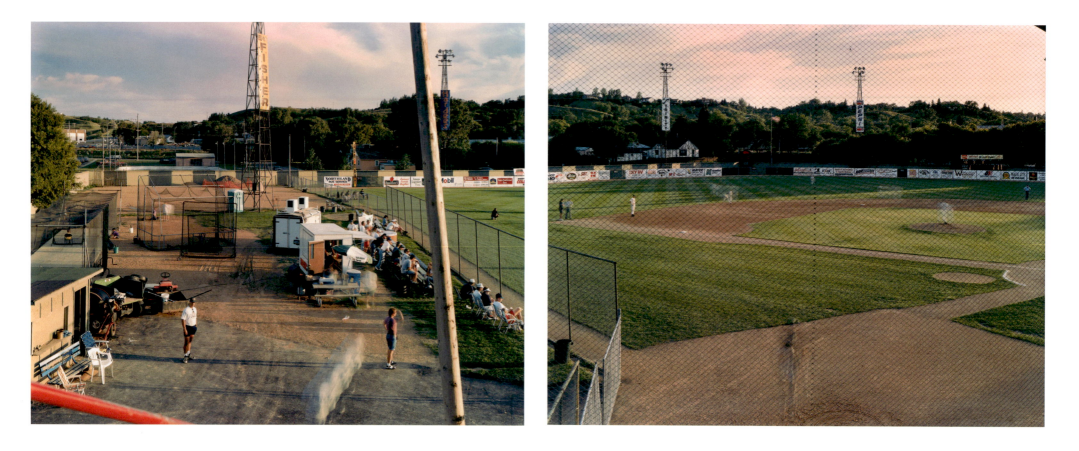

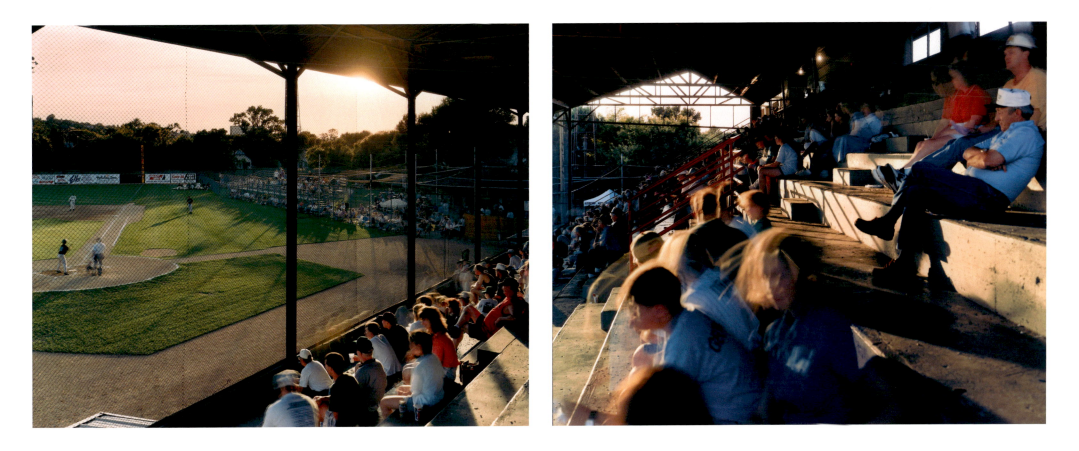

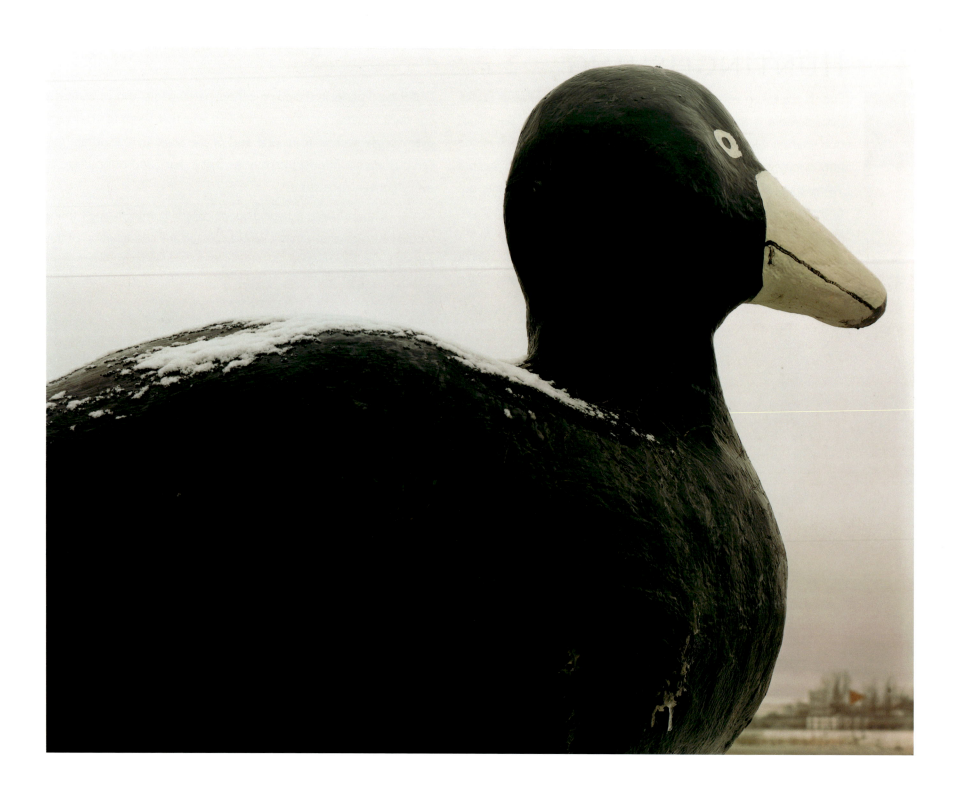

156

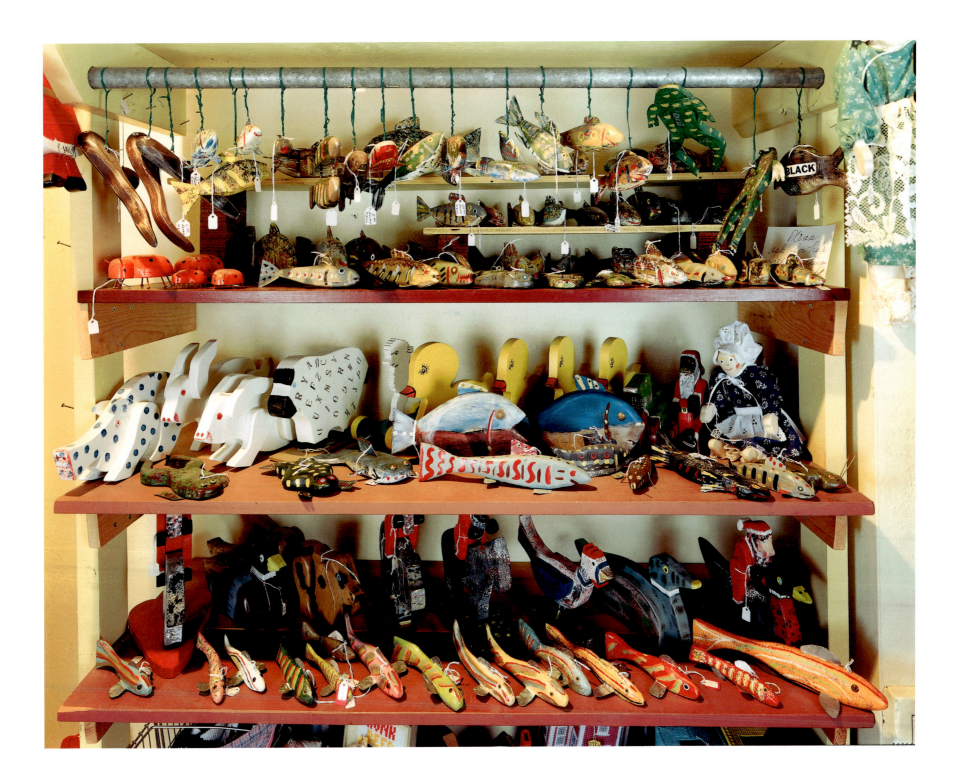

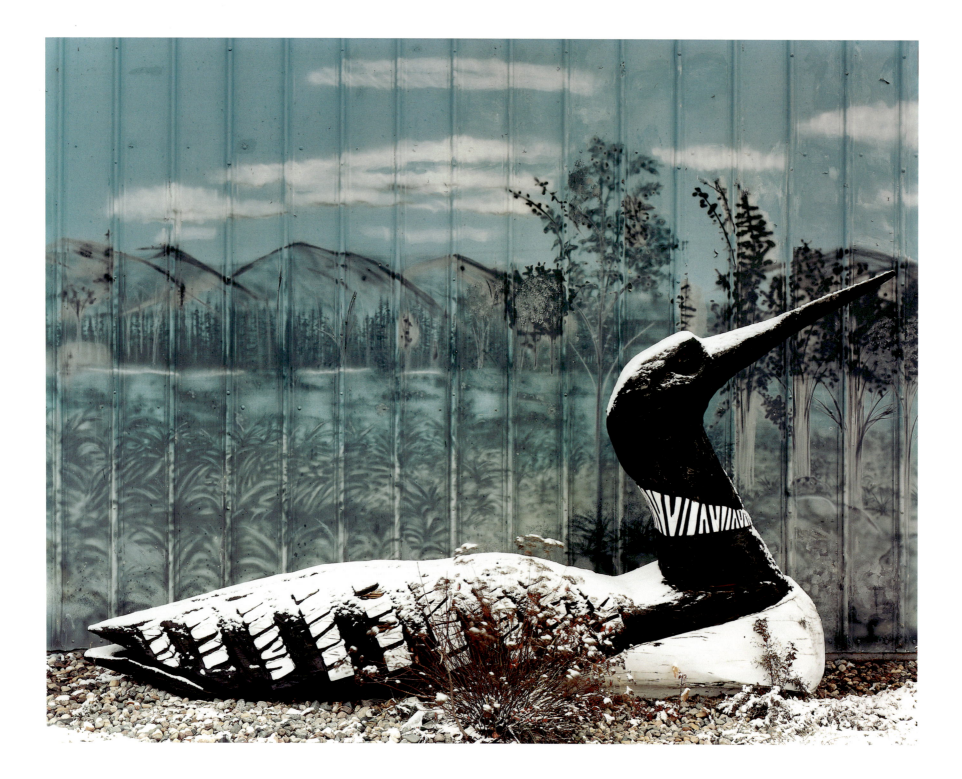

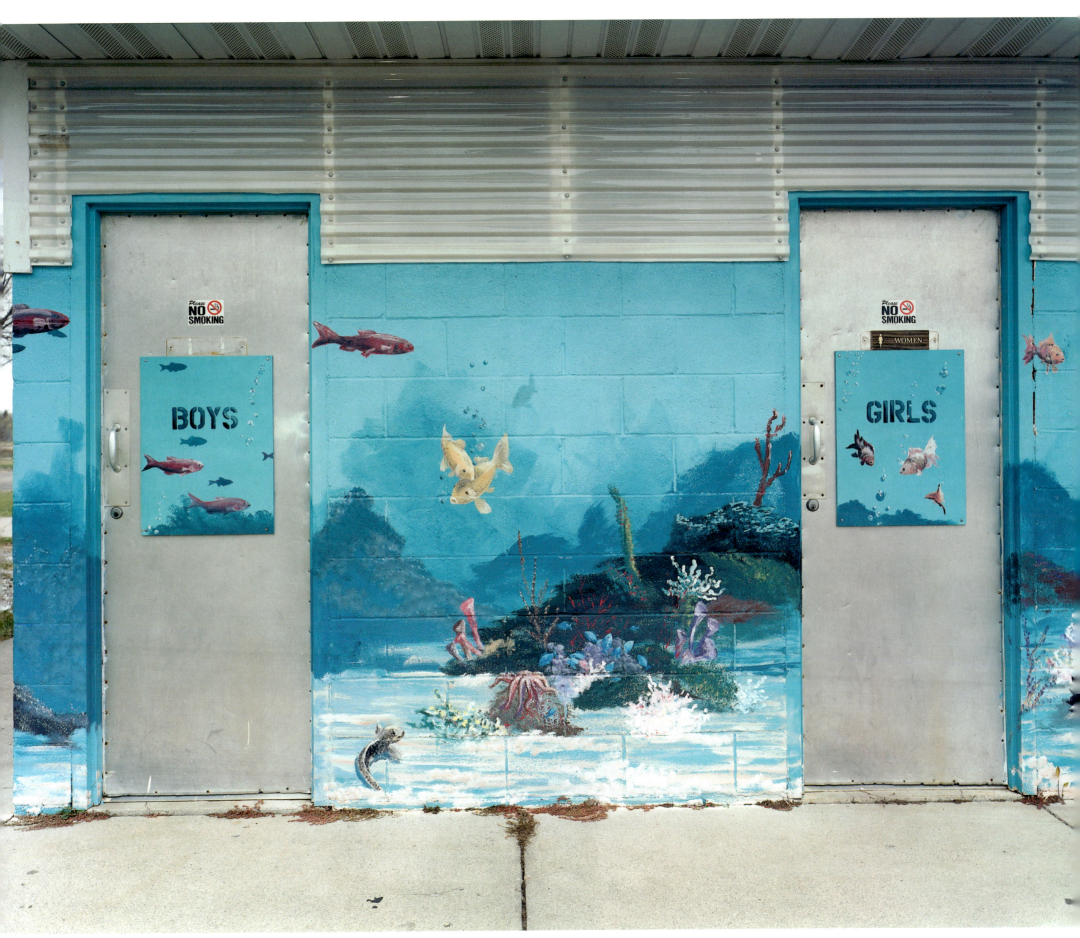

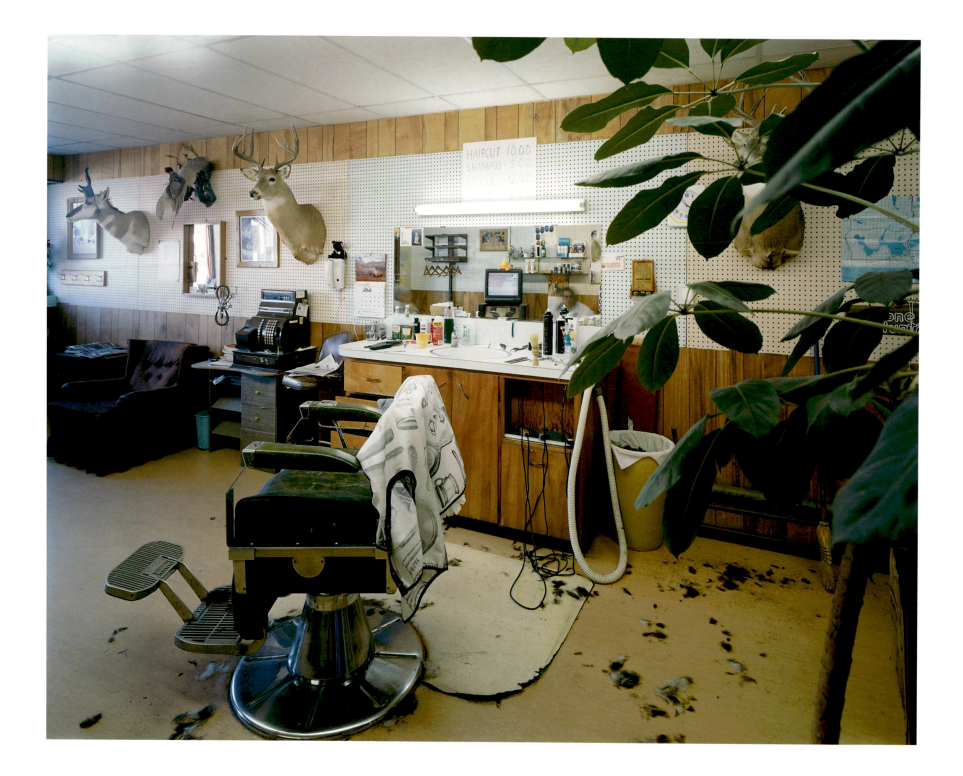

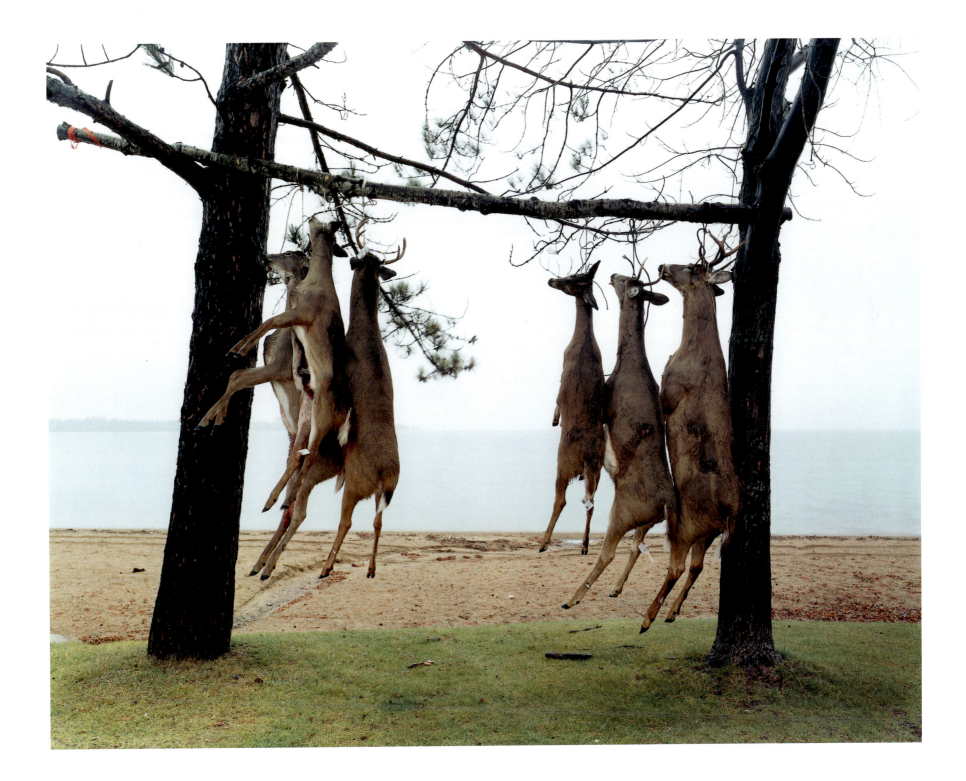

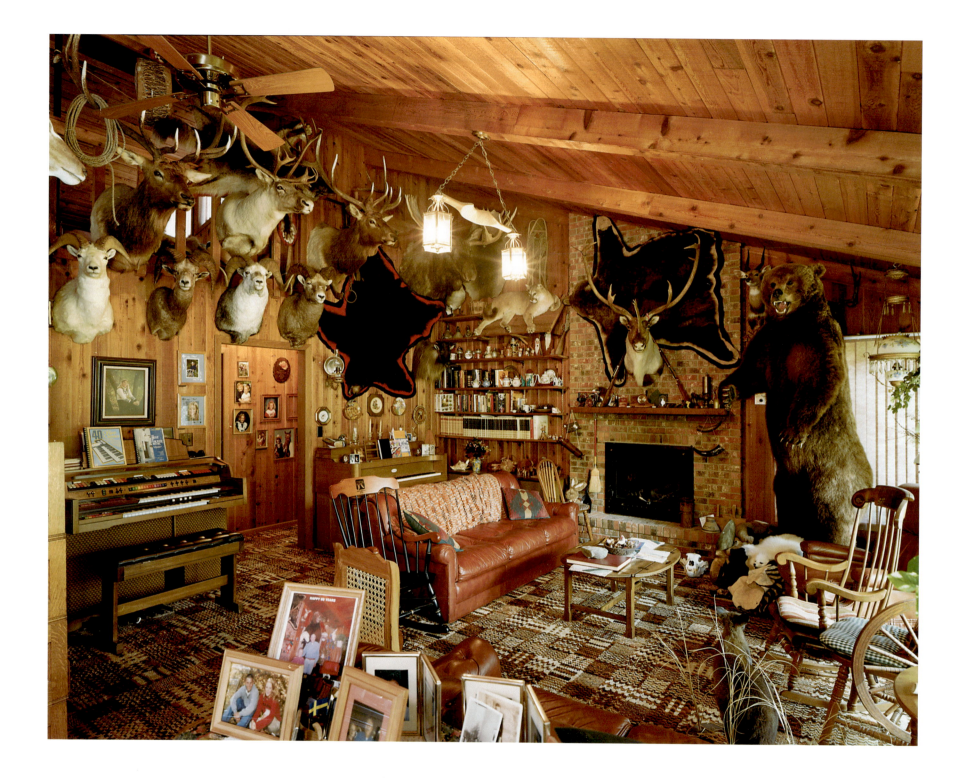

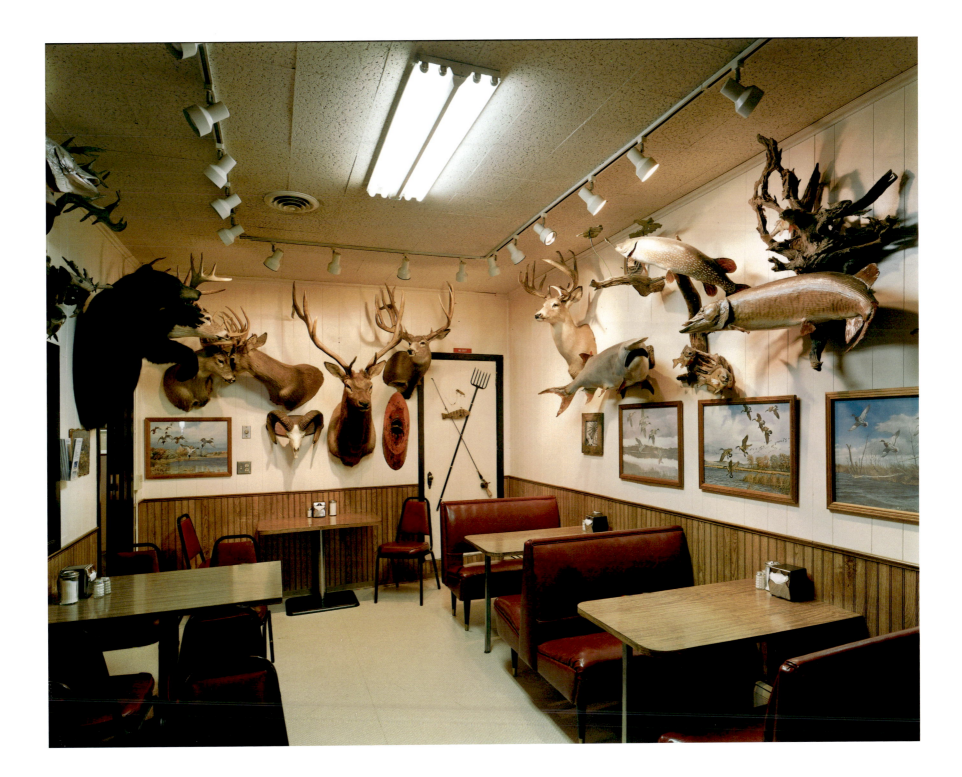

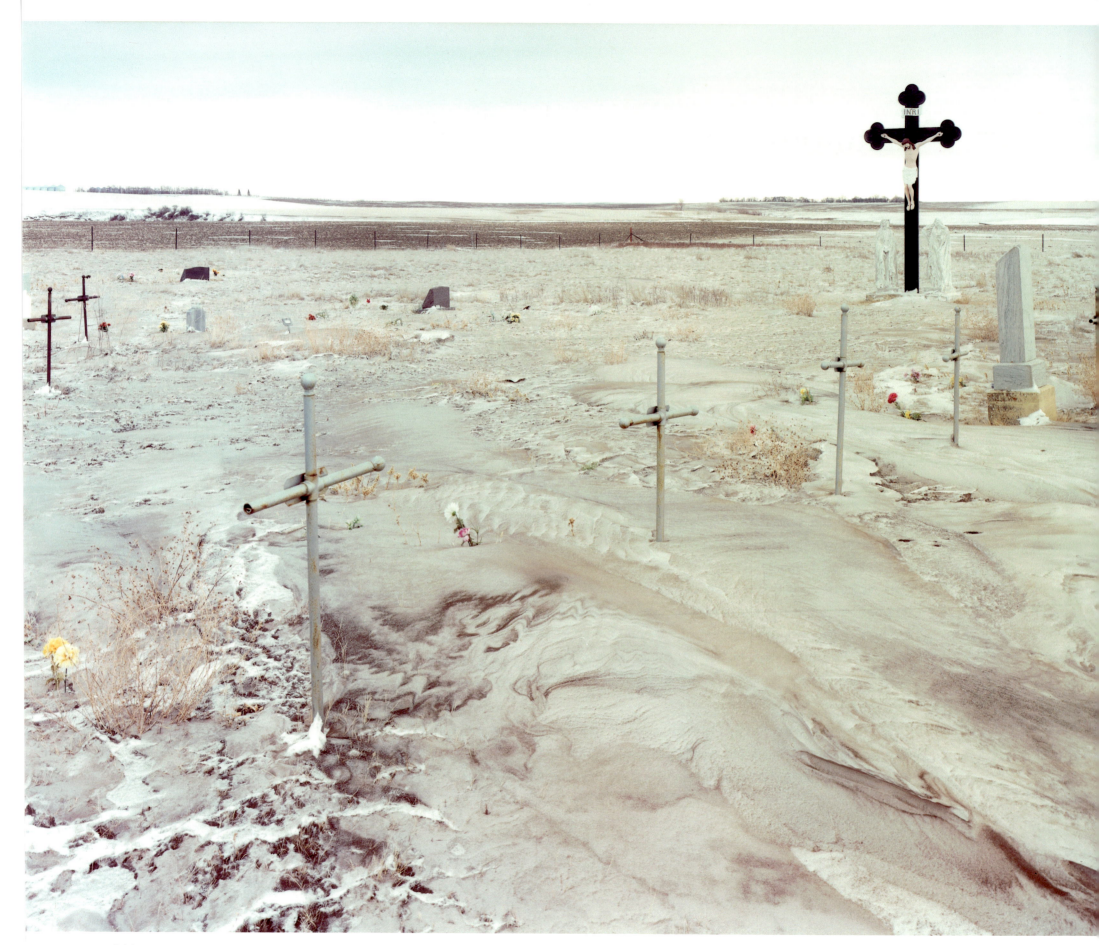

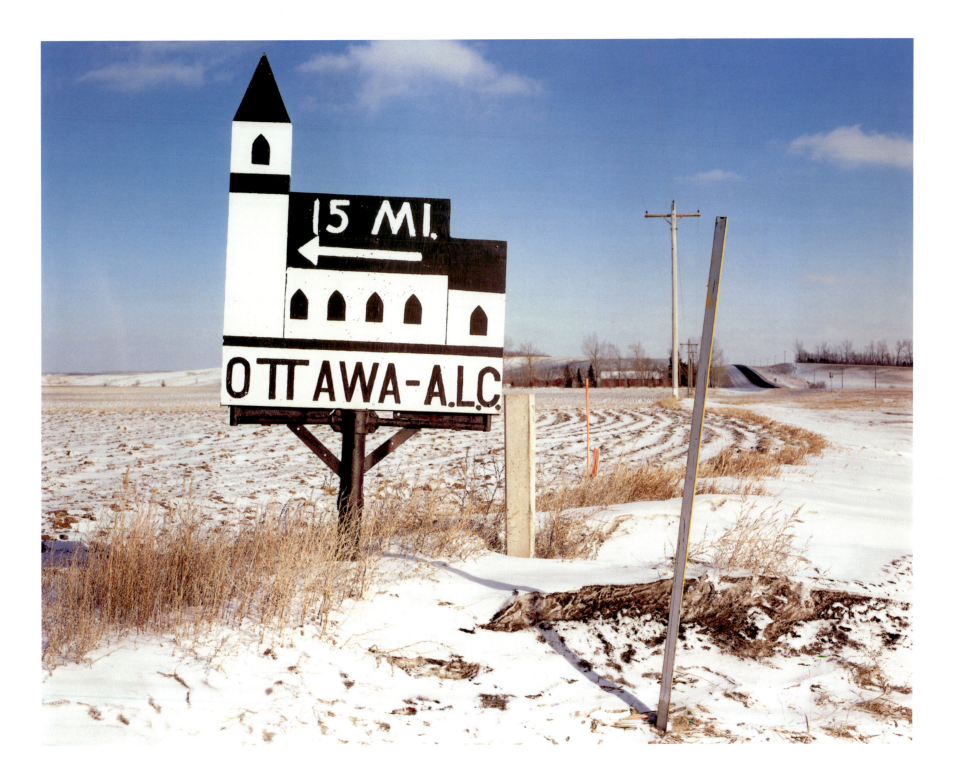

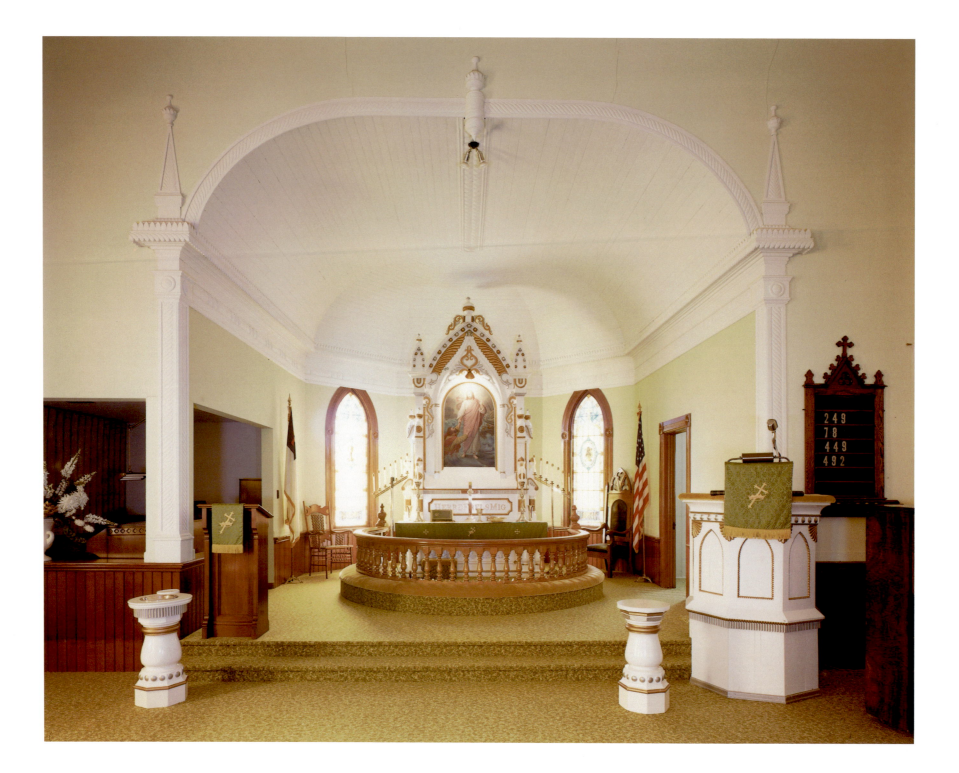

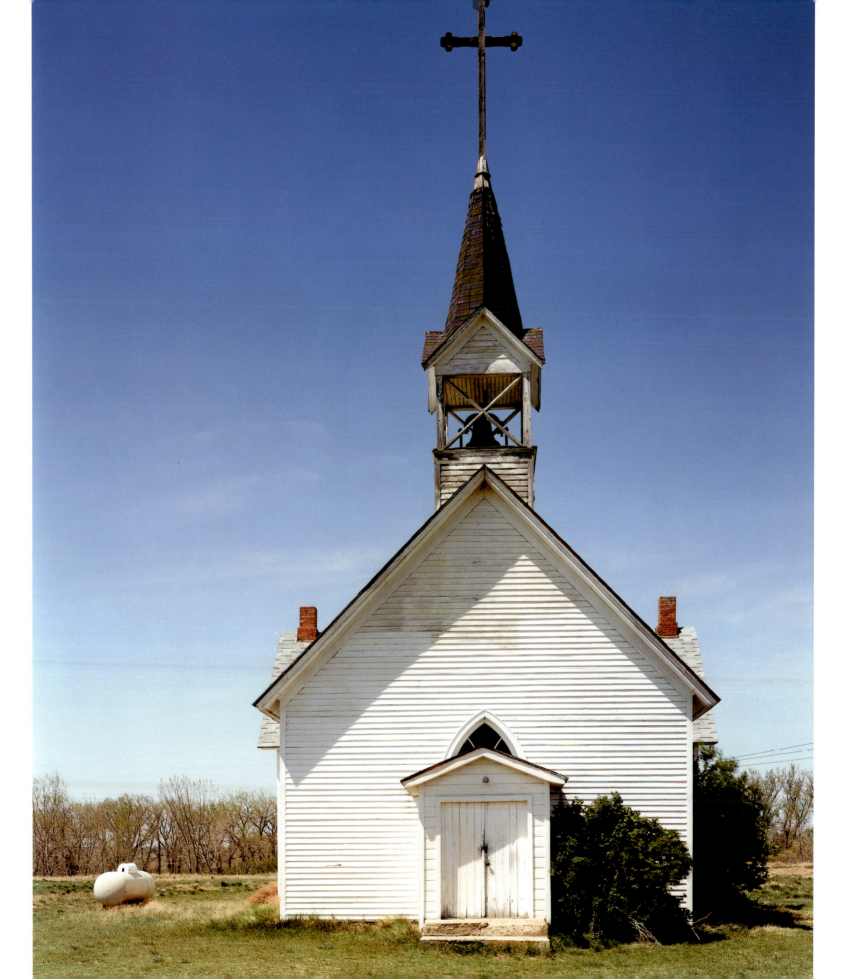

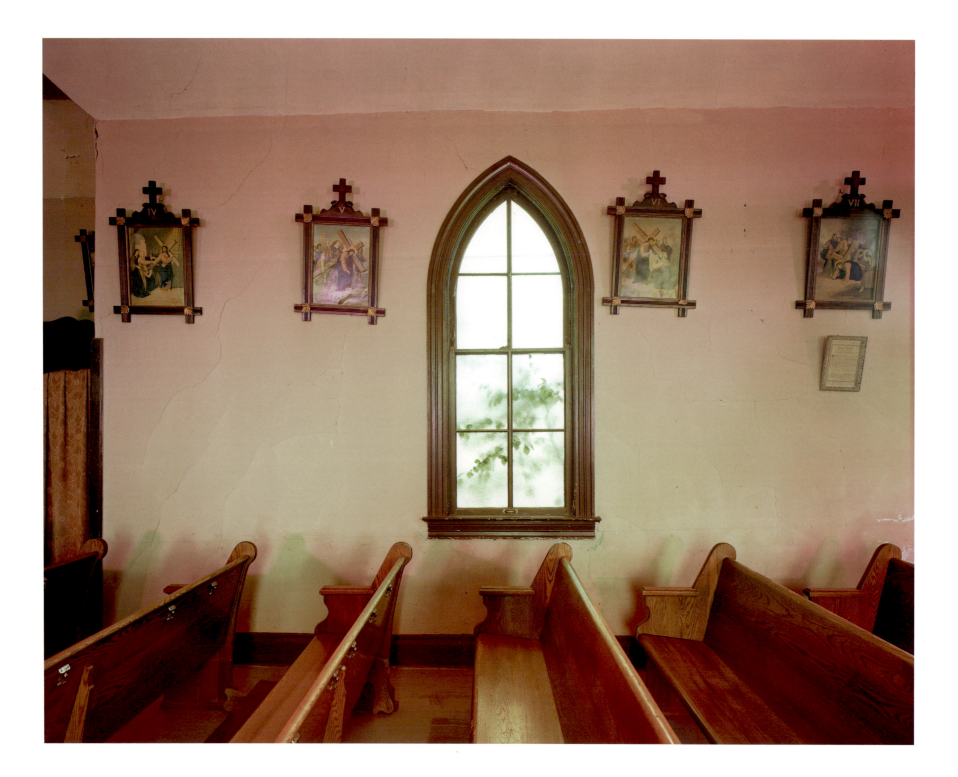

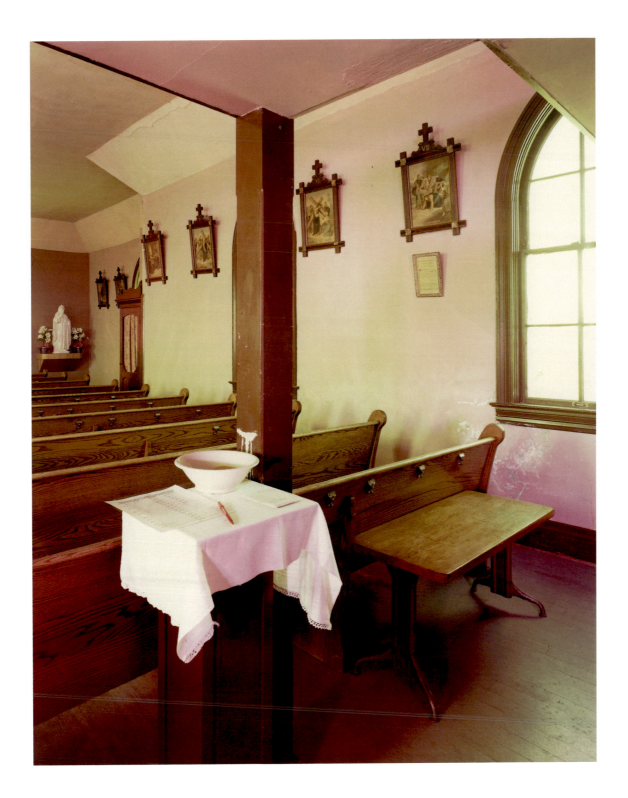

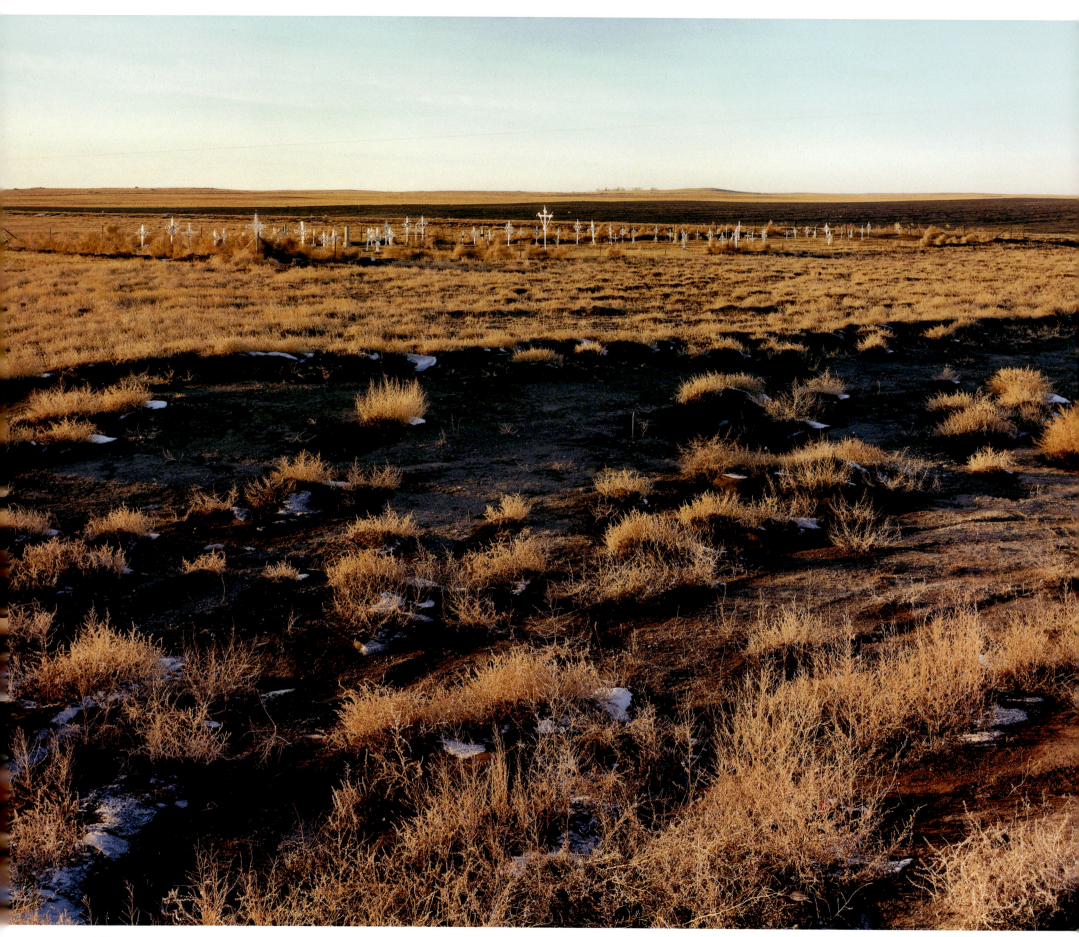

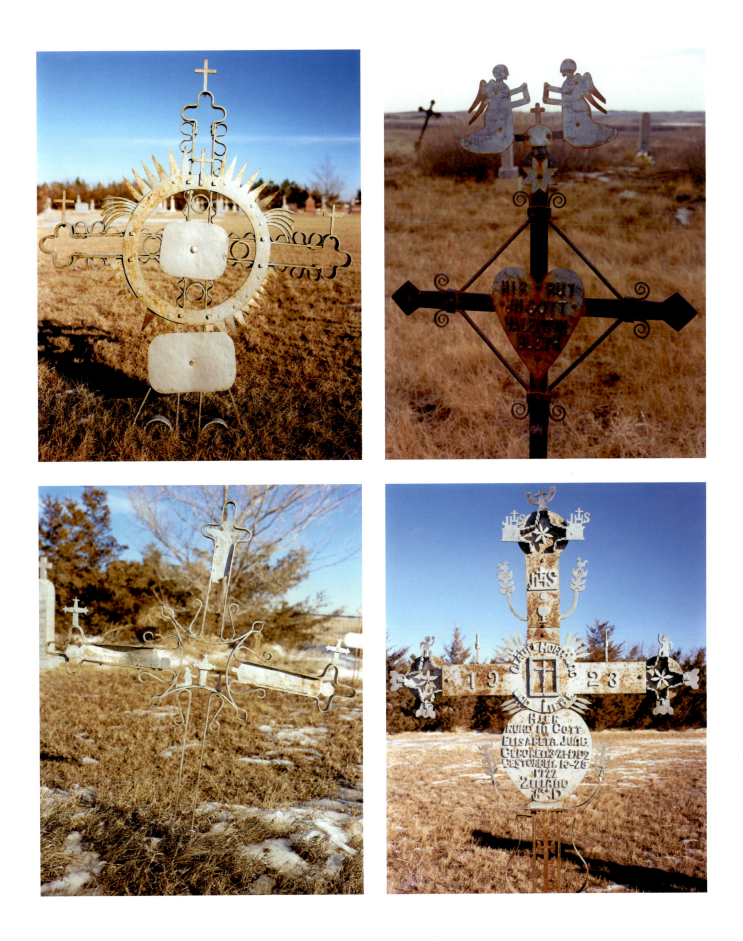

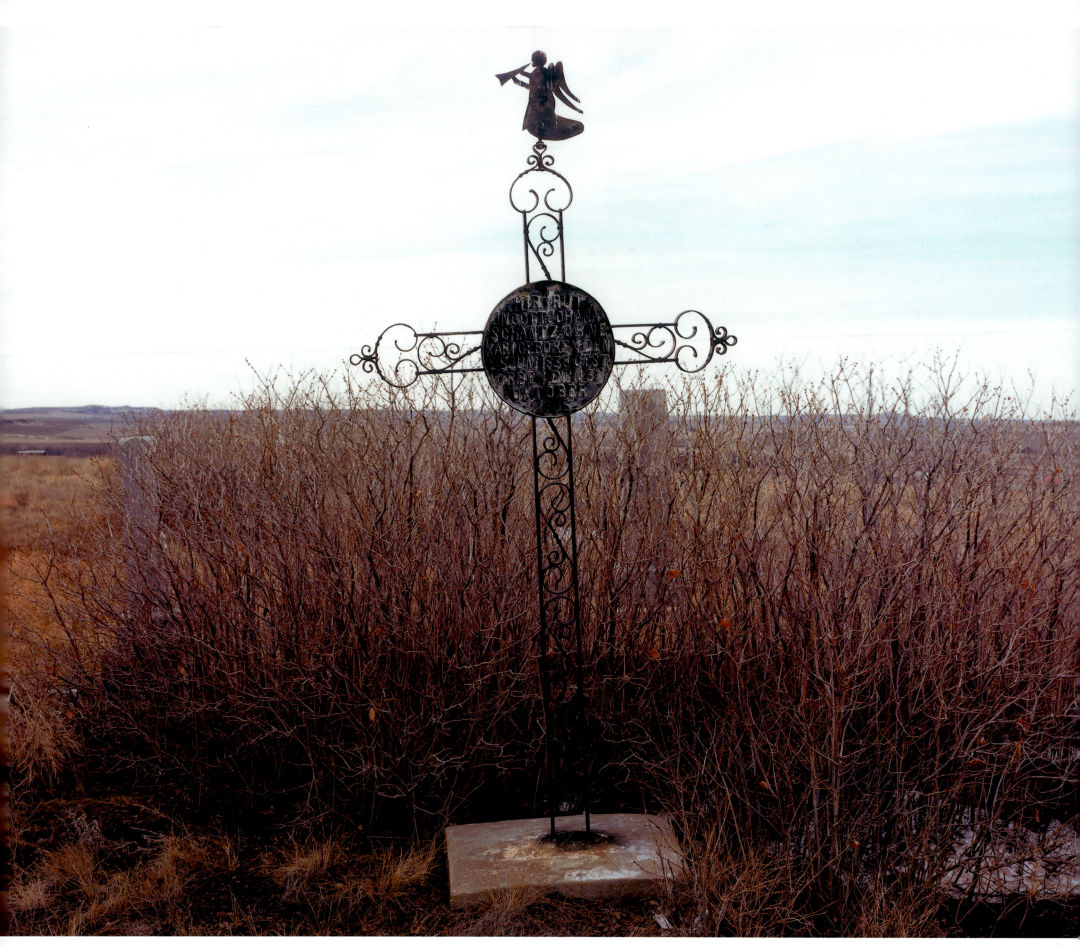

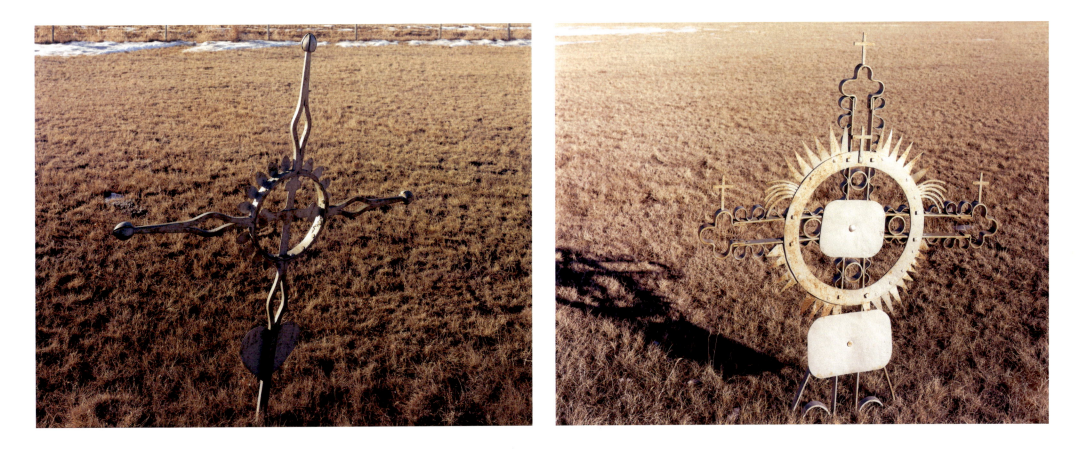

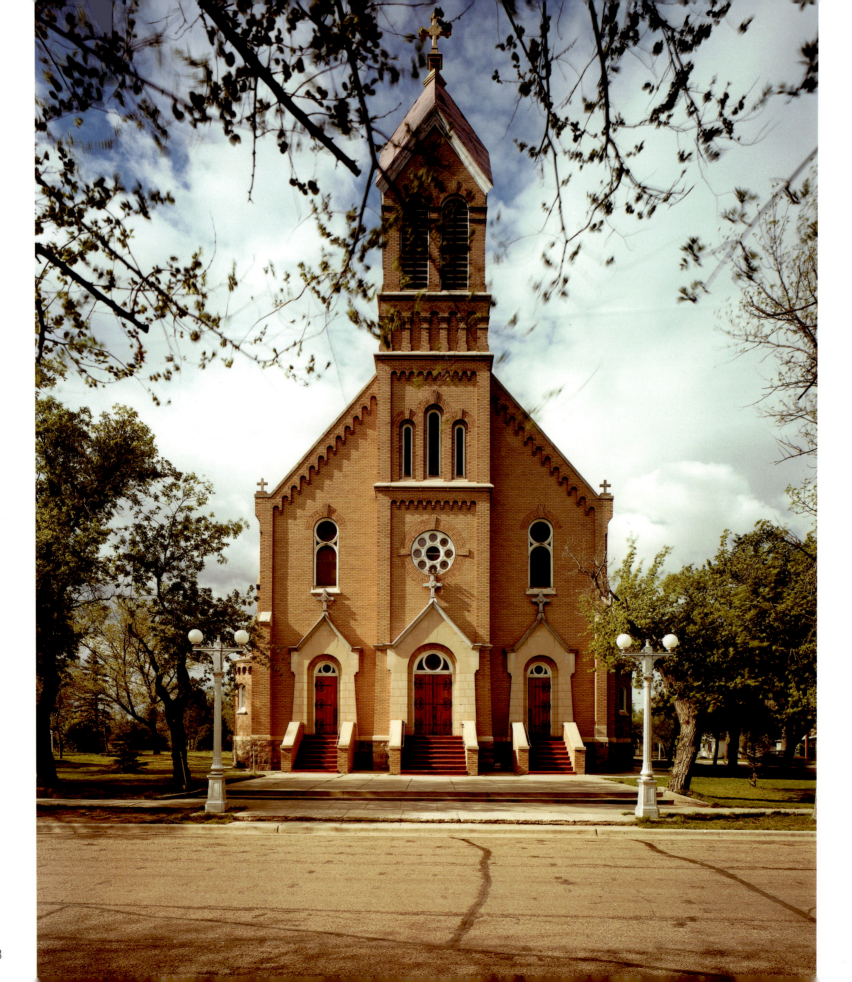

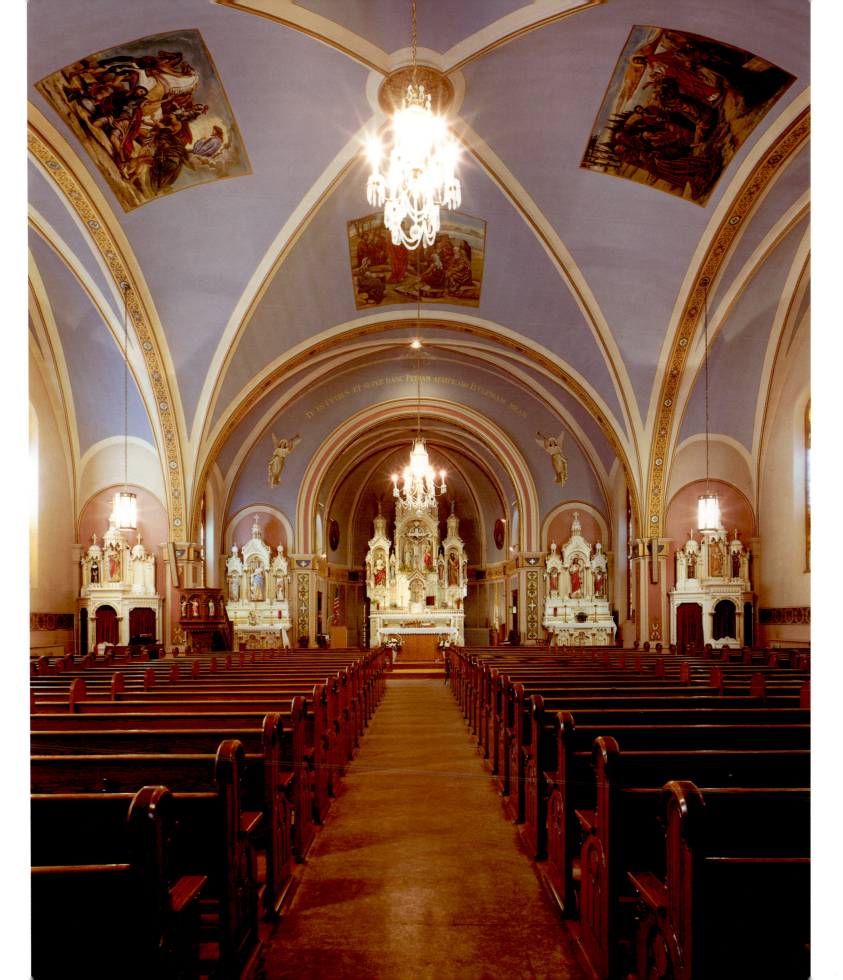

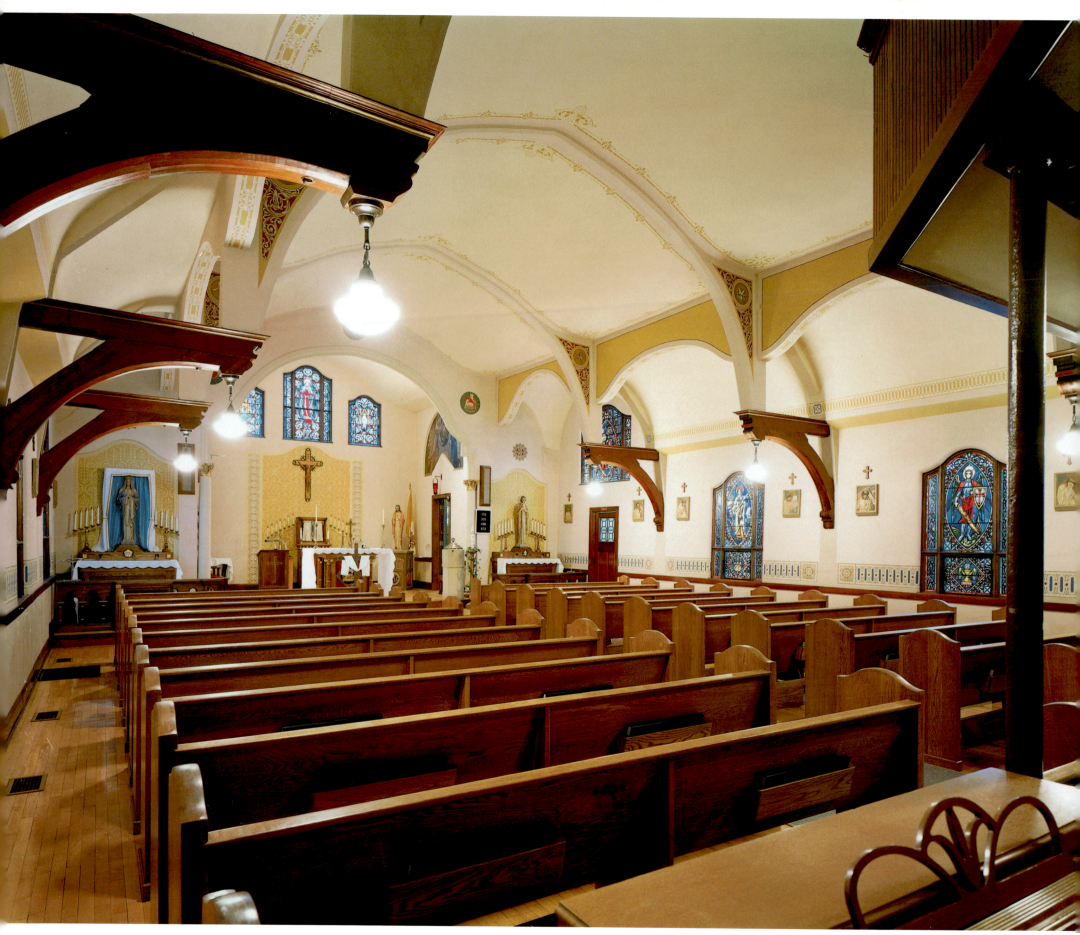

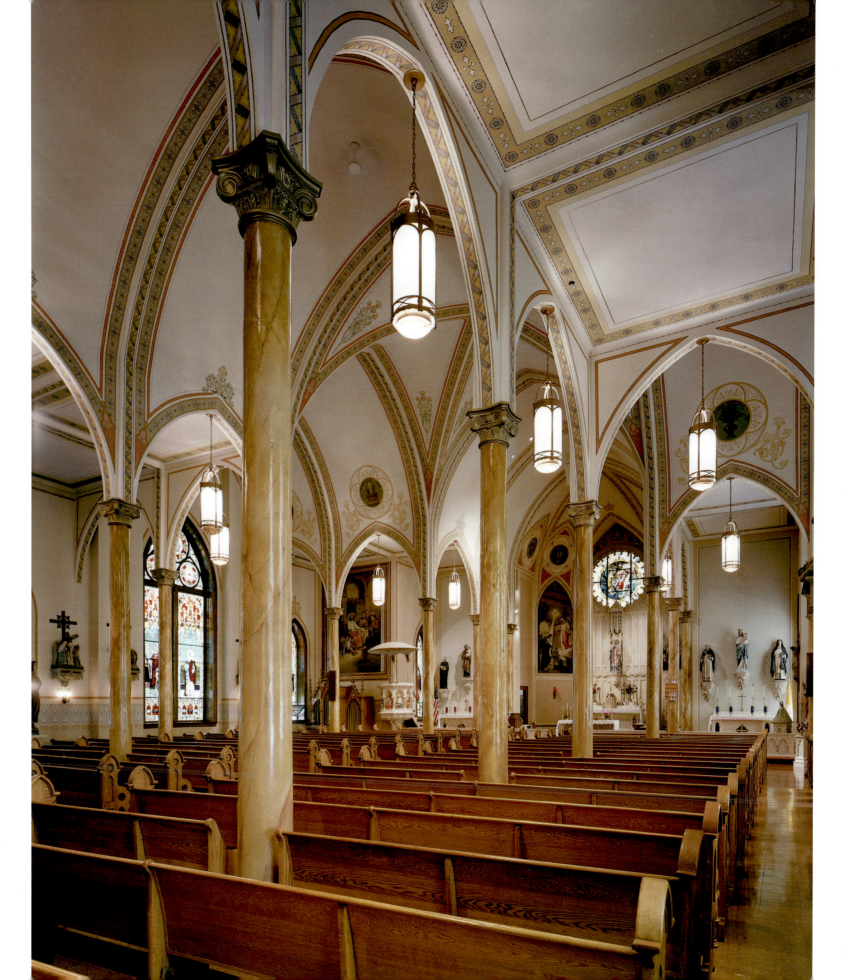

DREAMING AND REDEMPTION

Those unfamiliar with North Dakota habitually say that it is cold, boring, flat, desolate, and empty—inadequate generalizations that simply don't hold up. In fact, the landscape continually changes, mile by mile, from a dead horizontal in the east, to rolling bluffs, high buttes, broad rivers, and deep valleys in the center and west. Practically every town of any size contains a grain elevator, but there is as much shale oil drilled, coal mined, cattle grazed, and electricity produced from the land as barley, oats, sugar beets, sunflowers, and wheat harvested. Milk is the official state drink by law, but beer is far more popular, and signs bearing magical names like Grain Belt, Leinenkugel, and Summit dot the landscape with as much frequency as those proclaiming Bud and Miller. While the sunflower is the state flower of Kansas, North Dakota leads the nation in the harvesting of the seeds for oil, snacks, and bird food. Prior to the breakup of the old Soviet Union, the state was the third leading nuclear power in the world because of the nuclear arsenals and the Grand Forks and Minot Air Force bases.

As of January 1, 2007, there were eight Wal-Mart stores and twenty Burger King franchises within its borders. But there were also six Home of Economy outlets, five Paradiso Mexican Restaurants, four Happy Harry's Bottle Shops, and three Space Alien Family Restaurants, in-state chains all started and owned by North Dakotans.

During the twenty-first century, almost 4,000 people have left the state annually despite the fact that per capita earnings and wages rose far more quickly than the national average. In 2004, North Dakota voters overwhelmingly supported George Bush, banned same-sex marriage, elected a Republican governor and lieutenant governor, plus heavy GOP majorities in both houses of the state legislature. But, at the same time, the Washington-

bound delegation of two senators and one representative were Democrats, elected by equally large margins.

The weather is, as always, overpowering in its fierce, implacable seasonal swings from broiling heat to bitter cold. But while wintertime North Dakota may be the coldest and windiest place in the lower forty-eight, the dramatic contrast in the seasons is only a climatic overture to becoming familiar with a place where dichotomy is the order of the day.

As I said, I went to North Dakota prepared to freeze and was greeted by people wearing T-shirts in the midst of a January thaw. And, over the ensuing years, each subsequent day spent in the state has exponentially compounded that initial blend of surprise and allure.

This book contains no pictures made along "America's Longest Straight Road" (a county highway between Hickson and Streeter), or the "Enchanted Highway" (a group of fantasy metal sculptures set on a county road between Gladstone and Regent). Nor are there any pictures of the "World's Largest Structure," the KTHI television tower at Blanchard, the "World's Largest Historical Quilt" at Antler, or the "Geographical Center of North America" (if you don't include Belize, Costa Rica, El Salvador, Guatemala, Honduras, and Panama) at Rugby. There are no photographs of the birthplaces of Roger Maris in Fargo or Lawrence Welk in Strasburg. Nor is there much if any mention of Lewis and Clark, George Custer, Sakakawea, Sitting Bull, or Theodore Roosevelt.

At the same time, there are images of the "World's Largest Buffalo" at Jamestown, "Salem Sue, the World's Largest Cow" at New Salem, and Henry Luehr's Giant Hereford Bull, now in Buchanan. There is a picture of Earl Bunyan, the supposed brother of the more famous Paul, as well as the "World's Largest Tin Can Pile" in Casselton, the "North Dakota Hall of Fame" at the State Capitol in Bismarck, and Uncle Sig's "Jugville, USA" in Auburn.

All of this is to say that a significant part of my depiction of North Dakota has been along the lines of the obvious: tourist traps, odd manifestations, and surface appearances. At other times, the process has been perhaps more intrusive: people's places of business, classrooms, workshops, homes, backyards, and hunting lodges as well as churches, cemeteries, and prison yards. While it would be presumptuous to offer my view as authoritative or even exhaustive, there is enough nuanced irregularity in this collection of pictures and stories to suggest that the actuality of the place is far more complex than either the muted incongruities of *Prairie Home Companion* or the debauchery lurking behind every door in the movie *Fargo*.

The photographs have been made through a method that more or less guarantees some form of interaction with the landscape, the weather, or the people, often all at once. The camera, an old wooden box atop a tripod, uses film that calls for long exposures, sometimes as much as five to ten minutes in low-light situations. Coupled with the time that it takes to gain permission, set everything up, and, finally, take the picture, the pace is as unhurried as a weekday afternoon in a prairie bar or a Sunday spent watching the Vikings. It is impossible to hide, sneak, or speed things up, and so, for at least a short period, the whole undertaking becomes as much a part of the scenery and fabric of the everyday as anything else. My deliberate approach has been described as "dumb, in the honorific sense of the word," which is entirely apt given the extent to which I value practically every characteristic of the absorbing subject, North Dakota.

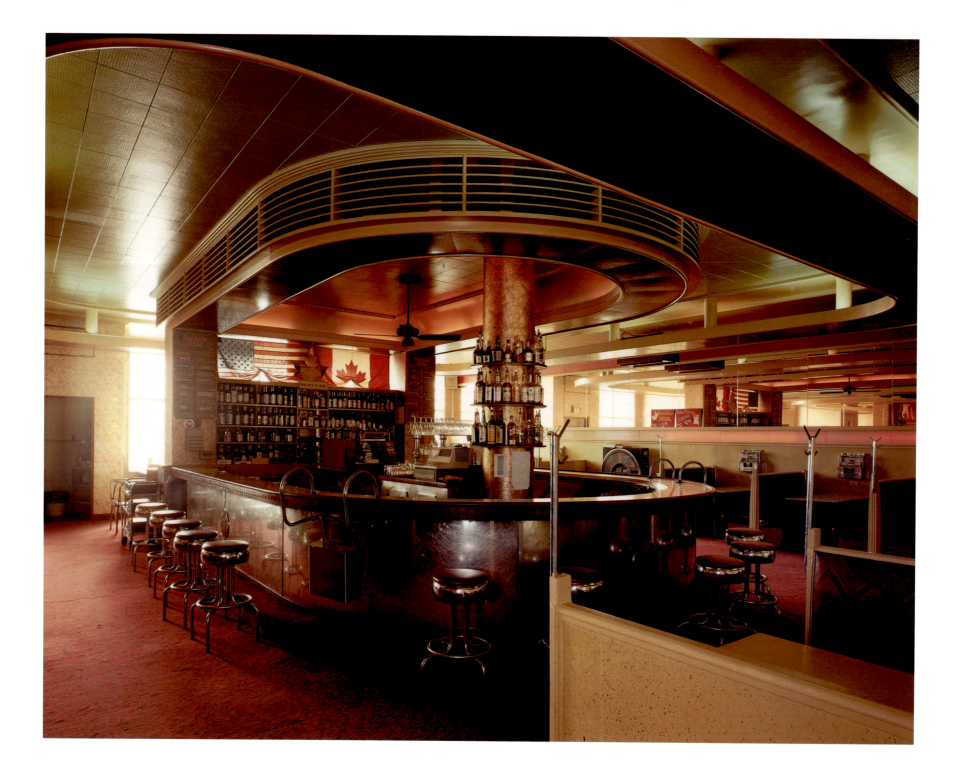

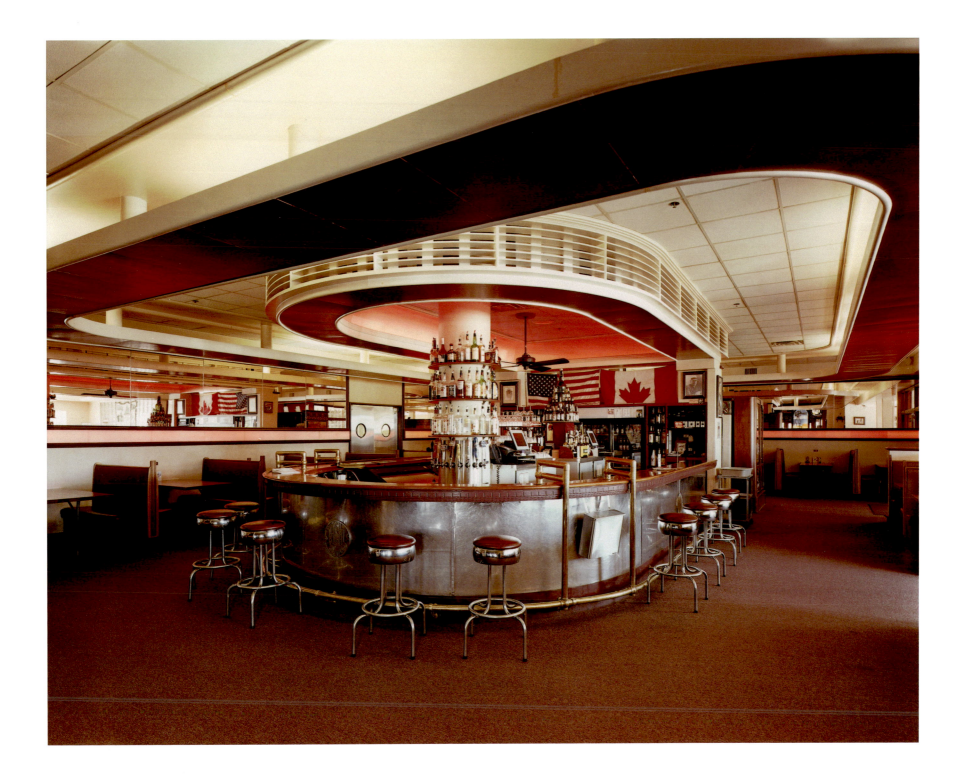

Notes on the Plates

ii. Left: Lowell and Barbara Endrud's Palm Tree People with Plastic Flamingos. I-29, Buxton, ND. 10/10/04

Driving across the Red River flatlands around the new millennium, Lowell Endrud saw what looked like a palm tree wrapped in Christmas lights glowing in the dark. Inspired, he hit upon fabricating the plants from metal rebar rods, ordering pink flamingos online ("as seen in the finest trailer courts"), and interweaving the cords and bulbs between the two, even going so far as stuffing the birds' bellies with clusters of flickering filaments.

With a wit both deft and laconic, Mr. Endrud insists that he takes great pleasure in irking others with his bad taste, yet he also talks about the tranquil effect of looking out the window when it is twenty below to see the plastic heads and metal leaves peeking above the snow; or, after a long summer's evening of piloting a combine, being welcomed home by the on/off winking of the holiday lights across the dusty prairie.

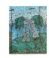

ii. Right: Wall Painting of Palm Trees. US 12, Marmarth, ND. 8/23/03

viii. Gina's Drive-in. US 2, Devils Lake, ND. 1/17/04

The yellow and red paint job stood out against the white snow and deep blue sky, glowing with beckoning warmth as the last rays of the sun struck the facade at the end of a twenty-degree-below January day. Within a few minutes the year-round holiday lights would be switched on at Gina's Drive-In to further entice customers in from the highway. Even in North Dakota it was unusual for a drive-in restaurant to stay open all winter. In many ways it appeared to be as much a combination of faith and defiance as economic common sense.

While the bulk of the off-season business shuffled through the front door, stamping their feet and blowing on their hands as they picked up baskets of burgers or fried chicken and fries to go, there was drive-in service year-round for the hardy, and there always was at least one parked auto idling in the back, spewing plumes of condensation from the heater turned on full blast. Bitter cold aside, the main risk to the overheated, drowsing occupants seemed to be a fright-inspired heart attack when the waitress scratched on the driver's frost-covered window to gain a semicomatose customer's attention to roll it down and collect his order. Apparently, on more than one occasion a parka-clad carhop was mistaken for a burger-searching bear.
Note: Gina's closed in 2005 and, as of this writing, has yet to reopen.

x. Ken Flaten's Barbershop. ND 18, Hatton, ND. 5/19/01

Like the traditional family farm, North Dakota Main Street businesses survive on the skill, ingenuity, and physical well-being of the individuals who run them. Among all the different small-town concerns there is no enterprise that depends more on the collective qualities of its proprietor than the local barbershop where the tonsorial, informational, recreational, and even counseling needs of the male portion of an entire community are served with equal measure.

Ken Flaten runs just such an operation in Hatton, but, as the area's population shrinks and his own retirement looms, he has reduced his hours, now coming into the shop only every other afternoon.

Looming over his single barber chair are two enormous cabinets, built to hold all the equipment—lotion, soap, tools, and towels—that his occupation requires. With the practical self-sufficiency so characteristic of the High Plains population, Flaten has designed each of these massive pieces of furniture to be held together by a mere four screws, permitting them to be disassembled and removed with only a negligible degree of difficulty when circumstances at last dictate that he close down his establishment.

Views of North Dakota

3. Views of North Dakota Mural by Charles Olive on Wall of Prison Yard. State Penitentiary, Bismarck, ND. 2/6/81

4. Long Wall of Murals by Charles Olive with Guard Tower, shot at an angle. State Penitentiary, Bismarck, ND. 2/6/81

5. Mountain Scene Mural by Charles Olive on Corner Wall of Prison Yard. State Penitentiary, Bismarck, ND. 2/6/81

6-7. Panorama of Prison Yard with Baseball Backstop and Murals. State Penitentiary, Bismarck, ND. 2/6/81

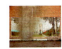

8. State Capitol Building By Charles Olive. State Penitentiary, Bismarck, ND. 2/6/81

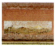 9. Interstate 94/US 10 by Charles Olive. State Penitentiary, Bismarck, ND. 2/6/81

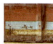 10. Pronghorn Antelope Looking at Badlands by Charles Olive. State Penitentiary, Bismarck, ND. 2/6/81

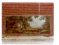 11. Pheasants with Mailbox by Charles Olive. State Penitentiary, Bismarck, ND. 2/6/81

 12. Woodsy Scene by Charles Olive. State Penitentiary, Bismarck, ND. 2/6/81

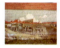 13. Farm Scene by Charles Olive. State Penitentiary, Bismarck, ND. 2/6/81

 14. Town by Charles Olive. State Penitentiary, Bismarck, ND. 2/6/81

 15. Cowboys with Cattle by Charles Olive. State Penitentiary, Bismarck, ND. 2/6/81

MARKING THE LAND

 18. View of Dinosaur at Railroad Sign. Kathryn, ND. 5/15/02

 19. Dinosaur on Hill, from the front. US 85, Amidon, ND. 2/16/81

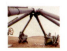 20. Group of Five Dinosaurs. Paul Tormaschy's Farm, US 10, Gladstone, ND. 2/17/81

21. Tormaschy's Dinosaur, detail. 2/17/81

 22. World's Largest Holstein Cow. Near New Salem, ND. 2/5/81

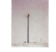 23. Wind Towers. US 83, near Sawyer, ND. 3/6/04

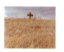 24. Cross for Fatal Accident. US 2, Berthold, ND. 10/7/04

 25. Mannequin in Wagon on D. Bohl's Farm. ND 36, Pingree, ND. 5/12/81

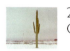 26. Wooden Cactus in Snow. Henry French's Farm, Cashel, ND. 1/30/81

 27. Wooden Cactus at Sunset. Henry French's Farm, Cashel, ND. 2/22/81

 28. Tin Can Pile. US 10, Casselton, ND. 1/24/81

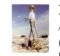 29. Earl Bunyan Statue by Fred Larocque, a Well-Known Cowboy and Tavern Owner. (Earl is the cowboy brother of Paul Bunyan, the Bemidji, Minnesota, lumberjack.) ND 23, New Town, ND. 2/4/81

 30. Holiday "Greetings" Sign. Along US 83, Wilton, ND. 1/16/04

 31. "Let Not Your Heart Be Troubled" Sign. ND 37, Parshall, ND. 2/4/81

 32. "Resist the Devil" Sign. ND 37, Parshall, ND. 2/4/81

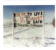 33. "For Me to Live" Sign. US 2, Minot, ND. 2/4/81

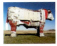 34. Henry Luehr's Bull. At the junction of US 52 and US 281, Buchanan, ND. 10/6/04

 35. Metal Coffee Cup by Ken Nyberg. At the Big Foot Truck Stop, Vining, MN. 11/10/00

 36. Metal Indian Stucco Horse. US 281, Millarton, ND. 2/9/81

 37. Metal Indian Stucco Horse Atop a Hill. US 281, Millarton, ND. 2/9/81

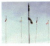 38. Former Viking Statue. Tioga, ND. 2/19/81

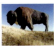 39. World's Largest Bison made from Concrete and Weighing Sixty Tons. The National Buffalo Museum, US 52, 281, and I-94, Jamestown, ND. 10/6/04

 40. Root Beer Float. US 12, Delano, MN. 8/12/02

 41. Sign For Barlow Meats. US 281, Barlow, ND. 7/26/01

 42. Fuel Tanks, Independent Oil Company of McHenry. McHenry, ND. 10/9/04

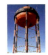 43. Water Tower at Jamestown College. ND 20, Jamestown, ND. 10/9/04

 44. Left: Home of Economy Sign. US 2, 52, and 83, Minot, ND. 10/7/04

 44. Center: Happy Harry's Sign. US 2, Grand Forks, ND. 10/4/04

 Right: Highlander Sign. US 81, Grand Forks, ND. 10/5/04

 45. Painted Potato on Wall of Corrugated Steel Building. MN 1 and 220, Alvarado, MN. 2/22/81

 46. Horse Made of Metal Slats with Wire Rein. D. Bohl's Farm, ND 36, Pingree, ND. 5/12/81

 47. Upper Left: Sign For Oasis Bar. US 52, Cooperstown, ND. 1/14/04

 Upper Right: Sign for Red Owl Supermarket. ND 22, Dickinson, ND. 2/16/81

 Lower Left: Sign for Delong Sport Center. MN 34, Park Rapids, MN. 11/9/00

 Lower Right: Badlands Trout Sign. Medora Campgrounds, I-94B, Medora, ND. 2/15/81

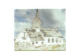 48. "Respect for Life" Sign. ND 15 west of Northwood, ND. 10/9/04

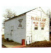 49. Sign for Norwegian church, detail. ND 200, Mayville, ND. 2/24/04

Artist and the Workplace

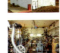 52. Alex Paluck's Shop, exterior view. Belfield, ND. 2/17/81

53. Alex Paluck Shop, interior view. Belfield, ND. 2/17/81

Alex Paluck's workplace was as carefully organized as a library or operating theater, yet as inviting as a familiar easy chair. Paluck had a machine shop in Belfield for more than fifty years, and in his spare time created small, intricately cut metal bucking horses, rope-throwing cowboys, and trophy-sized variations of candlestick holders.

 54. BACK OF SIGN FOR THE BUFFALO TRAILS MUSEUM. US 2 and 85, Williston, ND. 10/7/04

 55. MEMORIAL TO BUD KAHO. US 10, Mandan, ND. 10/9/04

 56. "REINDEER," BARN PAINTED BY FRIDL EGGL, WHO FARMED THE BOB BRIGHTBILL HOMESTEAD, DOOR CLOSED. ND 81, near Cando, ND. 2/20/81

 57. "THE MINNESOTA SCHOOLTEACHER" BARN PAINTED BY FRIDL EGGL, DOOR OPEN. ND 8, near Cando, ND. 2/20/81

 58. ALBERT REDDIG'S "MACHINE MONSTER." Gift to the North Dakota Museum Of Art. Grand Forks, ND. 2/23/81

 59. INTERIOR OF ALBERT REDDIG'S FARM SHOP. Cathay, ND. 2/21/81

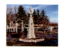 60. STONE MONUMENT AT ENTRANCE TO JUG PARK AT UNCLE SIG'S JUGVILLE. US 81, Auburn, ND. 1/23/81

 61. BRICK STRUCTURES AT ENTRANCE TO UNCLE SIG'S JUGVILLE. US 81, Auburn, ND. 1/23/81

As the only Polish Catholic kid in a one-room schoolhouse full of Scandinavians, Sigmund Jagielski endured a youth full of poundings enthusiastically administered by his Lutheran classmates. Seventy years later, he was able to laugh at this experience by saying that he was a complete supporter of interracial marriage: by his lights, it was okay for a Pole to marry a Norwegian. Never, ever, politically correct, Uncle Sig, as everyone knew him, was part rapscallion, part raconteur, part renegade, but always a realist. A successful farmer by the time he was forty-five, he spent increasing amounts of his time designing, building, and showing off his very own North Dakota rural theme park, Jugville, which featured a quarter-sized town complete with chapel, saloon, doctor's office, and printing shop. On top of all this, he amassed enormous collections of yardsticks, pens and pencils, and every kind of farming implement used in the valley of the Red River of the North. He even built his own hearse with two stuffed horses to pull it.

Right up until his death at the age of ninety-six, he hosted a weekly polka show on radio, built scores of decorative wooden clocks, and entertained visitors with stories and observations on every subject. There are hundreds of Sig stories, every one worth the telling, but perhaps the most fitting indication of just how wise he was in the ways of the world came when I first met him, in 1981. We were talking about the Depression and what it was like, and he pointed over to the railroad tracks and told about the freight trains that would pass during harvest time with every car carrying men waving their arms and calling for work as they went by fields bursting with ready-to-pick potatoes, corn, and sugar beets. Suddenly he stopped and said, "You know, people always talk about how cheap things were back then and how much money you pay for stuff nowadays. Well, I don't give a damn, but that makes no sense at all. When I was a young guy, baching it y'see, I used to have to work three whole days to make enough money to buy a new pair of shoes. Now, well maybe I have to work three hours. So don't tell me about inflation; just figure it out, that is, if you're capable."

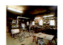 62. TWO SCULPTURES AT UNCLE SIG'S JUGVILLE. US 81, Auburn, ND. 1/29/81

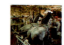 63. UNCLE SIG'S WORKSHOP WITH WINDMILL. US 81, Auburn, ND. 1/29/81

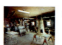 64. STORAGE AREA AT UNCLE SIG'S JUGVILLE WITH HORSES AND TOOLS. US 81, Auburn, ND. 11/04/00

 65. UNCLE SIG'S WORKSHOP WITH GO-KART. US 81, Auburn, ND. 8/27/01

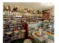 66. SALOON AT UNCLE SIG'S JUGVILLE, VERSION 1. US 81, Auburn, ND. 11/4/00

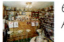 67. SALOON AT UNCLE SIG'S JUGVILLE, VERSION 2. US 81, Auburn, ND. 11/4/00

 68. YARDSTICK COLLECTION AT UNCLE SIG'S JUGVILLE. US 81, Auburn, ND. 11/4/00

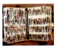 69. Pencil Collection at Uncle Sig's Jugville. US 81, Auburn, ND. 1/29/81

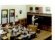 70. Chapel Interior at Uncle Sig's Jugville. US 81, Auburn, ND. 1/29/81

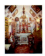 71. Whirligig at Uncle Sig's Jugville. US 81, Auburn, ND. 5/25/01

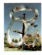 72. "A Visit to the Dentist's Office" Diorama by Elmer Halvorson. Buffalo Trails Museum, Epping, ND. 10/8/04

Epping (population 79) currently advertises itself as "The Second Biggest Little Town in North Dakota" (Golva, some ninety miles to the south, now claims the appellation of first). At this writing, there is a cafe, a church and separate Bible camp, the city hall and senior citizens' center, a post office, rural fire station, and saloon. During the first decades of the twentieth century, there were, of course, far more enterprises as well as people, including two banks, a feed mill, garage, general store, hardware store, harness and machine shop, hotel with a restaurant, jewelry store, and a realtor. There were around forty active businesses at the time of its incorporation as a city in 1905 when Epping was known as "The Biggest Little Town on the Great Northern" (now the Burlington Northern Santa Fe Railway), the main line between Minneapolis and Seattle.

Many Northern Plains localities have gradually become one-person operations, but few compare to Epping where, starting in 1966, local artist Elmer Halvorson, along with Pastor Duane R. Lindberg, converted nine different buildings into a multitude of displays to create the Buffalo Trails Museum. Among the restorations and exhibits is a schoolhouse, a Sons of Norway Hall, and a number of striking dioramas of both Indian and settler culture that include tiny figures that range from a few inches high to life-size. The centerpieces of the displays are Halvorson's semiautobiographical reconstructions that show him playing on the living room floor as a toddler, as an older child watching the family doctor pour out medicine for his sick sister, as a young suitor cuddling his girl friend, and as an adult sitting in the dentist's chair about to undergo a drilling.

Halvorson was born in 1916 and grew up in Wheelock, five miles northeast of Epping. He studied art at Minot State Teachers College and Concordia College in Moorhead, Minnesota, where he taught until 1945 when he returned to the town of his birth to open a studio and teach in the public school. He was quite successful regionally, winning awards and commissions and exhibiting regularly as he began to organize, research, curate, and create the exhibits at the museum. Right up until his death in 1994, he continued to execute every task from touching up the exhibits to taking oral histories on a cassette recorder.

 73. "The Doctor's Consultation" by Elmer Halvorson. Buffalo Trails Museum, Epping, ND. 10/8/04

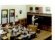 74. "One-room School House" by Elmer Halvorson. Buffalo Trails Museum, Epping, ND. 10/8/04

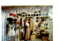 75. "Display of Hats" by Elmer Halvorson. Buffalo Trails Museum, Epping, ND. 10/8/04

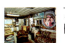 76. Greg Vettel and Doug Bergman's Hunting Cabin. Rural Thompson, ND. 8/19/02

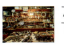 77. Detail of Workbench, Edward Vettel's Shop. Thompson, ND. 5/19/01

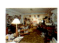 78. Walter Piehl's Studio. Minot, ND. 1/16/04

Artist, tavern owner, college professor, and cowboy, Walter Piehl brings so many different talents and locations to his daily life that it is impossible to categorize him and often difficult to find him. Try one of his many telephone numbers and he might be painting in his studio, perhaps pulling beers for customers behind the bar, showing slides in class, out riding a bronco, or talking on his cell phone. At the same time, the continuity of his diverse interests is always evident, regardless of the venue. His artwork contains and conveys all the energy and movement of the rodeo ring, and every wall and surface of his workplace and Blue Rider bar are plastered with objects and images that evoke similar themes and memories. Step into his classroom at Minot State University and you enter a perpetually evolving still life of cow skulls, wine bottles, ibex horns, dried flowers, and alligator skins that could just as readily be found in or on a canvas or next to the cash register.

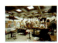 79. Walter Piehl's Classroom. Minot State University, Minot, ND. 10/7/04

 80. Door of the Safe in Walter and Becky Piehl's Blue Rider Bar. Minot, ND. 7/25/01

 81. Interior of The Blue Rider. Minot, ND. 7/25/01

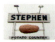 82. Sign for "Stephen Potato Country." US 75, Stephen, ND. 5/20/01

 83. Sugar Beet Campaign Underway. US 81, Reynolds, ND. 10/10/04

 84. Detail of Pit shovel at the Velva Coal Mine. Velva, ND. 5/16/81

 85. Mural of Charging Buffalo Painted by Robert Bykonen (1996-97) at Auto Graveyard. US 2, Grand Forks, ND. 11/3/00

 86. Farmers Co-op Grain Elevator. US 10, Little Falls, MN. 5/4/81

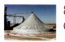 87. Tent Covering Grain in Winter. US 10, Carrington, ND. 2/2/81

 88. Mirrors Outside Boys Room at Closed School. ND 200, Bowdon, ND. 7/30/01

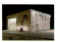 89. Car Wash at Night. US 12, Mobridge, SD. 8/15/02

 90. Façade of Fertile Sand and Gravel Company. MN 32, Fertile, MN. 8/20/02

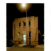 91. Façade of Apartment Building at Night. Valley City, ND. 8/13/02

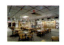 92. Interior of Neathery-Simensen VFW Post. US 2, Devils Lake, ND. 1/19/04

 93. Stairway to Apartments at the Neathery-Simensen VFW Post. Devils Lake, ND. 1/19/04.

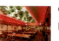 94. Dining Room at Paradiso Mexican Restaurant. US 81, Grand Forks, ND. 9/14/02

 95. Facade of Crooks Lounge and Bowling Alley. US 2, Rugby, ND. 7/24/01

 96. Interior of the Palm Gardens Broasted Chicken House. US 12 and 281, Aberdeen, SD. 5/19/81

 97. Cafe at the El Rancho Motel. US 2, Williston, ND. 10/7/04

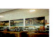 98. J-Mart Store. Pisek, ND. 5/21/01

 99. The Velva Bar. US 52, Velva, ND. 5/16/81

 100. General Store. US 12, Waubay, SD. 8/16/02

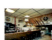 101. T & V Store. ND 36, Wing, ND. 10/6/04

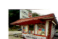 102. Doug's Bar. ND 11, Fairmount, ND. 8/21/01

 103. Tastee Freez Stand. ND 13, Kulm, ND. 9/13/02

 104. Page Theatre. ND 38, Page, ND. 8/22/01

 105. Strand Twin Theater. US 81, Grafton, ND. 5/20/01

 106. Masonic Temple. US 12, Webster, SD. 8/16/02

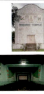 107. Delchar Theater. ND 18, Mayville, ND. 1/18/04

 108. Wishek Auditorium. ND 13, Wishek, ND. 8/14/02

 109. Mystic Theatre. US 12, Marmarth, ND. 8/23/03

 110. Shop Window, "Going Out of Business." MN 28, Glenwood, MN. 7/20/01

 111. Kunkel's Bar. ND 17, Edmore, ND. 7/27/01

The People and their Ingenuity

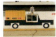 114. Hockey Chalk Board. Locker room, Jamestown High School. 2/9/81

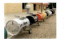 115. Drive-thru Window at Western Liquors. ND 1, Langdon, ND. 5/21/01

When Margaret Keitz decided to install a drive-thru lane at the liquor store that she ran with her daughter, Camille, they wanted to give it a unique identity. Margaret's husband, Victor, proposed a representation of an idealized customer, everlastingly pulled up to the window, ready to place an order. Thinking that his freehand rendering might be lacking, Mr Keitz parked his pickup truck as close to the building as possible and traced its shadow on the bricks. He enlisted his seven-year-old niece, also named Camille, to help fill in the outline with black paint and hang Christmas lights around the perimeter. Note: As of this writing, Western Liquors had closed.

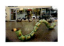 116. Kiddy Car Train Made from Oil Barrels. ND 200, Hazen, ND. 7/26/01

117. Metal Sculptures at Gas Station. US 2, Bagley, MN. 11/6/01

 118. Kit Carson Sign. ND 21, Carson, ND. 8/15/02

 119. Window of Lion's Club. ND 13, Wyndmere, ND. 8/13/02

 120. Donkey Ball Game by Ole "The Hermit" Olson.

Carved in 1933, it depicts actual people attending game in Litchville, ND, 4.75 x 28 x 24 inches. Photographed at the North Dakota Museum of Art, Grand Forks, ND. 1/26/81

 121. Donkey Ball Game, detail. 1/26/81

 122. Painted Tree Trunk at Sam Bjertness's Home. ND 18, Hatton, ND. 1/31/81

 123. Classroom Decorated for Halloween. Hannaford School, ND 1, Hannaford, ND. 8/25/03

The large number of empty school buildings found in towns across North Dakota bear witness to the human erosion since the state's population high-water mark of the 1930s. Not all of these changes are negative; sometimes they reflect consolidation and improvement, positive adjustments to more contemporary needs, as when a former school is reincarnated as low-cost housing, a community service center, or even an arts and crafts consignment shop. Yet, a functioning school building represents a continuity of youthful optimism, for towns are severely compromised when children have to board a bus to go elsewhere. Depending on the age of the structure, multiple generations of the same family may have doodled initials on the same desks, eaten in the same lunchroom, and shot baskets in the same gym.

In Hannaford, the old school in the center of town is a WPA (Works Project Administration) structure with Art Deco overtones, which has only been closed for a few years. There are still sports trophies in the cabinets, class banners in the halls, and Bunsen burners in the chemistry lab. The school board sold the building to the town for a dollar, and, from time to time, community activities are held there. What first appeared to be the aftermath of vandalism, with "bloody" handprints on the wall and Goth graffiti, turned out to be left over from a house of horrors set up by high schoolers on Halloween to entertain and scare the daylights out of the younger kids.

124. "CHAIN-SAW GNOME" AT IVER AND MARGARET GROTH'S HOME. ND 200, Portland, ND. 11/5/00

125. "CHAIN-SAW WATERMELON SLICE" BY LOLENE TORMASCHY. US 10, Gladstone, ND. 5/10/81

North Dakotans of both genders traditionally learn to handle most any sort of implement or tool at an early age. Women drive combines, men repair clothes, and kids grow up knowing how to change the oil on the family pickup. But, even by these standards, twelve-year-old Lolene Tormaschy's dexterity and creativity stood out, as her watermelon slice won the chain-saw sculpture contest during the Gladstone Winter Carnival in 1981. Afterward, her proud parents placed her work on permanent display atop a stump in the yard beside their house.

126. MORRIS BAR WALL PAINTING. US 52, Drake, ND. 5/22/01

127. THE FUNHOUSE BOWL. US 12, Atwater, MN. 8/12/02

128. DARCY'S CAFE. US 2, Grand Forks, ND. 5/18/01

129. THE TERRACE LOUNGE, VIEW FROM THE BAR. US 52 and 281, Carrington, ND. 2/2/81

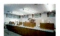

130. KETTER'S BUTCHER SHOP. US 10, Frazee, MN. 8/21/02

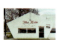

131. THE SHARON BANK. ND 32, Sharon, ND. 8/22/01

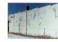

132. THE KITE CAFE. US 2, Michigan, ND. 5/14/81

133. EXTERIOR DECORATIONS FOR THE B & B LOUNGE. ND 3 and 13, Wishek, ND. 3/13/81

134. STARLITE GARDEN THEATER. ND 32, Fingal, ND. 5/24/01

135. ENTRANCE TO THE BIG FISH SUPPER CLUB. US 2, Bena, MN. 11/8/00

136. CHAIR DETAIL, FABULOUS WESTWARD HO MOTEL. US 2, Grand Forks, ND. 1/31/81

137. THE FABULOUS WESTWARD HO MOTEL & CONVENTION CENTER. US 2, Grand Forks, ND. 8/19/02

The Fabulous Westward Ho Motel & Convention Center was once routinely packed with truckers, business travelers, hockey fans, tourists, and the odd visiting artist to the North Dakota Museum of Art. It was famous up and down the state as a slightly rowdy, eminently comfortable, and reasonably affordable place that featured over-the-top Western decor with mild overtones of a bordello. Every room had Naugahide chairs decorated with a stitched horse head, cowboy tiles in the bathrooms, ghost-town wallpaper murals above the beds, and tongue-in-groove paneling, with branding irons and horseshoes on all the walls. There was a late-night saloon, package store, restaurant, and casino replete with a real back room where stakes were high and liquor flowed.

The complex was located near a giant potato processing plant that continually spewed out billowing thunderheads of greasy steam, particularly when the temperature was below freezing. The immediate area always reeked of a combination of boiling oil and spuds, and in winter the casino parking lot and nearby highway turned to black ice from the collision between fifty degrees or more differences in temperature. After dark, when things would really get hopping at the Ho and the multi-colored neon lights from the faux ghost town cabaret were ablaze, the whole scene was a mélange of avarice, gluttony, and lust; a cumulonimbus cloud of frozen French-fry miasma propelled across US 2 by the prevailing winds, part inadvertent skating rink for vehicles and part Dante's Inferno.
Note: The Casino and Convention Center closed in 2001. The motel suffered a serious fire from a suspicious explosion and subsequently was sold and the name changed. In February 2007, plans for restoring the entertainment complex were announced.

138. MASONIC TEMPLE BLUE ROOM. US 200, Cooperstown, ND. 5/19/81

139. MASONIC TEMPLE BILLIARD ROOM. Cooperstown, ND. 5/19/81

 140. LADIES' RESTING LOUNGE, STATE CAPITOL. US 83 and I-94, Bismarck, ND. 1/15/04

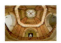 141. FOYER CEILING, LAMOURE COUNTY COURTHOUSE. LaMoure, ND. 8/14/02

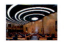 142. STATE CAPITOL BUILDING, HOUSE OF REPRESENTATIVES CHAMBERS. Bismarck, ND. 1/15/04

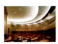 143. STATE CAPITOL BUILDING, SENATE CHAMBERS. Bismarck, ND. 1/15/04

Completed in 1934 during the depths of the Great Depression, the North Dakota State Capitol building stands at the juncture of the eastern plains and western hills, not far from the banks of the Missouri River. While the exterior is simple, even severe, the interior of the eighteen-story building is full of architectural treasures in the Art Deco style, including Memorial Hall, both houses of the State Legislature, and the Theodore Roosevelt Rough Rider Award Gallery. The latter is a permanent exhibition of thirty-four portraits of prominent North Dakotans, such as the trio depicted in the photograph on page 144: Casper Oimoen, an Olympic skier who emigrated from Norway as a teenager; Harold Schafer the creator of Gold Seal Products and the most youthful recipient of the Horatio Alger Award on record; and Era Bell Thompson, track star and scholar at the University of North Dakota, who became a noted author and long-time editor at *Ebony* magazine. In many ways, these three successful individuals effectively illustrate the range of backgrounds, experiences, and diversity to be found across the state and its immediate environs.

While the portraits have been painted by three different artists over a forty-five-year period, they are remarkably consistent in their style: a sort of Day-Glo hyper-realism where each image appears to emanate light from within. Other well-known individuals depicted include the late Eric Sevareid, CBS television commentator and scourge of the Nixon administration; Angie Dickinson, who has appeared in almost ninety Hollywood movies, including both versions of *Ocean's Eleven*; and Phil Jackson, the New Age basketball coach and corporate guru, late of the Chicago Bulls and again of the Los Angeles Lakers.

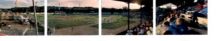 144. STATE CAPITOL BUILDING, NORTH DAKOTA HALL OF FAME, DETAIL. (Portraits of Casper Oimoen, Harold Schafer, and Era Bell Thompson), Bismarck, ND. 1/15/04

THE SEASONS

 146. DR. PEPPER CAN MADE FROM CONDUIT PIPE. US 83, Max, ND. 1/16/04

 147. ROLLER-SKATING COUPLE ON WALL. City Ice Rink, US 2, 52, and 83, Minot, ND. 10/7/04

 148. RAGGEDY ANN AND ANDY HAY BALES. Johnny Flemmer Ranch, US 2, Ray, ND. 8/22/03

 149. JOHN DEERE TRACTOR HAY BALES. ND 200, Golden Valley, ND. 10/8/04

150-51. PANORAMA OF CORBETT FIELD. US 2, Minot, ND. 8/5/96

Corbett Field, originally completed as a WPA project in 1940 and located across from the entrance to the State Fairgrounds, has been home to American Legion, Babe Ruth, and numerous minor league teams since that time. Some of baseball's greatest stars have performed here, either en route to the big time or in barnstorming exhibitions.

One such luminary was the legendary Satchel Paige, perhaps the greatest pitcher ever, who appeared at what was then called the Municipal Ball Park. Paige's Kansas City Monarchs played the Minot Merchants in the summer of 1947. Ingewald "Eli" Anderson, later the stadium groundskeeper, was the co-founder, second baseman, and manager of the Merchants, as well as the lead-off hitter who managed to whack the maestro's initial offering over the fence for a home run, to the delight of a packed house. Mr. Paige was not so pleased; when Anderson came up again, he sent the upstart spinning into the dust on the first pitch and then mowed him down with nine straight called strikes in his remaining three turns at bat.

"After he knocked me down, I didn't see a single pitch and I never forgot it," said Anderson, still lanky and fit when he recalled the experience thirty-five years later while leaning on a rake at the pitcher's mound. Apparently, neither did Paige, because, when he returned to Minot in the 1970s as the Grand Marshal for Opening Day at Corbett Field, he spotted the groundskeeper holding the gate for him to enter the field and pointed at Anderson accusingly saying, "You, you got a lead-off homer off me in 1947 before I was even properly warmed up!"

 152. Batting Cage at American Legion Field. US 52 and 281, Jamestown, ND. 5/12/1981

 153. Grandstand at American Legion Field. US 52 and 281, Jamestown, ND. 5/12/1981

Huntingfishing

 156. Close-up of Black Duck. Black Duck Motel, US 71, Black Duck, MN. 11/8/00

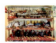 157. Display of Fishing Lures at the Old School House Consignment Shop. Bemidji, MN. 11/9/00

Lois Dale started an art supply store and consignment shop in a corner of a disused Bemidji school building, which has kept growing and growing to the point where all five former classrooms are chock-full of northwestern Minnesota crafts, with another cultural enterprise, Diane's School of Dance, occupying the entire top floor.

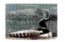 158. Loon and Wall Painting at Mini Golf Course. US 2, Bemidji, MN. 11/8/00

 159. Doors to Boys and Girls Rooms at City Pool. MN 29, Wadena, MN. 11/10/00

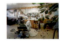 160. Gil's Barbershop. ND 200, Cooperstown, ND. 11/5/04

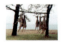 161. Hanging Deer Carcasses at the Edgewater Motel. US 2, Bemidji, MN. 11/7/00

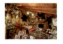 162. John and Inez Beckstrand's Living Room. ND 20, rural Warwick, ND. 8/21/03

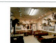 163. Red Apple Cafe. US 59 and 200, Mahnomen, MN. 8/18/02

Note: Shortly after the photograph was taken the restaurant was sold and the "wild life" removed.

Religious Life

 166. Snirt-covered Graveyard. ND 37, Raub, ND. 2/4/81

 167. Lutheran Church Sign. ND 45 and 65, Jessie, ND. 2/12/81

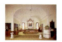 168. Altar, Goose River Church. ND 18, Hatton, ND. 1/28/81

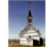 169. Saint James Church. Shields, ND. 5/9/81

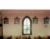 170. Sidewall, Saint James Church. Shields, ND. 5/9/81

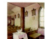 171. Interior Saint James Church. Shields, ND. 5/9/81

 172. View of Graveyard with Snirt. ND 11, Hague, ND. 2/13/81

 173. Upper Left: Grave marker at Saint John's Catholic Cemetery. ND 11, Zeeland, ND. 2/13/81

 Upper Right: Grave marker. US 10, Glen Ullin, ND. 2/14/81

 Lower Left: Grave marker at Saint John's Catholic Cemetery. ND 11, Zeeland, ND. 2/13/81

 Lower Right: Grave marker at Saint John's Catholic Cemetery. ND 11, Zeeland, ND. 2/13/81

 174. Grave Marker. US 10, Glen Ullin, ND. 2/14/81

 175. Left: Grave Marker at Saint John's Catholic Cemetery. ND 11, Zeeland, ND. 2/13/81

 Right: Grave Marker at Saint John's Catholic Cemetery. ND 11, Zeeland, ND. 2/13/81

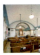 176. The Gran Lutheran Church. ND 200, Mayville, ND. 5/24/01

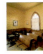 177. Rear Classroom, Gran Lutheran Church. ND 200, Mayville, ND. 5/19/01

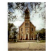 178. Peter and Paul Catholic Church. US 83, Strasburg, ND. 5/8/81

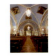 179. Peter and Paul Catholic Church. US 83, Strasburg, ND. 5/8/81

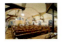 180. Saint Mary's Catholic Church. ND 1, Dazey, ND. 5/23/01

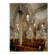 181. The Catholic Church of St. Stanislaus. I-29, Warsaw, ND. 7/23/01

Dreaming and Redemption

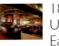 184. Whitey's Wonder Bar before the 1997 flood. US Business 2, (De Mers Avenue), East Grand Forks, MN. 2/24/81

 185. Whitey's Wonder Bar after the 1997 flood. US Business 2, (De Mers Avenue), East Grand Forks, MN. 8/21/03

The spring floods of 1997 affected the lives of practically everyone living in the proximity of the Minnesota/North Dakota border. Houses, farms, and businesses situated miles away from the riverbed sustained water damage, and there were fires that couldn't be extinguished because the flooding wouldn't allow the pump trucks to get close enough to train their hoses. Up and down the border, damages were in billions of dollars, and predictions for the future of the region were dire.

But a distinctly Northern Plains combination of hardiness, ingenuity, and willingness to share travails led to an almost complete recovery. There is perhaps no better symbol of that resurrection than the glistening stainless steel horseshoe that forms the Wonder Bar at Whitey's Café in East Grand Forks, MN. Originally part of a Prohibition-era complex of drinking and gambling rooms bankrolled by Ed "Whitey" Larson, the stylishly curving, seventy-five-year-old bar with its double-W symbol survived a six-foot cascade of river water to be rebuilt and reinstalled by the current owners but now rotated 180 degrees to directly face the Red River of the North. And in a deft acknowledgment to the rowdy past, the staff at Whitey's offers customers the chance to roll dice against the house for the price of each new round of drinks.

 198. The Bobbisox Drive In. ND 40, Tioga, ND. 10/7/04

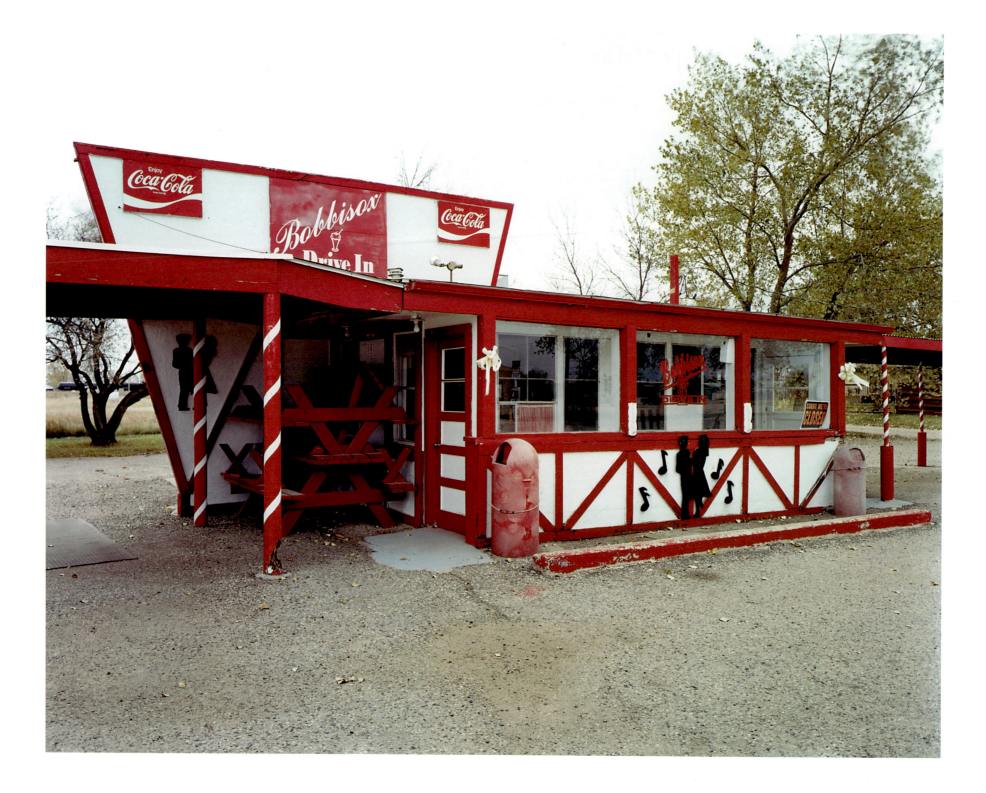

Author's Acknowledgments

When I first began photographing in North Dakota in 1981, Jacquie and I had been married less than two years. In the ensuing time together, we have managed to raise two wonderful boys, Roy and Alex, and to build upon those values that brought us together in the first place. Nothing would have been possible without the love and support of this family.

No project such as this could be realized without an inordinate amount of inspiration, help, and sustenance that others have kindly given over more than twenty-five years. Laurel Reuter initiated this work, and her extraordinary acumen, ability, determination, and dedication have made it possible for the original conception to evolve to what it has come to be. Her sense of how the pictures might fit together was illuminating, and her encouragement to write the text was an initial vote of confidence that I will always treasure.

The staff at the North Dakota Museum of Art was, at every turn, unfailingly professional in its advice, help, and support, but what made our myriad interactions such a pleasure was the gracious good humor and thoughtful manner that permeates their every endeavor. North Dakota folklorist, Nicholas Vrooman, did an extraordinary job of research on sites and locations throughout North Dakota. The results of his labor have proven invaluable again and again and made a fascinating task all the more inclusive.

Going on the road for days at a time can be wearing, even debilitating, without wonderful travel companions. Jacquie and Roy Dow, Amber Duntley, Mark Malin, Morgan Owens, Kent Rodzwicz, and Guillermo Srodek-Hart shared conversation, driving, picture taking, and navigation with grace and skill and were instrumental in making the results even better. And, to elevate them all to sainthood, they managed to put up with every one of my dietary, exercise, logistical, and sleep idiosyncrasies with uproarious wit and sagacious understanding.

Jeffrey Beatty, SA Bachman, Emily Drabble-Moore, Laurel Reuter, and George F. Thompson were of invaluable help in affirming, editing, and making suggestions in the writing.

Over the entire time and countless trips, the goodhearted expertise of Steve Brettler has helped every aspect of my photography. In the bargain, he has become an intrinsic part of our family. Bruce Berman, Janet Borden, Emmet and Edith Gowin, the Hart family, and Rose Shoshona have extended a level of generosity that exceeds my ability to thank them properly. Without their collective help this book would not have been possible.

Many, many people kindly welcomed us into their homes and lives, but I particularly wish to single out Paul and Marilyn Fundingsland, Walter and Becky Piehl, Greg Vettel, and Dale Zohn. Their warmth and willingness to help has been a classic demonstration of the intrinsic kindness found across the High Plains.

The late Sig Jagielski, his wife, Josie, and cousin, Evelyn, were more than hosts to myself and to my friends and colleagues. In a great many ways, Sig was a mentor and a teacher, and he provided wonderful artwork, great counsel, terrific polka tunes, and a withering reality check whenever we took ourselves too seriously. As much as any one person, I think of him as a symbol of what is so remarkable about North Dakota, and this work is dedicated to his memory.

North Dakota and Northern South Dakota

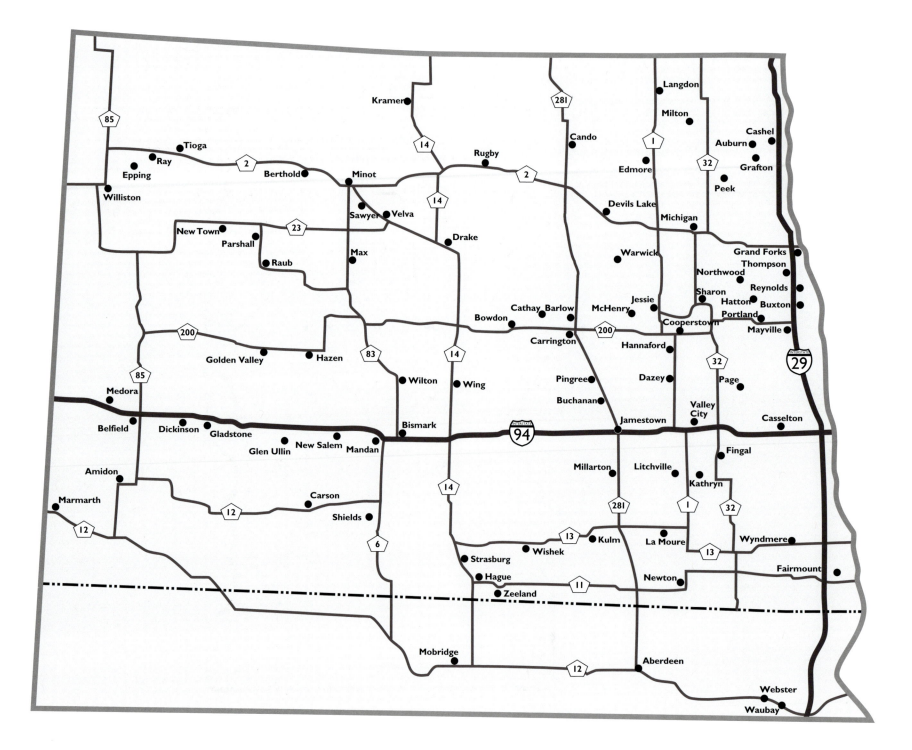

CENTRAL AND NORTHERN MINNESOTA

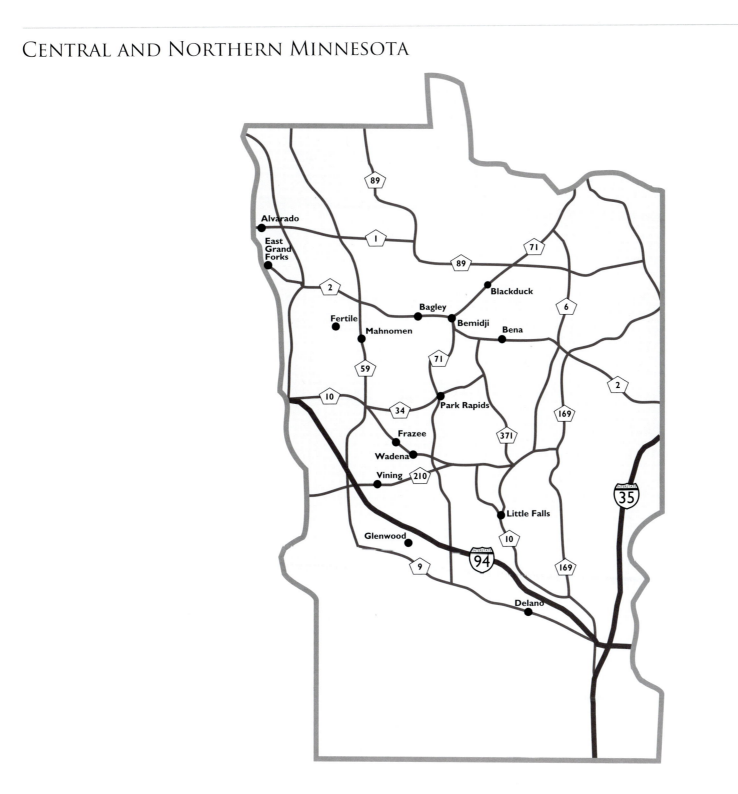

INDEX

JIM DOW

An indifferent student in graphic design at the Rhode Island School of Design, Jim Dow took a photography course with Harry Callahan, which caused him to switch his major. His fate was sealed when, purely by chance, he met Walker Evans and saw the book *American Photographs*. The combination of these two influences gave him the impetus to begin to travel throughout the United States to photograph vernacular roadside structures, decorations and sights, first in black-and-white and, after 1977, in color.

Supported by a wide variety of grants, collectors, and commissions, including a John Simon Guggenheim Memorial Foundation Fellowship, he has continued to pursue his interests in such subjects and locations as private gentlemen's clubs in New York City; barbecue joints and county courthouses across the South; baseball parks in the United States; soccer stadiums in the United Kingdom and Argentina; mom and pop shops in London, Buenos Aires, and Mexico City; and, of course, all manner of things in North Dakota.

In addition to the North Dakota Museum of Art, which owns a complete set from *Marking the Land*, Jim Dow's photographs are in the permanent collections of the Art Institute of Chicago, Center for Creative Photography, George Eastman House, J. Paul Getty Museum, the Metropolitan Museum of Art, and the Museum of Modern Art, New York City, among others.

Dow teaches photography, photo history, and contemporary art at Tufts University in Medford, Massachusetts and the School of the Museum of Fine Arts, Boston. He and his wife, Jacquie, live in Belmont, Massachusetts, and they have two children, Roy and Alex.

LAUREL REUTER

As Founding Director of the North Dakota Museum of Art, Laurel Reuter has commissioned many artists, including Jim Dow, to create work about the Northern Plains. The resulting collections focus upon life during the late twentieth century that vie in significance with Karl Bodmer's nineteenth-century watercolors of the Mandan, Hidatsa, and Arikara nations.

Reuter has curated dozens of exhibitions of contemporary art and published extensively in the art field. Publications include *Whole Cloth* (with Mildred Constantine); *Under the Whelming Tide: The 1997 Flood of the Red River of the North* (co-editor); *Georgie Papageorge: A South African Experience; Will Maclean: Cardinal Points; Paula Santiago: Septum; Japanese Textiles, Vol. II; Machiko Agano, Portfolio Series; Juan Manuel Echavarría: Mouths of Ash*; and *The Disappeared/Los Desaparecidos*.

A North Dakota native, Reuter makes her home in Grand Forks.

THE NORTH DAKOTA MUSEUM OF ART

The purpose of the North Dakota Museum of Art is to foster and nurture the aesthetic life and artistic expression of the people living on the Northern Plains. Founded in 1974, this contemporary art museum is located on the campus of the University of North Dakota in Grand Forks. In 1996, the Museum separated from the University to become a private not-for-profit institution managed by its own Board of Trustees and supported by the North Dakota Museum of Art Foundation. By legislative act the Museum serves as the official art museum of the State of North Dakota.

The Museum's guiding mission states, "We, as inhabitants of the Northern Great Plains, struggle to ensure that the arts are nourished, and that they flourish, because we know that a vital cultural life is deeply essential. We have concluded that to study the arts is to educate our minds, for through the arts we learn to make difficult decisions based upon abstract and ambiguous information. This is the ultimate goal of education. Furthermore, we have come to value the arts because they make our hearts wise—the highest of human goals. Therefore, we propose to build a world-class museum for the people of the Northern Plains."

The Museum has become known for its ground-breaking work in human rights with internationally recognized exhibitions such as *Snow Country Prison: Interned in North Dakota*, *Mouths of Ash: Juan Manuel Echavarría*, and *The Disappeared*, an exhibition toured throughout the United States and five countries in Latin America beginning in 2005. The Museum's definition of human rights extends to the cultural rights of those living on the Northern Plains to view their own lives through the work of contemporary artists. *Marking the Land: Jim Dow in North Dakota* is one of many North Dakota Museum of Art exhibitions, commissions, and publications to respond to this need.

THE CENTER FOR AMERICAN PLACES

The Center is a tax-exempt 501(c)(3) nonprofit organization, founded in 1990, whose educational mission is to enhance the public's understanding of, appreciation for, and affection for places of North America and the world—whether urban, suburban, rural, or wild. Underpinning this mission is the belief that books provide an indispensable foundation for comprehending and caring for the places where we live, work, and explore. Books live. Books endure. Books make a difference. Books are gifts to civilization.

With offices in Santa Fe, New Mexico, and Staunton, Virginia, Center editors have brought to publication more than 300 books under the Center's own imprint or in association with numerous publishing partners. Center books have won or shared more than 100 editorial awards and citations, including multiple best-books honors in more than thirty academic fields.

The Center is also engaged in other outreach programs that emphasize the interpretation of place through exhibitions, lectures, seminars, workshops, and field research. The Center's Cotton Mather Library in Arthur, Nebraska, its Martha A. Strawn Photographic Library in Davidson, North Carolina, and a ten-acre reserve along the Santa Fe River in Florida are available as retreats upon request.

The photographs for
Marking the Land: Jim Dow in North Dakota
were made between 1981 and 2004.

This first edition is limited to
500 limited clothbound edition and
2,500 paperback copies.

The book was designed by
Steven Kirschner.

Maps on pages 200 and 201 were created by
Elizabeth Laxson and William Wetherholt of the
University of North Dakota Geography Department.

The text was typeset in
Gill Sans and Trajan Pro.

The book was printed on acid-free
Productolith Dull Text,
100 pound weight,
in Winnipeg, Canada, by
Kildonan Printing (2000) Ltd.
kildonanprinting.com

The book was bound in Vancouver, Canada, by
Northwest Book Company.